701.17

47661

THE DEVELOPMENT
OF
AESTHETIC EXPERIENCE

CURRICULUM ISSUES IN ARTS EDUCATION

Series Editor: Malcolm Ross, University of Exeter

Vol. 1. The Arts and Personal Growth

Vol. 2. The Aesthetic Imperative

Vol. 3. The Development of Aesthetic Experience

A related Pergamon journal*

LANGUAGE & COMMUNICATION
An Interdisciplinary Journal

Editor: ROY HARRIS, University of Oxford

The primary aim of this new journal is to fill the need for a publicational forum devoted to the discussion of topics and issues in communication which are of interdisciplinary significance. It will publish contributions from researchers in all fields relevant to the study of verbal and non-verbal communication.

Emphasis will be placed on the implications of current research for establishing common theoretical frameworks within which findings from different areas of study may be accommodated and interrelated.

By focusing attention on the many ways in which language is integrated with other forms of interactional behaviour it is intended to explore ways of developing a science of communications which is not restricted by existing disciplinary boundaries.

*Free specimen copy available on request.

THE DEVELOPMENT
OF
AESTHETIC EXPERIENCE

Edited by
MALCOLM ROSS
University of Exeter

PERGAMON PRESS
OXFORD · NEW YORK · TORONTO · SYDNEY · PARIS · FRANKFURT

U.K.	Pergamon Press Ltd., Headington Hill Hall, Oxford OX3 OBW, England
U.S.A.	Pergamon Press Inc., Maxwell House, Fairview Park, Elmsford, New York 10523, U.S.A.
CANADA	Pergamon Press Canada Ltd., Suite 104, 150 Consumers Rd., Willowdale, Ontario M2J 1P9, Canada
AUSTRALIA	Pergamon Press (Aust.) Pty. Ltd., P.O. Box 544, Potts Point, N.S.W. 2011, Australia
FRANCE	Pergamon Press SARL, 24 rue des Ecoles, 75240 Paris, Cedex 05, France
FEDERAL REPUBLIC OF GERMANY	Pergamon Press GmbH, 6242 Kronberg-Taunus, Hammerweg 6, Federal Republic of Germany

First edition 1982

Library of Congress Cataloging in Publication Data

Main entry under title:
The Development of aesthetic experience.
(Curriculum issues in arts education; v. 3)
Papers presented at Exeter University's 1981 Arts
Education Summer School.
Includes bibliographies and indexes.
1. Aesthetics–Addresses, essays, lectures. I. Ross, Malcom, 1932- II. University of Exeter.
III. Series.
BH39.D46 1982 700'.1 82-3742 AACR2

British Library Cataloguing in Publication Data

The Development of aesthetic experience.–
(Curriculum issues in arts education; v. 3)
1. Aesthetics–Congresses
I. Ross, Malcom II. Series
700'.1 BH39
ISBN 0-08-028908-8

In order to make this volume available as economically and as rapidly as possible the author's typescript has been reproduced in its original form. This method unfortunately has its typographical limitations but it is hoped that they in no way distract the reader.

Printed in Great Britain by A Wheaton & Co. Ltd., Exeter

Introduction to the Series

MALCOLM ROSS

This series of books springs from a particular impulse: a feeling that those of us active in the field of arts education must redouble our efforts to ensure the greater effectiveness of our work.

The impulse is strong, the felt need a matter of urgency, even emergency. It arose against a background of economic cut-backs and ideological reactivism: the troubles besetting our society were being identified not merely by the politicians and economists but by the populace in general with the alleged failure of the schools to produce suitably trained personnel for the country's industrial and technological needs. With the judgement that we'd all been having it too good (and on the cheap). And with the call to apply the strictest, most utilitarian and cost effective criteria to an overall assessment of our society, the way it works, the services it relies upon and the output it generates. In such a climate we should expect the arts, arts education, the life of feeling, intuitive knowing and the things of the spirit all to be severely tested - and, as I write, the evidence offers all too plain an endorsement.

But I should like to think that we might have launched this project even in less searching times - for the impulse is not merely a reflex act in self defence as it were. Behind the decision regularly to publish a collection of papers treating the arts in education not as separate subjects but as a <u>single discipline</u> lies the conviction that it is only through the recognition of their common educational function (as

distinct from their separate several identities and
processes) that the arts will ever come to play the
significant part in the education of everyone, young
or old, artistically gifted or otherwise, that we
confidently proclaim they should. It is because we
feel that arts teachers, artists and everyone involved
in arts education wherever and at whatever level they
work must find common cause, discover their common
interest and express themselves as far as possible in
a common language, that this series has been conceived.
Our hope is that these books - and the conferences from
which, in large measure, they will derive - will make
a useful contribution to the establishing of this sense
of identity and towards the strengthening of the hands
of individual teachers in their efforts to create the
appropriate grounds for their encounters with those
whose feeling lives they seek to enliven and enhance.

The following topics will be the subject of further
issues and conferences:

1. Arts Education and Contemporary Arts
2. The Core of the Arts Curriculum.

Preface

'Aesthetic Development' was selected as the theme for
Exeter University's 1981 Arts Education Summer School
and the speakers were asked particularly to consider
what the term development might mean in the aesthetic
field, how development might be thought to occur, and
what factors might enhance or inhibit healthy aesthetic
growth. The hope was expressed that answers to these
questions might help teachers understand their purpose
better and, in particular, that arts teachers would be
encouraged to create learning experiences for children
that took account of their changing needs. The
introduction to the Conference brochure concluded with
the following statement:

> "Unless curriculum design and assessment
> are based on a clear conception of develop-
> ment it is difficult to see how either
> could be the outcome of coherent planning
> or stand up to public evaluation."

It has become the pattern with these conferences that
the first part of the week be given a strong
theoretical/discursive basis. There were some ten
major lectures from specialists in the fields of
philosophy, psychology and the different arts subjects -
with the conference responding in seminars and group
discussions. It soon became clear that the questions
posed by the topic would admit neither of ready
answers nor of swift agreement. Perhaps understand-
ably many of our lecturers elected to treat the theme
in a general way: others certainly took up the central
issues directly but often to find the familiar

difficulties emerging when philosophers talk to
psychologists and arts to non-arts people. However,
many valuable insights emerged alongside a number of
specific ideas for future development, as will
become clear from reading the papers collected in
this volume. All the conference papers have been
included - for the most part without comment. What
unfortunately cannot be presented is the very lively
discussion provoked by all the papers. If few
delegates left with categorical answers, the issues
themselves had been made very clear and people felt
on the whole better equipped to pursue them in their
own working circumstances. No one challenged the
assertion quoted above: that it was critically
important for arts teachers to have a better under-
standing of aesthetic development. What had become
clear was that this was still, perhaps surprisingly, a
very new area and one urgently in need of basic research
and study.

The second half of the week was spent in a wide range
of practical activities - all of which explored and
extended in various ways the theoretical input of the
first few days. The commitment to the practical
investigations was intense and sustained - with the
result that the 'sharing' on the last day revealed a
high quality of thought and of artistic activity that
was as surprising - to everyone - as it was delightful.
The whole course had been characterised by a remarkable
spirit of comradeship, tolerance and good-humour that
in no way blunted the group's critical faculties.
The final presentations took on the character of a
celebration.

The conference will be remembered, one supposes, for
many things - the high quality of discussion and art
work, the glorious weather, the creative sense of
fellowship amidst the largest number ever recruited
for these conferences (the Centre was fully booked).
One event, however, stamped itself upon the week's
activities in a most unexpected way: this will be
remembered as the summer of the Royal Wedding. Until
the actual morning in question no one had given it
much thought and such comments as were made had a
predictably cynical flavour. Certainly few, if any,
of the conference participants had planned to watch
the television presentation. As it happened, in the

course of the morning more and more people drifted
into the television room and stayed - so that when it
was all over a considerable number had been involved
and, many (myself among them) deeply moved. Although
those who for whatever reason missed that morning's
action remained tolerantly amused by the 'gullibility'
of the rest of us, there was no doubt in the minds of
those who had luckily been drawn into that attentive
circle that we had witnessed and somehow participated
in an astonishingly powerful and significant occasion.
To walk away into the house or into the gardens after-
wards was to know just how deep had been the enchant-
ment cast by the event. Certainly there could be no
doubting the impact on the millions able to watch the
occasion as it unfolded. Here, if we needed it, on a
vast and almost impersonal scale, was a supreme instance
of feeling finding appropriate form and of the
spiritual dimension of art. It was heartening and
refreshing to discover that such an experience was
still possible in the 1980s - and that people such as
we are could be knocked out by it.

There was a perceptible sense of elation as individuals
left Dillington to deal in their own ways with the
'cuts', the 'core curriculum', 'falling roles' - to
say nothing about the symptoms of a wider national
malaise that in recent months had assumed such
frightening proportions. Dillington has become a
very special place to us over the years and much of
what it offers is directly due to the care and
imagination of the Director, Peter Epps, and his
staff. Long may it continue to provide the sanctuary
and stimulation for which we are all so grateful. Our
appreciation of the continuing vital support of the
Michael Marks Charitable Trust is equally heartfelt.

Contents

Contributors xiii

Section I - Philosophical Issues

 Introduction 1

 The Concept of Aesthetic Development 2
 Louis Arnaud Reid

 The Aesthetic Dimension in Art Education: 27
 A Phenomenological View
 Victor Heyfron

Section II - Psychological Issues

 Introduction 47

 Aesthetic Development: A Psychological 48
 Viewpoint
 David Evans

 The Concept of 'Development' in 67
 Aesthetic Education
 Robert W. Witkin

Knowing Face to Face: Towards Mature 78
 Aesthetic Encountering
 Malcolm Ross

Section III - Curriculum Issues

Introduction 92

Aesthetic Development in Music 94
 Dorothy Taylor

The Challenge of Art Education: the 110
 Role of the Teacher and the Role of
 the Student
 Alfred Harris

Aesthetic Development in Dance 124
 Sarah Rubidge

Drama as Learning, as Art and as 137
 Aesthetic Experience
 Gavin M. Bolton

Postscript to Gavin Bolton 148
 Malcolm Ross

Section IV - Educational Issues

Introduction 153

Emotional Development in Adolescence 155
 James Hemming

Everyman - Artist 169
 David Farnell

Meaning in Aesthetic Experience, some 186
 Personal Observations
 Leonard Jenkinson

Aesthetic Assessment and the Reliability 195
 Factor
 Karen M. Moloney

Author Index 207

Subject Index 209

Contributors

GAVIN BOLTON, Lecturer in Drama in Education,
University of Durham.

DR. DAVID EVANS, Senior Lecturer in Education,
University of Exeter.

DAVID FARNELL, Head of Art, Melbourn Village College,
Cambridgeshire.

ALFRED HARRIS, Senior Lecturer in Art Education,
University of London.

DR. JAMES HEMMING, Writer, Broadcaster, Psychologist.

VICTOR HEYFRON, Senior Lecturer, Worcester College of
Higher Education

LEONARD JENKINSON, Art Teacher, Tiverton School,
Devon.

KAREN MOLONEY, Researcher, Leicester Polytechnic
School of Postgraduate Studies in Education.

LOUIS ARNAUD REID, Professor Emeritus of Philosophy
of Education, University of London.

MALCOLM ROSS, Lecturer in Education, University of
Exeter, Director of the Arts Curriculum Project.

SARAH RUBIDGE, Dance Teacher, Research Student at
University of Exeter.

DOROTHY TAYLOR, Lecturer in Music Education,
University of London.

DR. ROBERT W. WITKIN, Lecturer in Sociology,
University of Exeter.

SECTION I

Philosophical Issues

Introduction

Louis Arnaud Reid analyses the concept of aesthetic
development in terms of "the development of
discriminating understanding of 'given' art". He
claims that there is no way of knowing the secret of
artistic creativeness "just because it is free and
original". The common aesthetic ground of all the
arts is aesthetic appraisal, which he calls "dis-
interested interest". Mature aesthetic responses are
cognitive - "the cognitiveness of feeling". It is
cognitive feeling that, in mature perception, discerns
the embodied meaning of the work of art. In the
second part of his paper Professor Arnaud Reid
investigates consciousness as cognition, conation and
feeling, and enlarges upon "the functions of feeling
in the process of knowing and understanding". He
concludes that the mature appreciation of art has to
be learned.

Victor Heyfron stresses the personal and expressive
importance of art in exhibiting to us "that to which
we attach fundamental value". He explores the
relationship of objective judgement to subjective
encounter, and draws a fundamental distinction between
the uses of imagination and of fantasy. He believes
the notion of aesthetic development to be essentially
concerned with the relationship between "the
distinctive perspective of the individual pupil and
the general canons embodied in an art form".

The Concept of Aesthetic Development

LOUIS ARNAUD REID

I

My title is "The Concept of Aesthetic Development".
'Development' is a word of many uses, some of them
overlapping. There is biological development, the
development and growth of plant or animal or of the
human embryo. There is the natural psycho-physical
development of a normal growing human being (contrary-
wise the 'development' of schizophrenia or of cancer).
Or, with a specifically normative flavour, we can
speak of moral or intellectual development, or of the
development of a logical argument, of a musical theme,
the development of a photograph or an industrial plan.
So we might go on. None of these uses exactly fits
our theme here; though some of them have a bearing on
it.

Our concern is with 'aesthetic' development, and here
with specific reference to the arts. At once we run
into complications. Of 'arts' there are many, and of
individual works of art an indefinitely large number.
Aesthetic development of musical understanding is,
speaking concretely, quite different from the devel-
opment of aesthetic understanding of sculpture, or
painting, or of literature, drama, dance.

Then, within any art, there are the very different
'developments': of the original creative artist, of -
in some arts such as music or dance - the interpreting
performing artist or artists, of the discriminating
appreciation of 'given' art by the spectators or
audience, of the expertise of artistic criticism.

This is all so bewildering that one might despair of
getting any kind of order into the treatment of such
a (comparatively) simple-sounding title as 'aesthetic
development'. Indeed a full exploration of all these
aspects of aesthetic development would entail the
work of a lifetime! Clearly I must limit myself here;
and I shall limit myself mainly - though not exclusive-
ly - to the development of discriminating understanding
of 'given' art, and (again not exclusively) to visual
art. I shall of course have in mind too the ongoings
in the source, the _fons et origo_, of everything in art -
the creative artist. But (except in sofaras any
general findings about aesthetic development in
children and adolescents have bearing upon this) I
shall make no direct attempt to investigate the
'development' of the artist. This - because the
creative artist is the centre of everything - may
seem disappointing. But my failure to attempt to
treat of it directly is due not just to lack of space
and time but partly to the fact that we do not know,
and in principle cannot know the secret of the
'development' of artistic creativeness in the artist,
just because it is free and original. It is true that
there has been much writing, some superficial, some
very penetrating, about creativity itself, and about
the conditions - it might almost be called the
'environment' - in which creativity springs up. But
the springing up is a mystery, a sort of magic, whether
as partially manifest in children or more fully in
the mature artist. As such, it can only be thank-
fully acknowledged. And, as far as _education_ goes,
it is a question whether development of artistic
creativeness can be taught (though the conditions of
its happening may be safeguarded, and children given
all the technical help they may ask for or need). Of
artistically creative children (or adults) it might
be said, After Bo-Peep, 'Let them alone, and they'll
come home ...'

On the other hand, development, through education, of
discriminating understanding of given art, _is_ I
believe possible, and educationally of great
importance, not only in schooldays, but for a lifetime.

The problem of the multiplicity of the arts (to cite
only one kind of complexity), though it seems to make
any kind of generalisation desparingly impossible,

need not however do so. For - cutting straight
through recurrent controversies about whether, because
of the varieties of the arts and of the infinity of
differences between different individual works, 'art'
can be 'defined' - one thing, I think, is clear.
There is something common to all of our experiences of
art, of whatever kind - music, poetry, painting ...,
each art concretely utterly different from the others.
It is that any work of art, of whatever kind or genre,
must be experienced 'aesthetically'. What is called
the 'aesthetic' attitude or interest in an object, is
sometimes described as a 'disinterested interest'.
This is intended to mean that the object is attended
to, and in some sense 'enjoyed' 'for itself', 'for
its own sake', for the qualities it possesses in
itself as apprehended, and which arouse our attention
and interest. It is called 'disinterested' not of
course because we are uninterested, but because it
excludes extraneous or irrelevant interests, such as
the interest in increasing our factual knowledge, or
in improving us morally, or in making a good invest-
ment by buying a picture. Aesthetic interest might,
incidentally, achieve some or all of these other
things: but aesthetically speaking they are irrelevant.
And, if this defines generally the aesthetic interest,
attitude, experience, attention, as an essential
condition for the proper apprehension of any work of
art, a 'work of art', correspondingly, may be very
generally defined as 'a human artifact made with
aesthetic intention'. (This of course tells one
nothing about whether it is a 'good' or a 'bad' work
of art.)

Such a statement is of course very general. But there
are other, more particular, characteristics or
requirements generally applicable to all properly
aesthetic and mature approaches to art - though some
of them require special interpretations for particular
arts. (I shall illustrate what I mean by this proviso
a little later.) It will be helpful to look at some
of these more particular requirements, since the
presence, or absence, of them in children can be
clues to the stages of maturing aesthetic development.

This point is important. The study of aesthetic
development (like the study of the discursively-
cognitive in Piaget or of the moral in Kohlberg) is

'normative' in the sense that we could not know what
'development' means, could not know what questions to
ask or what to look for, without as clear a conception
as possible of what development is development towards,
namely mature (or more mature) aesthetic experience
and understanding. What this 'mature' experience and
understanding is, is a matter for an aesthetics
which attempts to understand philosophically the
nature of the arts and art-experience. Philosophical
aesthetics, dealing in general concepts, is futile
unless it is based on an inner personal involvement
and experience of the arts. (Ideally it should be as
many arts as possible; but this is an ideal.) But as
philosophical, it is a conceptual study. Hence my
title: 'The Concept of Aesthetic Development'.

But, though the concept of aesthetic development could
not be understood without the aid of philosophy,
neither could it be understood without empirical
studies, observation of how children actually do
develop, the stages of their psychophysical growth,
their capacities at different ages to apprehend
aesthetically. On this facet of the study of develop-
ment I can claim no expertise. There is some relevant
and helpful writing on aesthetic development, not a
great deal. (The preoccupation, almost the obsession,
with what is in my opinion, far too narrowly called
'cognitive' development, has blinded philosophers
and psychologists to the cognitiveness of feeling
which is an essential factor in all aesthetic
understanding. Aesthetic cognition has been
scandalously ignored, except by a few. But more of
this later.) I shall, in this paper simply draw,
here and there, from the writings of one or two
writers whose work seems to me sensible and reliable.

I have, so far, given only a very general and abstract
description of what is essential in order that there
should be even the beginning of properly aesthetic
understanding of art. But it can be expanded a
little in a way which can be helpful in the study of
aesthetic development.

In describing aesthetic experience above, I stressed
that there is interested attention to an object 'for
itself', 'for its own sake'. This is cardinal. If
the object is an art-object of any kind, the

attention, if it is to be aesthetic, is focussed on
the picture (poem, drama, symphony, dance ...) in its
wholeness, in its parts, in its qualities, all in
relation to one another and to the whole.

By 'object' here is meant the object-as-we-experience-
it, the object of our attention. There is of course,
always a physically material thing or event or
succession of events. Yet the work of art is not a
physically material thing only, but the thing as-we-
see-or-hear-it, as-it-appears-to-us. In other words
it is a 'phenomenon' or 'phenomenal object'. When we
talk of an art-object in the full sense, we always
mean a phenomenal object, an object as it is seen in
a certain way. It is with this essential proviso that
we say that the art-object and its qualities as
apprehended, has to be the focus of attention. This
focus is the opposite of any focussing of attention
upon our own subjective states or events, subjective
associations, feelings, emotions ... any subjective
states as such. Certainly subjective states occur.
There could not be any aesthetic appreciation of art
if they did not. There is a subjective side essential
to this subject-object relationship. But in the
aesthetic experience of art they must, as it were, be
gathered into a relevant focal attention to the art-
object. This is a crucial point. A child (or an
adult) may confuse the two things if he thinks a
picture is 'good' just because the perception of it
causes excitement in him, gives him a thrill or 'kick',
or just because it reminds him of something pleasant
or 'good'.

Connected with this is the central fact that
meaningfulness of a work of art-as-we-apprehend-it is
embodied in it. I have written pretty voluminously
over more than sixty years on the bearing of what I
believe to be this central principle of the aesthetics
of art. Here I can only say briefly that, positively,
it entails that any good work of art is, in its own
way, individual, unique, a sort of self-contained
'monad', and that as we apprehend it aesthetically as
presented, it contains its meaning. This is, very
emphatically, not for a moment to deny that art
draws experiences of meaning (of many kinds) from
outside art: indeed these resources beyond art and
from which art can draw, are illimitable. The poetry

and drama of Shakespeare are an obvious example; and
in literature and drama perhaps it shows most
clearly. It can be shown too in the visual arts (in
Guernica, for instance). Of purely abstract visual
arts, and of pure music, it is more difficult to show,
though these are not, I believe, an exception.
Speaking generally, all art is made in a context of
life-experiences outside art, and art in its own way
expresses some of them. But 'its own way' is the
'way' of embodiment. Meaning in the arts is trans-
formed and transmuted so that it can only be known
through direct confrontation with this picture, this
sculpture, this poem, this music. It is a unique way
of knowing which has no parallel.

Any experience of art which is short in the realis-
ation of this fact is undeveloped, immature. (I don't
of course mean that to understand art aesthetically
one has to have theories of 'embodiment'. The
realisation of it - or its absence - shows in the
actual approach to art.) If someone is too
'realistic', thinking that there are rules that (say)
a picture must be 'like' its subject-matter, or a
rule that certain subject-matters ought to be barred
from treatment in art, or that there are abstracted
formal rules about balance, harmony, contrast, valid
without any consideration of their embodied
expressiveness in the whole - then the person
concerned has missed out on the central principle of
meaning-aesthetically-embodied. So he does too if he
is unaware of the peculiar and distinctive trans-
forming power of different media - the sounding words,
the weight and order of them in poetry, the
different kinds of transformation into aesthetic
meaning of tempera, oils, guache, stone, clay, or of
the sound-qualities of different instruments in music.
Such a person is, aesthetically, immature, undeveloped,
whatever his chronological age.

But the words 'immature', 'undeveloped' are
ambiguous. I have up to this point been using them
as they might apply indifferently to a child, or an
adult. But an adult may be mature chronologically
and in the 'natural' sense, and, sometimes, in what
is counted mature in an intellectual sense - yet be
aesthetically without the natural sensitive insights
of a young child. Aesthetic maturity has certainly a

relationship to chronological age; but it is not a
simple one. The idea that there is a one-to-one
relationship between chronological age and aesthetic
development is sometimes flatly contradicted by the
facts. This needs some further analysis.

The empirical psychologist whose interest is in the
development of children is concerned with certain
facts about what can be called their 'natural'
psychophysical growth, the stages through which they
pass in childhood as they move towards adolescence
and adulthood. If his interest is in aesthetic
development, he must, as I have suggested, have as
clear an idea as possible (derived from studies in the
aesthetics of art) of the nature of mature under-
standing of art, if he is to know what to look for,
what observations and tests are relevant to his study.
In other words, though his concern is with factual
recording of natural stages in children's growth, a
normative element is involved too. He may be said to
be interested in stages of 'readiness' to respond to
and understand art aesthetically, a later stage
(normatively, and usually chronologically) being
marked off from an earlier stage by its relation to
certain criteria of the nature of mature aesthetic
understanding of art.

The natural facts of 'readiness' can be recorded (as
Piaget in the conceptual-discursive field, and
Kohlberg in the moral field, recorded facts about
'concrete' and 'abstract' thinking). They are
interesting in themselves, and particularly important
for education (insofar as they can be accepted as
valid), as indicating, for instance, what can be
expected and what is possible in the way of learning,
at this or that stage. In the realm of the under-
standing of the arts, it is quite certain, in my
opinion, that a measure of understanding of given art
can be taught. Equally, it seems sadly true that
discriminating aesthetic appreciation of given arts
is not taught (in England and at any rate in the
visual arts) except here and there. Appreciative
understanding, I am suggesting, can be taught. Or,
speaking rather more broadly, it can be learnt,
whether taught or not, by a person himself, given
interest and sufficient development of natural
capacity. What should be taught, and when and how,

is - or ought to be - a burning question for teachers
of art in the first place, and, if we think more
generally of aesthetic education (which covers much
more than the aesthetic of the arts) not only for
teachers of the arts, but for all teachers whatso-
ever. I shall return briefly to this question.

But meanwhile, what are some important facts as noted
by empirical developmental psychologists interested
in aesthetic development? I shall take the empirical
account of the factual evidence of development in
children from two papers, one by Michael J. Parsons
(1976)[1], the other by Parsons, Marilyn Johnston and
Robert Durham (1978)[2]. The findings in these papers
are confirmed in a later article by Antonio D'Onofrio
and Calvin F. Nodine (1980)[3].

Parsons (1976) in his initial paper distinguishes
"four stages in the development of aesthetic
experience, each founded on an underlying cognitive
structure. This structure consists in the way in
which the aesthetic qualities of an object are con-
ceived. The variable is the relation as between
persons and the object of these qualities. Thus by
way of a guiding summary, children at the first stage
speak as if these qualities lie in an egocentrically
close relation between the self and object. At the
second stage, children conceive them as residing in
the satisfaction of a specific set of rules. At the
third stage, account is taken of a wide variety of
possibly conflicting sets of rules, and authority for
judgements lies either in the artist's intentions or
with the individual and characteristic response.
Finally, at the mature stage, aesthetic qualities are
thought of as qualities of the object itself, being
in principle publicly accessible and based on the
perceptual or intentional aspects of the object."[4]
The passage is "from a highly egocentric response to
a response that is highly sensitive to aesthetic
qualities as such, i.e. to a power of highly relevant
and subtle feeling."[5]

This can be developed a little. The child (to about
age seven) does not distinguish clearly between art
objects and natural ones, nor between liking and
judging, is influenced by subject matter and pleasing
colours, and is heavily idiosyncratic in preferences:

he can be said to be "confusedly aesthetic".[6] Irvin
Child (1964)[7] found that between ages six and eleven
there is no distinguishing between subjective
preference and judgements of aesthetic value. (One
might comment that this extends to many adults.)

At the second stage (roughly between seven and
twelve), 'rules' seem to be important - rules of
'realism', of form, of subject-matter. The 'rules'
are not particularly clear or specific about 'realism'
(or indeed about form and subject-matter), and Parsons
questions how far they apply to cultures other than
Western. Again, in music, 'realistic' rules have no
application, whilst as regards literature the
application is not simple or clear. Rules about form
concern questions of balance, harmony, contrast,
repetition, grouping ... An object is judged 'good'
if it is balanced, etc., and in this there is a clear
distinction between mere preference and aesthetic
judgement. The nature of rules about subject-matter
are harder to specify, but they seem more conventional
and less whimsical than at the earlier stage. "They
include sea-scapes, for example, in various moods, but
not oil slicks; handsome soldiers, but not Goya's
Execution of the Fifth of May. In general they
include the pretty, the picturesque, the nostalgic,
the magnificent. The most general praise word becomes
the 'beautiful'; the most difficult problem is the
tragic ... Children respond very much in terms of
heroes and villains ... Children identify with the
hero, and the violence happens to the villain."[8]
They do not admire Picasso's Guernica.

At the third stage, beginning at preadolescence, the
approach is much more flexible, there may be many
alternative sets of rules by which works may be
judged. Children who hitherto have thought that the
difficult task of art is to make it 'like' nature,
now call for different criteria. They become con-
cerned with the artist's intentions, what he is
trying to do, what is relevant. Confronted with
Klee's Head of a Man, a particular child did not
simply reject it as younger children did, but was
puzzled about what Klee was trying to 'say', "what
feeling he was trying to put down. I'm confused ...
I don't know what I'm supposed to be looking for.
It's not that I really don't like it; it's O.K., but

I don't know what he's trying to say."[9] Art at this
stage is recognised as expressive of personal
feelings, emotions, ideas, and this may well be
thought of as more important than questions of
technique or skill; and of originality rather than
just of hard work or skill. There are, now, different
genres of art.

Of the fourth stage, I need add nothing here; for it
simply illustrates the emergence of the kind of
mature discrimination which has been outlined
earlier.

The second paper I referred to, by Parsons, Johnstone
and Durham (1978), is a development of the same theme:
but there are differences in the structural approach
which bring out some further interesting points, as
well as reinforcing those already made.

Generally speaking, the child who is mature
aesthetically sees more in the art object than the
less mature child: but he also attends to far less,
because considerations thought important earlier are
seen to be irrelevant. The method by which this is
shown is to take different 'topics' - Semblance,
Subject-matter, Feeling, the Properties or qualities
of an Artist, Colour, aesthetic Judgement and to
examine three stages of development in each.

In the first 'topic', Semblance, a new distinction is
made, between 'realism' which is 'schematic' and
realism which is 'visual'. 'Schematic' realism,
occurring at about ages seven to nine, is the idea
that the things in painting should look like what
they are 'supposed' to be. What they should look
like is what one knows-about them. 'Visual' realism
(at perhaps about eleven to sixteen and beyond)
requires representative pictures to look real as they
can be seen by anyone. As a girl of sixteen has it:
"You can tell they are people but they aren't very
life-like."[10] But in the later years (say fourteen
to eighteen) the demand for 'realism' tends to be
dropped, except where a painting seems to require it.
"Otherwise various styles and degrees of abstraction
and distortion are accepted. There is increased
awareness of, and tolerance for, a variety of kinds
of painting, intentions of the artist, and responses

of the viewer. The criterion for deciding how
paintings should picture objects is usually inferred
from the painting as a whole."11 Examples are: "He
could have made it more real, if he wanted to, but for
this kind of painting, I think it's good."12 (Girl,
fourteen.) "If he's trying to show his feelings and
if this is what his feelings are then this is the way
the painting should be."13 (Girl, sixteen.)

As regards the second topic, Subject-matter, there is,
at the earlier stages, the familiar demand for 'happy'
and 'pretty' and 'nice' pictures rather than sad or
ugly ones. At the second stage (perhaps ten or
eleven to sixteen), the range expands, to include sad,
nostalgic and unpleasant subjects. Cruel, or tragic,
items are still rejected on grounds of morals or
mores ("most people wouldn't like it").14 At the
third stage "Good art can be made of any subject,
including the violent, cruel and tragic. Moral
objections are finally dropped as irrelevant to art.
Appropriateness of subject-matter is determined by
considering various criteria, e.g., the viewer's
responses or the reality of the theme."15 To a
question about Chagall's Circus: "Is this the kind of
thing you'd expect an artist to paint about?" the
reply (by a young man of eighteen) was "Yes, because
I think a circus has overtones on life. In a sense
it represents life and is also a chance to get away
from life. It offers the painter a wide range of
possibilities; whatever meanings he's trying to get
across, he can probably take a circus and find a
place to use those ideas."16

On the third Topic, Feelings, "the child focuses on
particular characters in the painting one at a time
and attributes feelings to them. In doing this he is
guided as much, or more, by the overt subject-matter
as by the expressiveness of the painting ... This is
an advance on the stage that we presume to precede it.
The child focuses on the painting itself and is
guided by what he sees far more than previously. He
is not prey to arbitrary associations, and he
distinguishes more clearly what he sees from what he
is reminded of. Nor does he project his own feeling
so freely; asked how the painting makes him feel, he
usually identifies the feeling as attributed to a
major character."17 At Stage 2, the distinction

between one's own feeling and that attributed to
characters in the painting is made explicit. There
is a new understanding that different people may
respond in different ways; one's own feelings may not
be shared by everyone. Stage 3 generalises beyond
the feelings of individual characters to the emotional
impact of the painting as a whole; and feelings are
seen as very complex and particular.

I shall not say much about the remaining topics –
Colour, the Artist's 'properties', Aesthetic Judge-
ment. The comments in the article mostly repeat and
develop in different contexts what has been already
said.

On Colour, there is the usual development from liking
colours, or liking this or that colour, to thinking
of their appropriateness to the subject-matter, and,
finally, of their appropriateness to the whole
painting – mood, theme, the intention of the artist,
and, at the very late stages, the recognition that
colour can express a mood directly.

As regards the Artist's properties, the question what
makes him a good artist is answered by the younger
children in terms of the physical items necessary to
paint a good painting – brushes, water, paints to
colour it. This develops, at the second stage, into
a recognition of manual skills, perseverance, patience,
hard work, craftsmanship. Then, at stage three, comes
the recognition of mental, mainly cognitive, abilities
as essential. An artist has to know what to do, to
know what things look like, and to be able to think
up subjects for painting. The stress is on the
cognitive rather than on the experiential or
affective. At stage 4, however, affective qualities
are recognised. Creativity, meaningfulness, or talent
is largely a matter of feeling. Of Picasso's
Guernica a girl of eighteen remarks: "It seems like
he can kind of remove himself from the whole situation
and he sees the war in a way and shows the uselessness
of it and the agony that people experience and the
destruction, and in a way, it gives the feeling of
how useless it all is."[18]

Judgement includes (and one might add, transforms)
all kinds of reasons offered for an aesthetic

judgement. It is more comprehensive, a culmination,
and it brings out fully the difference between the
early "I like it", and "This painting is good" (for
many reasons). It also distinguishes between the
idea (Stage 2) that the main criteria for judging
paintings are the amount of time and effort it took,
manual skill, the amount of detail, the degree of
realism involved. At stage 3, the criteria for
judgement expand and change. Of primary importance
is whether a painting is expressive. This is some-
times thought of as cognitive ('conveys a message'),
and sometimes affective ('expresses an emotion'). At
stage 4, the criteria for judgement are seen as
depending on the circumstance: the artist's intention,
the beholder's response, or the genre or style to
which it belongs. The emphasis is still on express-
iveness, but how, what, and whether something has
been expressed is a matter for interpretation.
"There is also the view ... that a painting is good
if it is exactly as the artist intended it to be. We
do not suppose that this is the final stage of
aesthetic judgement, but it is the last one we could
distinguish."[19] The authors conclude: "our work needs
corroboration and suggests a great number of further
questions."

I will not remark now on the third paper mentioned,
by D'Onofrio and Nodine (1980). It is sympathetic to
and confirmatory of Parsons, et al.

 II

The empirical investigations we have been looking at
are based on "a cognitive-developmental theory of the
aesthetic experience of children, somewhat parallel
to the work of Kohlberg on the development of the
moral judgements of children (Parsons, 1976)."[20]
This is Parsons' own declaration in the opening
sentence of his first article. The acceptability of
this very much depends on our interpretation of
'cognitive'. Kohlberg's emphasis, in his develop-
mental studies, is, like Piaget's, on cognition
chiefly as conceptual understanding. It is true, in
the case of Piaget, that he recognises also an
'affective' side to all behavioural development, as
a dynamic aspect of it. But generally, as with other

thinkers who deal with the 'cognitive', feeling and
the affective is relegated to a different part of the
mind. There is a dualism: 'cognition' belongs to one
realm, 'feeling' to another, though it is agreed that
cognition can affect feeling, and feeling, cognition.

For the understanding of art (and, I shall suggest,
for the cognitive understanding of anything whatever)
this is totally inadequate. Parsons, despite his
opening sentence, recognises this. "I assume", he
says, "that cognition and affect are importantly
interactive in the experience of both the child and
the adult. Affect is certainly important in aesthetic
response; but what develops is not just the power of
feeling. The young child already has that. It is
the power of relevant feeling that develops. This is
what aesthetic development is the development of:
the ability to respond relevantly to a work of art as
an aesthetic object. This ability rests on a
cognitive achievement, as the word 'relevant' makes
plain. And for this reason I speak of the develop-
ment of both aesthetic judgement and aesthetic
experience as part of a single story."21 So does
Howard Gardner.22 He points out the artificial
dichotomy; what (to me) is the exclusivist obsession
of the intellectualist with 'pure' feelingless
impersonal conceptual cognition. "The claim that
affect and cognition are two distinct yet related
aspects of child development is at least as wide as
the doctrine of affinities between child and artist.
The two aspects are frequently opposed to one
another, the young child being viewed as a creature
of affect who evolves into a creature of thought and
cognition. We read that 'the real task imposed on
child psychology by general psychology is to describe
how the child's thinking frees itself from emotional
fetters and approaches the ideal of pure objectivity
in a series of conquests of numerous obstacles and
mistakes.' Students of children's art echo this
dichotomy when they contend that the young child
painter is guided by his emotions and feelings, while
the older artist is controlled by rational thought
processes."23

"More suggestive in my view are certain contemporary
psychoanalysts who, instead of contrasting affect and
cognition, call attention to constant interplay and

interaction between the two systems. Thus Wolff
(1963) contends that affect may sometimes take the
lead in engendering psychological development:
'Clinical data suggest that, contrary to Piaget's
assertions, affects _are_ structure building forces
which give rise to semi-permanent emotional
predispositions (e.g. mood, character traits, etc.)
and that when so structured, affects may also serve
as defences to ward off other affective
experiences.'"24

I think that these observations, by Parsons, Gardner
and Wolff, all point in the right direction, but
that we need to be even more radical. Even Gardner's
insistence on interaction "between the two systems"
(italics mine) could be misleading. I believe that
cognition and feeling (as well as 'conation') are
organically related throughout the whole range of
waking human experience, though the stresses of
these aspects of consciousness vary a great deal in
different situations. I shall try to clarify this
by a brief but I hope fundamental analysis.

There is a familiar and long-standing analysis of
waking conscious mind which I find generally accept-
able - into Cognition, Conation and Feeling. In
cognitive awareness there is apprehension of the
structures of things - in commonsense, in perceptual,
conceptual, discursive thinking, in mathematics, the
sciences, philosophy, etc. Such cognitive awareness
is largely, though not exclusively, concerned with
facts, with 'what is the case', and with what can be
expressed with more or less clearness in the
propositional form of statements. But it should be
noted that the use of words like 'awareness',
'(cognitive) apprehension' implies something which is
ultimately very mysterious, not, in itself, propo-
sitional, a kind of direct 'seeing' that things are
(or are not) so and so. We could not perceive, think,
or understand an argument without this mental 'seeing'
or intuition. Looking outwards, as it were, from
inside ourselves towards matters of fact, we do not
normally notice this intuitive factor, though when
there is a difficult problem before us, we may be
aware of ourselves struggling to 'see' it, or a
possible answer to it, more clearly. When, however,
we are trying to 'know' another person better, or to

understand the dynamics of a moral problem, or to
grasp a work of art - parts and whole in relation to
one another - direct and intuitive cognising seems to
assume more importance.

Conation (conari, to try or strive) is the active
aspect of conscious life. Conating implies attending
to, being interested in whatever one is thinking,
doing, pursuing.

Feeling is commonly described as the 'affective' side
of consciousness, and this used to be identified with
'hedonic tone' along a positive-negative range of
pleasure-unpleasure. But this is a very limited and
restricting view. It is better to think of the
affective (or 'affect') and hedonic tone as one aspect
of feeling rather than as identified with feeling as
a whole. I shall have to go on to explain this,
since it involves a different and (I think) a much
more fruitful view of feeling and the functions of
feeling in the processes of knowing and understanding.

In a paper to the Aristotelian Society I suggested
that feeling is immediate experience and an insepar-
able aspect of everything that happens throughout the
whole of waking consciousness. It is "the inner side
of conscious experience in the widest and most usually
accepted sense of that term, conscious experience
which in human beings includes bodily sensations,
actions of various kinds, thinking, imagining, having
moral and aesthetic experiences, maybe religious ones,
coming to know and coming to terms with the external
world, ourselves and other people ... Feeling is the
immediate experience of indwelling in that conscious
life in its most inclusive sense."25 (Arnaud Reid,
1977.) This feeling has an affective side (but is
not identified with 'the affective'). We can talk
about it as being pleasantly or unpleasantly toned
(but not as identical with hedonic tone). But since
- on my account - feeling is "the immediate experience
of indwelling in conscious life in its most inclusive
sense", the affective tone cannot be adequately
described in terms of degrees of pleasure or
unpleasure. The quality of feeling in its affective
aspect, whilst it may be positive or negative, will
depend on what it is the feeling of in any particular
case. Winning in a sweepstake, getting the better of

someone in an argument or a game, climbing Everest,
solving a problem, helping a person in dire need –
all can give satisfaction: but how thin the word
'pleasure' is, in itself telling nothing of the
concrete differences between the different kinds of
positive feeling involved. Again, one may be
frustrated, impotently angry, terrified, sad ... The
'tone' is negative, of 'unpleasure' (or, less
technically, pain). But these words in no way
describe the different feeling qualities of the
different experiences. To get nearer to that, one
has to take into account that in all the examples
cited there is a cognitive element inextricably
involved. In all of them it is, inter alia, because
we are cognitively aware of an objective situation of
some particular sort, that the feelings are so
different in kind. Feelings are always feelings – of
something, and so, in an extended sense, are always
cognitive.

I say 'in an extended sense' because some philosophers,
who are tied to a view of cognition which tends
exclusively to emphasise what can be expressed in
propositional statements, deny that feeling, immediate
awareness of our own states, is cognitive. On this
view, we just have the states (say of pain-sensation,
or vague anxiety, or joie de vivre) and it is super-
fluous to add that we feel them cognitively. Merely
to experience a mental state is not cognition or
cognitive. But this denial is made in the context of
an assumption about cognition, that cognition always
involves the bringing of something under a concept,
expressible – potentially at least – in propositional
form. But if, as I have suggested, the possible
contents of feeling vary in each individual case of
feeling according to what the feeling is feeling-of,
the range of possibility is infinite, and the bringing
of every one under a verbally articulated concept out
of the question. Some contents of feeling have names
and come under clear categories. Examples are,
emotional feelings – feelings of anger, frustration,
sex, fear – or the feelings mentioned above: pain-
sensation, feelings of anxiety or joie de vivre. But
most of the very complex contents of our feelings
during a single day not only have no names, but do
not need to be named, because they are cognitively
experienced, known directly. Naming, categorising,

which is so important in the realm of discursive
propositional knowledge, is unnecessary here, and out
of place. Naming and explicit categorising is one
kind of activity: during most of life we get on with
other things. And in the arts, where cognitive
feeling plays an essential part, it is direct,
intuitive experience which centrally counts. If we
try, in the process of actual aesthetic experience,
to subject the content of cognitive feeling of a poem,
a painting, a sonata ... to conceptual analysis, we
miss out on its aesthetic significance.

But although there is this what I have called
'extended' sense of cognition to the immediate (and
often unnameable) feeling of content, feeling can
also be called cognitive in the sense that it
participates actively in, and is organically related
to, cognition in the more generally accepted sense.
Indeed it is a radical mistake to think of cognition
as if it functioned as a separate faculty. Cognition,
Conation, Feeling always work together; and it is
better to think of the whole person as knowing-
conating-feeling than of knowing as a function of
what is called 'cognition' only. (And so of the
others, conation and feeling.)

Take a simple and familiar example. You have got out
of bed in a pitch-dark room. You lose your bearings.
What you want to do (it is a very practical situation)
is to get out of that door. So you gropingly feel
about. You move your arms cautiously, your attention
particularly on your finger-tips. At first nothing
opposes your waving arms and hands. Kinaesthetic
sensations of movement, but, so far, no touch. Then
resistance comes; you feel an edge; it is the edge of
the dressing table. Your fingers convey sensations
of resistance, pressure, coolness, your hand sliding
along the edge. With touch sensations the vague
mental image you have had of the plan of the room and
its furniture becomes united with actual sense
perception; you now know where you are and can make
your way out.

This brief sketch of an experience is of course
entirely (or nearly entirely) onesided, emphasising
sensation. More fully, you want to get out. You
desire, strive, all-attentive, acutely interested.

This is the <u>conative</u> aspect, without which nothing
could get started or continue moving, and which you
'immediately experience', or <u>feel</u>. The feeling is <u>of</u>
wanting, striving, etc. It is also of wanting to
<u>know</u> where you are in the dark room, and to know
where the door is, and this in turn presupposes that
you have the vague image of the room and its contents,
together with concepts of (say) 'dressing-table',
'door'.

It would be tedious to go on. The main point is that
cognition, conation and feeling, though distinguish-
able in various ways, are in the actual situation
inseparably together. You could not come to know
without wanting to know or without feeling: nor would
feeling have any cognitive significance except in a
conceptual and imaginal framework of knowledge.

One could go on to illustrate the existential
inseparability of cognising and feeling (and
conation) in knowing or coming to know and understand,
in different modes of knowing, such as intellectual
knowing in science and philosophy, or in moral knowing,
or in knowledge of persons. In science or
philosophy, for instance, one may cognitively 'feel'
oneself moving towards (or away from) a so-far satis-
factory hypothesis or solution. The affective tone of
the feeling-towards is hedonically positive, and the
cognitive-conative striving is encouraged to explore
further in that direction. (Or it might be the
opposite: one turns back and perhaps starts again.)
Of course it is not just feeling: it is not what is
sometimes pejoratively called 'thinking with the
emotions'. <u>That</u> occurs when the affective side of
feeling is allowed to dominate over the cognitive
side: a finely tensioned balance is destroyed.

In all this I have of course been dwelling of <u>knowing</u>
and coming to know (participles), and not explicitly
upon the character of objective <u>knowledge</u> (the noun),
with its demand for testing for conceptual and
factual objectivity and truth. This <u>is</u> a main aim;
although progress towards it can be profoundly satis-
fying and humanly speaking very important, the
feelings of the scientist or philosopher are
irrelevant to the relatively impersonal truth-aims of
science or philosophy.

It is not so in the arts. Certainly artistic
judgements strive towards their own peculiar sort of
objectivity. If it were not so, 'development' of
aesthetic understanding of the arts would have no
meaning; nor would criticism. Aesthetic 'education'
would lose its point. But artistic judgements are
value judgements; they are not centrally connected
with establishing stateable facts - though critics,
who talk and write, undoubtedly speak both of matter
of fact (in describing, for instance the 'geometry'
of a picture) and also about what can be, quite
legitimately, called 'value-facts'. But the critic's
propositional statements and judgements, if they are
worth anything, must be based upon another kind of
knowing of a direct, intuitive, and very intimate
kind, in which cognitive-affective feeling is
involved, not as in science and philosophy, just up
to the point where the purely conceptual judgement
has to give over to independent logical and empirical
testing. In artistic judgements, cognitive-affective
feeling is not only intrinsic to the final judgements,
but intrinsic to the testing of these judgements. I
said above that "the feelings of the scientist or
philosopher are irrelevant to the relatively
impersonal truth-aims of science and philosophy". The
feelings (cognitive-affective) of the critic are not
irrelevant to the validity of the considered judge-
ment of an art work, but inescapably relevant.

The aesthetic understanding of given art comes through
the cognitive-affective feeling of values-embodied
in the presented work. In conceptual thinking as such,
the aim is clear, cool apprehension of facts and
conceptual structures. Mature understanding of art
certainly presupposes an indefinite amount of factual
knowledge and conceptual understanding - of the human
material of literature and drama and its media of
expression, of the very different materials and media
of the musical arts, of the conceptions of musical
structure. The visual arts have, as resources behind
them, storehouses of factual and technical knowledge.
But the possession of all such knowledge of fact or
conceptual understanding never in itself begins to
approximate to aesthetic understanding. One has to
feel, with sympathy and empathy, the human dilemmas
of dramatic characters, to feel the embodied
symbolism of the rhythmic form of the sounding

sequences of words in poetry, spoken or read with the
perception of aesthetic <u>nuances</u>. One has to feel
intuitively the musical significance of the fugue,
sonata or symphony, dwell within the dynamic yet calm
beauty of <u>Le Lac D'Annecy</u> – or the dynamic and
tortured drama of <u>Guernica</u>. One must enjoy complexity
in unity, tension, balance, depth. The list is
endless; but it is never a list, but a many-layered,
multi-dimensional form of living, its items and
immediately presented events always symbolically
reaching to ranges of meaning which can never be
spoken in the restricted language of intellect.

Howard Gardner (1973), penetratingly aware of the
function of feeling in the apprehension of art, asks:
"How can the arts facilitate a rapprochement between
affective and cognitive approaches?"[26] and says that
rather "than contrasting affective and cognitive
components, feelings and thoughts, it may be prefer-
able to think of them as two kinds of systems or
approaches that may be operative in the organism at
any time and in various combination."[27] It seems to
me that this is very nearly, but not <u>quite</u> right. It
is admittedly difficult to put into words the intimate
relationship. Conceptually, cognition and feeling
are distinct, yet to speak of two "systems" can be
misleading. Existentially, and as actually
functioning, it is hardly true to speak of two
systems as if they were separate, and cooperating;
rather we should think of one integrated psycho-
physical organism which aesthetically apprehends.

What, in all this, about the developing child's
aesthetic understanding of art? One thing seems to
be self-evidently true. If the aesthetic under-
standing of art when it is mature is as complex as I
have described (and it is infinitely more so), then a
young growing child, who is not yet mature, cannot
attain to it. This is of course a commonplace: yet,
in view of some of the things that even sophisticated
psychologists and others say about children as
artists, it is necessary to stress the obvious. I
will refer to a few quotations given in Gardner, and
comment, perhaps a little hypercritically, on them.

"Arnheim comments: 'I can think of no essential factor
in art or artistic creation of which the seed is not

recognisable in the work of children'." (1954.)28
It is an innocent enough remark; but is it, quite
strictly, true? Younger children's comments seem to
show an entire lack of the insights of the older
children; their work seems to show this too. Again,
'seed' is a misleading analogy. Given the necessary
conditions, a seed will develop naturally to a
preordained pattern towards maturity. But there is
no reason to think that artistic maturity will occur
in this way. The realisation of such maturity
depends on psychophysical natural growth; but mature
appreciation of art has to be worked at, learned; and
perhaps up to a point it can be taught. Goethe's
'romantic' observation that "'if children grew up
according to early indication, then we should have
nothing but geniuses'" (Katz, 1936)29 is open to
similar question.

These comments may seem pedantic, and ungenerous to
children as well. I hope not. I agree with what I
think is the truth behind some of the remarks I have
criticised. I agree that many (but would question
'all') children have some (but not all) of the
characters of artistry, and that there is a heart-
warming and loving spontaneity about some children's
art which is often later lost. Pfloiderer is quite
right when he says: "'What is for the adult a serious
and often very arduous task - training head and eye
to become absolutely obedient and trustworthy
servants of the artist's will - is for the child pure
pleasure. The child repeats with ceaseless delight
every new work, every new grasp, every new stroke.'"30
And the young child, who has not yet grasped adult
'logic', can be advantaged by this very fact: he is
not yet subject to the conflicts between logic and
feeling which beset adults, including artists. As
Jaensch suggests: "'the closest parallel to the
structure of personality in the child is not the
mental structure of the logician but that of the
artist.'"31 This does not imply, it ought to be said,
that because of the conflicts, the adult artist ought
to suppress his nagging intellect, at the times when
analytic thought has to be applied to the planning of,
or reflection upon, his work. But in actual artistic
creation, in the process of it, feeling and thinking
have to be fused together in the way I have tried to
describe.

I think, however, that the continual, and almost
exclusive, emphasis (in the discussion of children's
development) on <u>art</u>, is overdone. The full appreci-
ation of art is a very complex and sophisticated
thing, requiring not only natural psychophysical
maturity, learning - and a certain kind of teaching -
but a body of the experience from which different arts
draw, and each in their own way transform in
embodiment. Younger children in the nature of things
cannot have all this. But what of the world outside
the arts? There is the large world - sun or moon or
star-lit skies, clouds, rolling or mountainous
country, rivers, the flat lands of immense horizons,
the great masses of the forest trees, the breath-
taking vista on coming over the hill top. Or as
much - or for some children and adults maybe more -
there is the infinity of delight in small things, to
be seen, smelled, listened to, touched, felt for
their texture or smoothness or cool or warmth; admired
too - as with shells or moss-covered stones - for
their patterns of colours and shapes. An infinity of
them is always there, presented to the senses at
every turn. And the aesthetic pleasure is direct:
things 'speak' for themselves, their aesthetic
meaningfulness is embodied in them as apprehended.
Of the lichen-covered stone (which any unspoiled and
artistically uninstructed adult or child can enjoy
for its own sake) you do not ask - as people do of
abstract pictures or sculptures - 'What does it
mean?' What it means is embodied in what we <u>see</u>.
(If only this could be got into people's heads, what
a difference it would make!)

None of this is 'art'. But both for itself and as a
building up of cognitive-affective dispositions
towards the aesthetic, towards the perceiving and
feeling sensitively, which are the basis for art,
there can never be too much of it.

And how does it all relate to teaching, learning,
'education'? A large question which, fortunately, I
am not expected to tackle here, but with, perhaps,
two very short, broad answers. One is: in the
earlier years, give them every opportunity and
facility, encouragement, help in exploring for
themselves - as small spectators and small artists -
this intrinsic meaningfulness that comes to be known

directly through the senses, both in natural objects
and in works of art. Some children will demand, or
need, more than others: there can be no rules: the
perceptive teacher is the best judge.

In the later years comes the need for help and
opportunities for, on the one hand, such active
making of art as particular children are impelled to,
and on the other, quite definitely (and, I think,
most important), such educative teaching as is
possible, in the discriminating critical appreciation
of at least some examples of the good (and bad) arts
of our heritage. St. Thomas Aquinas once said that
"Only God can teach". This in a sense is very true
of art teaching: the teacher can do little if his
pupil will not look or cannot 'see'. But the teacher
can direct the pupil's attention to the things to
look for and, perhaps, how to 'see' (or hear, or
otherwise explore) them. To be initiated into this
in adolescence and early youth can, potentially,
transform the experience of a whole lifetime. To
miss out on it, to be deprived of it, is not only a
personal impoverishment, but, where the impoverish-
ment is widespread, a cultural and social disaster.

REFERENCES

[1]Parsons, Michael, J. (Spring, 1976). A suggestion
 concerning the development of aesthetic experience
 in children. Journal of Aesthetics and Art
 Criticism, 305-314.
[2]Parsons, Michael, J., Marilyn Johnstone and Robert
 Durham (1 January 1978). Developmental stages in
 children's aesthetic responses. Journal of
 Aesthetic Education, Vol. 12, 83-104.
[3]Antonio D'Onoforio and Calvin F. Nodine (4 October
 1980). Parson's model painted realistically.
 Journal of Aesthetic Education, Vol. 14.
[4]Parsons, op. cit., p. 309.
[5]Ibid.
[6]Ibid.
[7]Child, Irvin. (1964). The Development of
 Sensitivity to Aesthetic Values. New Haven.
[8]Parsons, op. cit., p. 312.
[9]Op. cit., p. 313.
[10]Parsons, Johnston, and Durham, op. cit., p. 89.

11Op. cit., p. 89.
12Ibid.
13Ibid.
14Op. cit., p. 90.
15Op. cit., p. 91.
16Ibid.
17Op. cit., p. 92.
18Op. cit., p. 99.
19Op. cit., p. 103.
20Parsons, op. cit., p. 103.
21Ibid., pp. 306-7.
22Gardner, Howard. (1973). The relationship of art
to human development. The Arts and Human
Development. John Wiley & Sons, New York.
23Op. cit., pp. 21-22.
24Op. cit., pp. 21-22, quoting P. Wolff, (1963).
Developmental and motivational concepts in Piaget's
sensori-motor theory of intelligence. Journal of
the American Academy of Child Psychiatry, 2, 241.
25Arnaud Reid, L. (1976-77). Proceedings of the
Aristotelian Society, Vol. LXXVII, p. 168.
26Gardner, op. cit., p. 20.
27Op. cit., p. 22.
28Op. cit., p. 20, quoting R. Arnheim, (Berkeley, 1954).
Art and Visual Perception, p. 164.
29Op. cit., p. 21, quoting D. Katz and R. Katz (1938).
Conversations with Children. Kegan Paul, London,
P. 302.
30Ibid., quoting W. Pfleiderer, quoted in H. Eng
(1957). The Psychology of Child and Youth Drawing.
Humanities Press, New York, p. 58.
31Op. cit., p. 20, quoting Jaensch, quoted by H. Read
in Education through Art. Pantheon, New York,
p. 58.

The Aesthetic Dimension in Art Education: a Phenomenological View

VICTOR HEYFRON

I

The notion of aesthetic development implies the identification of appropriate criteria against which the teacher is able to evaluate the child's responses to work he has made, performed, or appreciated under the concept of art. There are arguably two opposing approaches to assessing children's aesthetic development in art. The first favours a model approximating to Kohlberg's theory of moral development (Parsons et al, 1978). It argues that there are general aesthetic principles against which we are able to assess the quality of children's aesthetic performances. These principles are hierarchically structured in a series of invariant stages which constitute sequential qualitative improvement in a child's aesthetic behaviour. The direction of the stages is determined by some notion of aesthetic maturity, each stage registering an increment in aesthetic functioning. On this view, it is possible to claim that one child's work is qualitatively superior to another's, or superior to his own work produced at some previous stage. The assumption is that we agree both on the general principles constituting each stage, and that we are able to sensitively apply a set of pre-established general descriptions to individual pieces of children's work.

The second view criticises the project of identifying hierarchical stages exemplifying progressively superior aesthetic performance. It argues 1) that children's art work is expressively unique to its maker; 2) that

we do as a matter of fact differ in our interpretations
of art work and that this difference is acceptable in
the context of art; 3) that children's work is often
retrogressive, especially in the later stages of their
schooling. It concludes that to seek to identify
aesthetic norms generally applicable to different
children's work is fundamentally to misconstrue the
nature of aesthetic engagement.

There are important considerations in both accounts
for evaluating aesthetic development. On the one
hand, we must assume if our teaching is to have
direction the possibility of recognising qualitative
change in the creative work of our pupils. The
recognition of qualitative improvement does suggest
the identification of aesthetic principles against
which we are able to assess this change. On the other
hand, we recognise that creative ability does not lie
in the mere conformity to pre-established aesthetic
norms. In fact, it may lie in deviating from them.
For a 'good making' property in one person's work is
not necessarily a 'good making' property in another's.
Setting aside the logical problems involved in
applying general descriptions of aesthetic properties
to individual pieces of work, conformity to aesthetic
norms is no guarantee of aesthetic integrity even if
the end product has aesthetic merit, and intuitively
we hold that sincerity in artistic engagement is
crucial to the meaning of the aesthetic. We are
travelling in the wrong direction in art when we move
from the general to the particular, for until we have
understood what the child was trying to do in his
medium, we don't know the appropriate criteria to apply
to that work. The work itself in the context of art
suggests criteria appropriate to its evaluation.

I shall argue that the identification of appropriate
criteria should not be exclusively concerned with the
acquisition of artistic technique separated from the
point of having that technique, or with standard
aesthetic responses which do not centrally reflect a
child's spontaneous engagement in art. The evaluation
of a child's creative work should be concerned with
the relationship between the way his work is about
what it is about, that is to say, with the way he has
employed his artistic medium to exhibit preferred
content distinctive of his individual perspective.

I shall argue that the notion of aesthetic develop-
ment is essentially concerned with the relationship
between the distinctive perspective of the individual
pupil and the general canons embodied in an art form.
An understanding of this relationship is made
intelligible with reference to the way the general
non-artistic purposes that we have as human beings
have been transformed by, and incorporated into,
artistic traditions. I shall explore this notion in
an attempt to provide a schema for understanding the
nature of the value we attach to the aesthetic
dimension in art.

II

Crucial for an identification of appropriate criteria
for evaluating the work of an artist is a sensitive
understanding of what he was trying to do in that
work. We need to be able to relate to what is 'there'
before we can assess its success or failure.
(Wollheim, 1973.) What is 'there' takes a range of
descriptions, from the highly specific (e.g., pre-
dominant use of blue) to the highly general (e.g., a
depiction of the futility of life). We are interested
in the connection between these two elements. We
need to see how the artist has used his medium to
embody meaning, but until we look at the work we have
no way of knowing how effective the artist has been.
Applying general principles to children's work without
considering what the artist was trying to do in his
medium is mistaken.

There are fundamental problems connected with the
notion of what is 'there' in a work; and these
problems are compounded if we have in mind something
separate from the work itself when we refer to the
artist's intentions. What the artist claims, for
example, is not necessarily the most accurate account
of what he has done. (Heyfron, 1980.) For in art,
in contrast with the conventional expression of every-
day language, there is no independent characterisation
of the meaning to which the symbols of art correspond.
In art, we cannot assess the effectiveness of the way
the artist has used his medium in giving form to
content by passing through the artistic conventions
to that which they signify. The meaning is not
detachable from the way the elements in the work are

structured. And this point is important, for arguably
the meaning embodied in the work has no separate
existence apart from the unique configuration in which
it presents itself to the spectator. The art object
presents us with the occasion for experiencing the
otherwise inchoate, ineffable, and intangible aspects
of our being. It is a way of being about the other-
wise incomprehensible. Appropriate criteria are
related to an identification of what the work is about,
but what a work is about, what is 'there', is
inseparable from the way the work is about what it is
about, i.e., from the way the art medium transforms
its content. The upshot of what I am saying is that
there is no characterisation of what the work is about
more authoritative than the surface qualities of that
work. (Wollheim, 1979.) It is by contemplating the
appearance of the work with a sensitive eye that we
are able to recognise 1) what the artist intended, and
2) the effectiveness of the use of his medium in
carrying out these intentions. It would be absurd to
assess the way someone used his medium without implicit
or explicit reference to what it has been employed for,
or to apply a set of aesthetic norms generalised from
art practices but set off from the existential
purposes which they serve in those practices.
Gombrich (1960) argues that in principle we are able
to discern what an artist intended when we understand
the range of alternatives available to him in his
repertoire. He argues that it is because we share an
artistic tradition with the artist that we have access
to the symbolic meanings constituting his style and
the artistic purposes which they serve. Our under-
standing of these traditions does not guarantee, but
allows the possibility of arriving at 'agreements in
judgement'. Although there is a sense in which the
viewer can never know for certain what vision an
artist intended to convey (for example, Charles
Dickens had two endings to 'Great Expectations') we
accept the work as registering his commitment. If
there is to be authority in art, then there is nothing
more authoritative than 'agreements in judgement' by
reference to the features of the work. In art we
accommodate different interpretations of what is 'there'
in a particular work and accept the permanent
possibility of being mistaken about its meaning.
Nevertheless, we adopt an attitude towards art objects
'as if' their properties were public. In fact, we

check our perceptions of the work against the perceptions of other people, and act on the assumption that we can arrive at agreement about what is 'there'. The possibility of intersubjective validation of aesthetic properties is an essential feature of an aesthetic work, a feature which marks it off from the private world of the day dreamer.

It should be becoming clear that although the acquisition of artistic techniques is fundamental to the production of art objects, they are inseparable from the purposes for which they have been employed in a particular work, and that these artistic purposes which regulate the internal consistency of the elements of a work are themselves related to the external significance of the individual's psychological and existential concerns. Any account of aesthetic development which concentrated exclusively on the acquisition of technique would be a distortion. The child is not engaged in an essentially different type of activity to that of the mature artist: it fulfills a similar function in his life, namely, that of exhibiting the world as purposeful. It is a practice which should never be merely instrumental to some distant end, such as the acquisition of a technique so that one day the child will be aesthetically mature. The activity must be in some sense its own reward. (Ross, 1979.)

We do accept unquestioningly the meaningfulness of aesthetic activity, and we do not justify engagement in the arts by reference to something else we value more highly. Typically, we hold that art is an autonomous activity and that its value is non-dependent. We assume that when a person under the concept of art makes marks on canvas, or sounds on the piano, or gazes raptuously at a piece of sculpture, he is doing something purposeful. It would be churlish if, when demanding of someone disinterestedly con-templating an art object that they justify this engagement, we were to expect anything more than a description of the object. However, this is because at a more general level we assume that making or looking at beautiful objects is a meaningful activity. On the surface, making marks, sounds or movements seem strange activities in which to engage. In the context of our everyday pragmatic existence it would

be impossible to make sense of such activities with-
out some understanding of the kind of purposes which
people engaging in these activities might have.

Art is an intentional activity. We assume that for
an action to be meaningful, the agent must have an
awareness at some level of what he is doing. His
activity must be goal directed and not the outcome of
a sequence of causal events. But in what kind of
activity is the artist engaged? At one level we are
able to provide an adequate account of his activity
in aesthetic terms. And as far as it goes this is
legitimate, but it does not get us very far. We
escape circularity if we introduce such notions as
expressing our feelings or representing our world
view, but it still begs a number of important
questions. For example, why does it matter whether or
not we express our feelings? What is so significant
about our individual perspective on events? If such
notions as expression and representation are to
provide a clue to the purposes for which we engage in
art, then these notions need to be explored with
reference to the purposes art objects fulfil in a
culture. The kind of non-aesthetic purposes that
regulate the production of art objects, I suggest,
are more akin to the kind of purposes which regulate
the activities of such less obvious examples as those
of the daydreamer or the flirt. These activities, and
the pleasure derived from them, are made intelligible
with reference to psychological needs. I shall explore
a parallel notion in connection with children's
absorption in nursery rhymes.

III

A child engrossed in a nursery rhyme displays the
characteristics of an adult disinterestedly contem-
plating an art object. Typically, he is spontaneously
engaged in the activities of listening or reciting;
and he is not engaged in these activities for
instrumental reasons, such as, trying to please his
mother. The pleasure shown in the absorption is
evidenced in his request for the experience to continue.
How do we make sense of this phenomenon? I suggest
that a plausible account of the phenomenon can be
provided with reference to the psychological and
existential needs arising out of the child's

consciousness of his everyday surroundings. The
elements of the nursery rhyme are gratifying to the
child - albeit a gratification in fantasy - because of
their connection with the way he views his circumstances.
It is reasonable to suppose that the dominant features
of a young child's life are shared by all children to
a greater or lesser extent, e.g., they all have the
problem of growing up in an adult dominated world.
Consider some of these factors. Although there is joy
and happiness in a child's world, it is also a period
of extreme fears, anxieties, and rapidly changing
moods. He has not only to make sense of a strange,
chaotic, and often confusing environment, but also the
violent irrationality of his own psychological states.
He is surrounded by the threatening presence of adult
strangers and the dominant power of parents on whom
he is dependent for his feelings of self worth. There
is a preoccupation with mastering the spoken and written
word, eating food and controlling bodily functions.
All in all, he is confronted by an alien, unpredictable
world before which he feels impotent. It potentially
threatens both his physical and his existential
survival. A daunting characterisation, but not, I
suggest, an outrageously mistaken one.

How then does the enjoyment of the aesthetic features
of the nursery rhyme relate to the way the young child
apprehends his situation? Fundamentally, it is non-
alien, it responds to and accommodates the being of
the child. It is a warm, friendly, and familiar world,
inhabited by fascinating but uncomplicated creatures.
Unlike the perceived reality of his surroundings the
imaginary world of child art conjures up an unproblem-
atic existence to which there are magical solutions.
When he enters this world he is not confined by
physical or social laws. Animals become humanised and
speak his thoughts. The nonsensical irrelevancy of
'Hickory Dickory Dock', 'Little Miss Muffet sat on a
Tuffet', or 'Humpty Dumpty sat on a Wall' are all
accommodated in this cosy, welcoming world. The play
on sounds in the formal properties of internal rhyme
is not unconnected with the task of learning to speak
correctly. The strong rhythmic phrases emphasise
order and structure, and the frequency with which the
repetition occurs suggests a predictable and uncon-
fused world. The literal connection with everyday
events is not an obvious one in the early stages of a

child's development. It is as if the literalness of
a story is too constraining to provide the scope for
the imaginative leaps the child needs to make in order
to embrace its fundamental concerns. Events are
predictable and surprises softened; stories, games
and nursery rhymes can be repeated without loss of
interest.

It is plausible to suggest that the enjoyment derived
from the nursery rhyme for the child operates at a
number of different levels. At a psychological level
grasping the simple form of the nursery rhyme exhibits
to the child his capacity to apprehend his reality as
ordered and non-chaotic, and one in which threatening
omnipotent adults are contained and despatched. At a
more fundamental level, the absorption reflexively
exhibits the capacity to transcend his present circum-
stances, albeit in imagination. In the recognition
of this capacity is a realisation that he is not
condemned by the contingency of his present circum-
stances. The formal elements register this capacity.
Unlike the pleasure he may take in the knowledge of
the existence of his train set - the existence of
which is not dependent upon his capacity to conjure
it up in imagination - the pleasure in the existence
of the warm, secure, non-alienated world of the nursery
rhyme, and at another level the realisation of his
capacity to transcend the contingency of his lived
reality, lasts only so long as he is conscious of the
properties of the nursery rhyme.

We will be able to make clearer the connection between
the value we attach to art and fundamental human
concerns if we look at the situation of the adult.
Although the adult at a basic level shares similar
existential problems with the young child, for example,
the project of apprehending their being as significant,
at a psychological level their preoccupations are
different. For the most part the adult is preoccupied
with the mundane practical problems of living. He is
concerned, for example, with getting up in the morning
for work, remembering his sister's birthday, repairing
the dripping tap, and appeasing ungracious relatives.
The momentous occasions in his life, such as the birth
of his children, the death of his parents, separation
from friends, lack the dignity accorded to them in art.
There is no music playing in the background to

underline their significance. There is an arbitrari-
ness and gratuitousness about existence. Like the
child, we experience the world as alien and people as
a potential threat. We feel unfree and dependant upon
unpredictable physical and social forces. It is
important to stress these factors so as to give some
initial plausibility to the claim that the aesthetic
significance we attach to such qualities as uniqueness,
freedom, order, harmony, expressiveness and profundity
in works of art is somehow connected with the ideals
we aspire to in life. These qualities figure
prominently in our appreciation of art objects because
of our recognition of the significance they have for
human life in a wider sense.

IV

The production and enjoyment of art I have claimed is
made intelligible with reference to the purposes man
has. The child's absorption in nursery rhymes
illustrates at least the way properties in a work
relate to psychological states. The particular human
purpose I am going to instance art as partially
fulfilling is the project man has of apprehending his
being as significant. First, I shall assert rather
than argue in any detail conditional requirements for
this apprehension; second, consider the special way
that art contributes to this awareness, and finally,
consider the implications of the illustration for the
aesthetic development of the child.

Apprehending our being is not something we are free to
choose not to do in the way that searching for our
birth certificate is. Sartre argues that there is a
sense in which we only have being to the extent that
it is apprehended. A kind of Berkelian 'esse est
percipi'. Since our being does not have the sub-
stantiality of physical objects but is problematic,
and constantly being reconstituted in our awareness,
we have to create it in our commitments. The altern-
ative is a diminished existence. The three conditions
of apprehending our being as significant are as
follows: 1) there is something which is apprehended,
namely a content for consciousness which is identi-
fiably reflective of our distinctive perspective; 2)
there is something which apprehends, namely, a way of
being conscious which authenticates our distinctive

perspective; and 3) there is something on the basis
of which we attach significance to our being. The
first two conditions are inseparable from one another.
I am not able to be aware that I am conscious unless
I am also conscious of something. Sartre claims that,

> "A consciousness is conscious of itself
> insofar as it is consciousness of a
> transcendent object ... consciousness
> is purely and simply consciousness of
> being conscious of that object. This
> is the law of its existence. (The
> Transcendence of the Ego, 1957, p. 40.)

For example, I become aware I am able to see only when
I see an object. There is no other way of validating
the fact that I have eyesight other than by reference
to objects which are seen. Similarly, feelings exist
only when we are consciously aware of them. There is
no experiential distinction, for example, between
feeling depressed and being depressed. Insofar as the
act of awareness reflexively exhibits to us features
to which we attach fundamental value, then the third
condition is also inseparable from the first two.
For example, if I am aware I am able to see an object,
this exhibits to me a capacity, namely the ability to
see; and if I attach significance to this capacity,
then the act of seeing an object reflexively exhibits
something I value about my being. In much the same
way my awareness of works of art reflexively exhibits
in the engagement a capacity to which I attach the
utmost significance, namely, my freedom to transcend
the contingency of my situation.

> "Art is committed to that perception of
> the world which alienates individuals from
> their functional existence and performance
> in society - it is committed to an
> emancipation of sensibility, imagination,
> and reason in all spheres of subjectivity
> and objectivity. The aesthetic trans-
> formation becomes a vehicle of recognition
> and indictment. (Herbert Marcuse, The
> Aesthetic Dimension, 1979, p. 9.)

This freedom is given to us in the act of making or
appreciating. The appearance, the patterning of an

art work, is fundamental, for each element in the work
is the occasion for being reflectively aware of this
significance.

Let us examine each of these conditions in more detail.
What is the transcendent object of our attention when
we are conscious of our being as significant? There
must be a form with which we identify as reflecting
features definitive of our perspective, but our being
is not something totally separate from the being of
others. It is embedded in social institutions and
practices. We see aspects of ourselves embedded in a
situation, e.g., the way we dress, keep our house,
drive our car, are all indications of what we are.
The marks we make must not only be distinctive of our
perspective, but also be characteristics which do so
authentically. Being admired by significant others
is a way of getting our person validated, but we find
in this mode our being precariously dependant on the
valuations of others, and on our conforming to these
valuations, for example, the wise one, the trendy, the
carefree or the fast driver. The implications for art
are obvious. An artist slavishly adopting a style
because it is admired by others lacks integrity. We
are related to, and in turn apprehend, our being, in a
wholly generalised way in which our distinctive
perspective is irrelevant.

Authentic being, on the other hand, requires an
appearance with which we identify. Although we do
identify with our physical characteristics, e.g., the
way we dress, the dimensions which we typically
consider to be more definitive of what we are are our
values, as exemplified in our actions, i.e., our
attitudes, hopes, ideals, loves, hates, interests and
purposes. These dimensions are intangible and
impossible to experience reflectively by directing our
attention inwards. They are vital constituent aspects
of our being, and if our identity is irrevocably
intertwined with these ineffable features, and if to
apprehend our being and the being of others reflect-
ively is to be aware of these features, then it is
important that they have an externalised form in which
they can be experienced and thus validated as aspects
of our being. The institution of art provides such a
possibility. It is crucial if the externalised form
is to be reflective of our particular perspective that

the patterning of the marks in an art work correspond
and bear the distinctive flavour of this perspective.
The paradox of assessment in the arts is that we have
to be sensitive to the distinctiveness of the individual
style in the work but the form in which the artist's
vision is presented is a public one, necessarily
constrained by the medium. Points emerging from the
above are 1) apprehending our being as significant
requires a distinctive form (transcendent object)
authentically reflective of our perspective; 2) we do
not apprehend our being isolated and detached from
social institutions; and 3) the symbolic structures
embedded in artistic traditions provide the possibil-
ity for intersubjective validations.

The way we apprehend the features with which we
identify is an important consideration for the
validity of that which we apprehend. We are conscious
of people and events in different ways, e.g., emotion-
ally, conceptually, imaginatively and perceptually.
The way I am conscious of something registers the
status of its existence. This feature has implications
for 1) the possibility of apprehending authentic
perspectives of our being; and 2) the possibility of
attributing significance to this perspective in art.
Everything else being equal, we attach greater
significance to perceptual objects than to imagined
objects. Art has aspects of both the perceptual and
imaginative modes of awareness. We attach greater
significance to the images of art than we do to the
images of fantasy because art shares common features
with the perceptual mode of validating objects. When
we are imaginatively aware of an object we are also
reflexively aware that it is unreal. Correspondingly,
when we are perceptually aware of an object, we are
also aware that it is real. It follows that if we
imagine that we have certain characteristics, then by
definition, we are also aware that we do not have
them in reality, i.e., it is a pretence. A somewhat
shaky foundation on which to establish the significance
of my being! This has important implications for the
role I have assigned to art as exhibiting life as
significant. I will discuss this problem in the next
section.

Our sense of experience of perceptual objects validates
the presence of certain properties in much the same

way as the feelings we have towards events and people
authenticate our individual perspective. Although
we may be mistaken in our perceptual claims, or
unjustified in the attitudes we adopt towards things,
nevertheless, these modes are prime ways of being
aware of their respective objects: they lack as yet
intersubjective agreement for their validation.

The third condition of apprehending our being as
significant is seeing the world exhibited as purpose-
ful. Ultimately, there is no sharp distinction
between apprehending our being and apprehending the
world as meaningful. Inspirational acts of outstand-
ing intelligence, supreme courage, or physical stamina,
for example, move us even though we do not stand to
benefit materially. The achievements of others
register possibilities for man. In a similar way,
insofar as we are able to relate to, and identify with,
works of art they register something about the
humanity we share with others. The value we attach
to inspirational acts is typically made intelligible
with reference to people acting in the face of actual
obstacles in their real environments, whereas the
kind of achievement made in art is at base imaginative.
The problems the artist faces are voluntarily
encountered, they are problems that he creates for
himself. They are not unavoidable in the way that
starving is if we do not find food. We solve certain
problems in our daydreams. For example, in fantasy
we are able to transcend the exigencies of our present
circumstances and demonstrate a capacity to envisage
preferred versions of humanity. But this is a
capacity on the basis of which I have claimed we attach
significance to art. Although we would readily agree
that fantasy has an important place in art, intuitively
we are reluctant to reduce aesthetic experience to the
status of a daydream. The benefits of the daydream
are fundamentally impoverished. Sartre writes,

> "To prefer the imaginary is to adopt
> 'imaginary' feelings and actions for
> the sake of their imaginary nature. It
> is not only this or that image that is
> chosen, but the imaginary state with
> everything it implies; it is not only
> escape from the content of the real
> (poverty, frustrated love, failure of
> one's enterprises) but from the form of

the real itself, its character of
presence, the sort of response it
demands of us, the adaptation of our
actions to the object, the inexhausti-
bility of perception, their
independence, the very way our feelings
have of developing themselves. This
unnatural, congealed, abated formalised
life, which is for most of us but a
makeshift, is exactly what the
schizophrenic desires. (The Psychology
of the Imagination, p. 169.)

The pleasure we derive from daydreams is connected with
the gratification in fantasy of pre-existing desires.
We pretend that an imaginary situation satisfies an
actual need. But insofar as I am aware that I am
fantasising then to that extent I am also aware that
the capacity to satisfy the desire is seriously
diminished. In fantasy we totally determine the
content, nothing resists us, and thus there is not
only the lack of significance in the hollowness of its
gratifications, but also no independent way of
registering our authentic being. Insofar as we can be
anything we want, we are nothing, since in having
conflicting desires we are not in a position to identify
with either of the two desires; they are both aspects
of our being and therefore do not individuate our
essential characteristics. To have determinate being
is to identify with certain actions. The passivity of
the gratifications of desires in fantasy rules out this
possibility. We are sucked up into ourselves. The
conditions we normally expect to be present for the
verification of existential claims are absent. There
is no possibility of intersubjective agreement or
observing states of affairs. I shall argue that there
is a sense in which these two conditions do apply to
art objects, thereby raising them above the status
of fantasy. Another objection to the claim that the
imaginative awareness we associate with art is
reducible to fantastic gratifications is to assert
that it is a characteristic of the aesthetic not to
be dependant upon the peculiar psychological desires
of any particular person for its significance. A
person's dreams are dependant upon the particular
desires he happens to have, and these are no more than
a minor curiosity for other people. Nevertheless,

daydreams do partially satisfy some of the conditions
for attaching significance to our being, namely, they
are a passive projection towards states of affairs
which are postulated as a reaction to our actual
situation.

V

I have argued that the work of art enables a person
to apprehend his being as significant (albeit a
tenuous significance) by exhibiting man's freedom to
elevate himself above the mundane, to dignify suffer-
ing, and to ennoble the commonplace. In the activity
of creating forms distinctive of his perspective or
in the act of appreciating and sharing the artist's
committed vision, this freedom is exhibited in each
element of the work. In creating forms distinctive
of his individual perspective the artist crystalises,
articulates and gives form to inchoate longings of
man. Art exhibits in a concrete form those aspects
of our being to which we attach the utmost significance.
The capacity to apprehend them depends upon my
mastery of an artistic medium and on the sensuousness,
the non-corruptibility of the stuff of consciousness,
in which these dimensions are embodied. Insofar as
we attribute significance to the uniqueness of the
individual in everyday reality, we are able to make
sense of the claim that the elements of a work must
uniquely reflect the artist's vision. But this
uniqueness has a formal rather than an existential
significance. Existentially unless we are able to
recognise the distinctive aspects of our being in the
world, then there is no dimension on which we are
able to experience our being as separate from anyone
else's. This claim presupposes the uniqueness of
beings other than ourselves. If we have no way of
distinguishing characteristics of ourselves with which
we identify from other people's distinctive views
then we would be not only anonymous, but have no being
to apprehend, or at least an impoverished one. It is
comforting to share similar views with others, not
because we are identical with them, but because our
view tallies with another's distinct view, and this
is a kind of validation.

I have also claimed that the values, feelings and
attitudes which constitute the distinctiveness of our

being are not entities separate from the objects in
the world towards which they are directed. They
suffuse their objects in much the same way as light
animates a landscape. The artist does not first paint
the objects in a landscape and then paint the light.
The two aspects are interdependent. We demonstrate
our values in the ways in which we are prepared to
act. Analogously, in art the making of marks is an
act which reveals the distinctive evaluations of the
artist. The traces of a perspective are revealed in
his work. They are evidence of commitment to a
specific vision of the world. The work enables us to
apprehend a world in which things matter because of
this distinctive perspective. We are able to apprehend
our being as significant insofar as the art object
registers our freedom and uniqueness. I have previous-
ly stated that the aesthetic experience is fundamentally
imaginative, and that therefore we have to show that
if the freedom we experience in art is not actual,
nor is it chimerical. Art is not passive before
events. It is connected with action and commitment.
Unlike the fantasy world of the dreamer, in art we
assume that truth conditions apply, albeit in an
attenuated way, and we assume that what we see is
publicly available for other spectators, e.g., we do
not think that we are at a private picture show. It
still raises the problem of why we are prepared to
apply truth conditions to art objects and not to
daydreams.

It is here that we realise the importance that the
sensuousness of an artistic medium has for aesthetic
experience. The primary way that objects in the world
reveal themselves as distinct from us and not subject
to the arbitrariness of our desires is in the sensuous
form in which they present themselves to consciousness.
When the artist articulates his distinctive way of
looking at things in a work, it is at the same time
his perspective and not his perspective. For insofar
as they are embodied in the work they are independent
of him. For example, when we perceive rather than
imagine a state of affairs we believe at the same
time that it is there for others to see. In registering
our conscious determinations it both registers its
capacity to maintain itself independent of our will
and our capacity to apprehend it. The work of art
retains sufficient of our subjectivity, so that we do

not apprehend it as alienated from our consciousness.
In order for us to relate to it it must have dimensions
which are reflective of our being, we must be able to
relate experientially to what is there.

Typically meanings attach themselves to sensuous
properties, e.g., colours, sounds, shapes come to
stand for certain attributes, e.g., yellow connotes
cheerfulness, curves gracefulness, and blots on paper
violations of innocence. The world of our everyday
experience is imbued with the meanings, both private
and public, which we attach to properties; and these
properties come to stand for certain states of mind.

> "Sense experience is the vital communication
> with the world which makes it present us
> with a familiar setting of our life ...
> Sense experience points to an experience
> in which we are given not 'dead' qualities
> but active ones. The light of a candle
> changes its appearance for a child when,
> after a burn it stops attracting the
> child's hand and becomes literally
> repulsive. The vision is already
> inhabited by a significance which gives
> it a function in the spectacle of the
> world and in our existence. The pure quale
> would be given us only if the world were
> a spectacle and one's body a mechanism
> with which some impartial mind made itself
> acquainted. Sense experience invests
> the quality with vital value, grasping it
> first in its meaning for us. (M. Merleau-
> Ponty, (1962), Phenomenology of Perception,
> pp. 52-53.)

Merleau-Ponty is saying that we humanise our environ-
ment by coating it with dimensions of ourselves - but
equally we make sense of our own indeterminate,
transient feelings by embedding them in sensuous forms.
They are the occasion for experiencing and under-
standing our states of mind. The sensuous medium
exhibits and validates otherwise ephemeral fleeting
feelings by giving them a concrete form which can be
perceived. It enables these elusive aspects of our
being to be externalised and reflectively available
for consciousness. Richard Wollheim (1979) makes a

similar point when he writes,

> "... creative activity can become a
> process of self-knowledge when the work
> of art reflects with sufficient precision
> some complex constellation of inner
> states which the artist seeks to externalise."
> (The Sheep and the Ceremony, p. 19, 1979).

The patterns of the sensuous properties of line,
texture and shape in painting draw attention to
themselves as embodying what they are about. Unless
the meanings permeating sensuous properties become
transformed in an art form they will be too imprecise
to embody the complexity of the distinctive perspect-
ive of the artist. We do not experience significant
existence as a general category, but rather through
individual perspectives. The world is the totality
of individual perspectives and each individual
contributes to our understanding of the whole.

So we could say that in trying to make sense of the
value we attach to art objects with reference to the
purpose of apprehending our being as significant, the
transient aspects of our being with which we most
closely identify, and with which we are prepared to
commit ourselves in action, must have a form which
is capable of being apprehended. We must see ourselves
projected and reflected in the world. Typically in
art, this being is externalised in a sensuous form.
The artist in striving to find forms appropriate to
his perspective must pattern the elements of his
medium in such a way so as to fit with this vision.
The form is not a duplicate of some inner form. The
two aspects are interdependent, the outer becomes
articulated with reference to the inner, and the
outer form has the capacity to engage the attention
of the spectator because of this correspondence.
Both aspects are mutually dependent for their
existence. As Sartre claims, "Consciousness and the
world are given at one stroke: essentially external
to consciousness, the world is nevertheless
essentially relative to consciousness!" The work
provides the occasion for apprehending an imagined
existence which commands respect, and urges towards
action in the real world because it is a genuine
possibility for man.

VI

The development of a child's artistic work and the
development of his consciousness of the world are
inseparable. The child's art work provides us with
insights into his subjective states. The application
of general aesthetic norms is only appropriate as long
as the evaluator has a sensitive appreciation of what
the child is trying to do and this is always problem-
atic because the spectator inevitably brings his own
subjectivity to his judgements of art objects. Art
works are not detached objects which can be clinically
analysed. The work of art is constituted in the act
of awareness.

However, neither are works of art esoteric objects,
publicly inaccessible. Intersubjective agreement
about what is 'there' in a work of art is possible
because the articulation of distinctive perspectives
presupposes an initiation into an art tradition.

Nevertheless, art objects are essentially unique
perspectives on the human condition, and aesthetic
principles are no more than rationalisations of
artistic historical achievements. Any paedagogic
move which encouraged children to acquire techniques
unrelated to their own subjective states would be a
distortion of the aesthetic.

REFERENCES

Gombrich, E.H. (1960). Art and Illusion. Phaidon.
Heyfron, Victor (1980). The concept of art. In
 Malcolm Ross (Ed.), The Arts and Personal Growth.
 Pergamon.
Marcuse, Herbert. (1979). The Aesthetic Dimension.
 The MacMillan Press Ltd.
Merleau-Ponty, M. (1962). The Phenomenonology of
 Perception. Routledge and Kegan Paul.
Ross, Malcolm. (1978). The Creative Arts. Heinemann.
Sartre, Jean-Paul. (1948). The Psychology of the
 Imagination. Methuen.
Sartre, Jean-Paul. (1957). The Transcendence of the
 Ego. Noonday Press.
Parsons, Michael, et al. (1978). Developmental
 stages in children's aesthetic responses.
 Journal of Aesthetic Education, Vol. 12, 1, 83-104.

Wollheim, Richard. (1979). <u>The Sheep and the Ceremony</u>. Cambridge University Press.

SECTION II

Psychological Issues

Introduction

David Evans looks at some definitional problems to aesthetic development, drawing particularly on the work of Child and Gardner, and he discusses the theory of Feldman in considering the concept of development. The paper draws some parallels between aesthetic and linguistic development and concludes with a warning against the misuse of developmental theory in education.

Robert Witkin is interested in the paradox of the artist's ever deepening engagement with the sensuous aspects of experience and increasingly abstract mode of thinking. "The movement towards abstract 'thinking' is as important for the artist as it is for the scientist". The problem is to develop a theory of abstraction that will encompass both. The paper lays the foundations of such a theory and includes an account of Abstract Art. Art is human ideation in the aesthetic mode; aesthetic development depends equally upon appreciation and realisation. Dr. Witkin concludes that "aesthetic development is development of appreciation of the world, a sense of relatedness in events".

Malcolm Ross draws a parallel between moral and aesthetic development and, in particular, considers the characteristics of mature "cherishing" in relation to aesthetic maturity. The impulse to express and to discern order in the flow of events gives rise to the need for experiences that transcend our mundanety. "Art is man's answer to his mortal destiny". Aesthetic acts are essentially acts of love: in art, as in all loving, we continually remake and renew ourselves.

Aesthetic Development:
a Psychological Viewpoint

DAVID EVANS

INTRODUCTION

In terms of content this article does not have a lot
in common with the talk I gave at Dillington. The
response to my talk, in the shape of questions,
comments and discussion, persuaded me to think a lot
more about some of the things I said then. I have
also got more ideas and questions from two references,
both of which I regret not having read before the
Conference. The one is Gardner's The Arts and Human
Development (1973) which will probably be familiar to
most readers of this article; this confirmed my
suspicions regarding the naivete of some of the
questions I was asking! The other is Feldman's Beyond
Universals in Cognitive Development (1980) which,
serendipitiously, arrived on my desk the day after I
gave my talk. This will probably not be as well known
and I have drawn on it quite heavily for ideas about
development.

I have found it very difficult to translate my
questioning presentation of Dillington into anything
like a considered substantial contribution to this
volume and Feldman's ideas have helped a lot here.
But it is still the case that, in its style, this
article maintains the interrogative and 'in-parenthesis'
approach I adopted there; it has to - so few clear
answers seem to be around either in the literature or
in my head!

DEFINITIONAL AND CONCEPTUAL PROBLEMS

'Aesthetics'

My first problem lies in deciding what it is I should
be talking about when asked to talk about aesthetic
development. I was comforted, but no more, to realise
from the Conference discussions that I am not the only
one to find the field a very confused one. It was
also pointed out by Professor Louis Arnaud Reid in
his opening address that "this is all so bewildering
that one might despair of getting any kind of order
into the treatment of such a (comparatively) simple-
sounding field as aesthetic development" and Professor
Arnaud Reid has been working in this field for more
than half a century! In the first instance, I found
Child (1968) and then Gardner (1973) helpful in
sorting out the field for me.

Child points out that the term 'aesthetics' is unique
in being widely used to designate both a branch of
philosophy and a branch of behavioural science. It
is with the latter, of course, that I am concerned as
a psychologist. He then suggests that as part of a
behavioural science "aesthetics is the study of man's
making works of art, man's experiencing works of art
and the effects on man of this making and experiencing"
(op. cit. p. 853). These processes can be represented
diagrammatically as follows:

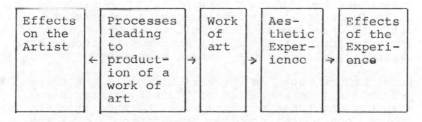

Effects on the Artist	Processes leading to production of a work of art	Work of art	Aes-thetic Exper-ience	Effects of the Experi-ence
←	→	>	→	

Child says that he intends the term 'work of art' to
include music, literature, plays, dances, as well as
paintings and other objects to be seen. Nevertheless
his diagram appears to leave out the performing aspects
of arts like music and drama (I think the discussion
at Dillington, while I was there, also tended to
concentrate on the visual arts). Gardner's model helps

to remedy this imbalance; it also takes a different
stance from Child's in that it emphasises <u>roles</u> rather
than <u>processes</u>. This seems a useful emphasis when one
is talking about development in children. A diagram-
matic representation of his approach is as follows:

I want to make two general points about these models.

First, I am not particularly well qualified, nor have
the time and space, to get into a proper discussion
about what constitutes a 'work of art'. The unresolved
and sometimes heated discussion around this issue at
Dillington warns me off that! But I have to make it
clear that I must include under this heading the
drawings of 'my Mum' by a seven-year-old and the simple
tunes that his five-year-old sister makes up. I am
aware that this leaves a whole host of questions
unresolved and I do not know if it is possible to have
a really fruitful discussion about aesthetic or
artistic development (I am following many writers,
including Gardner and Child, in treating these terms
synonymously) while they remain unresolved.

For instance, when do the scribblings of the three-
year-old or the babblings of his baby sister become
drawings and tunes respectively. Gardner tries to get
around some of the problems by defining art as the
communication of subjective feelings but this raises
all sorts of questions about what we mean by communic-
ation, including the question of <u>intention</u> to
communicate. This question of intention was also
floated at Dillington and though I understand why
people thought this a necessary attribute of a work of
art, I also saw the difficulties arising practically.

I feel that the amount of guesswork involved in
deciding 'intent', whether the artist is dead (e.g. an
old master) or inarticulate (e.g. a young child) is
enormous!

Another serious problem that arises out of a failure
to agree on what is a work of art, relates to the
notion of the goal (or goals) of artistic development.
Can one get very far in describing/prescribing/
facilitating such development if one cannot agree about
what art is? Parallels with other areas of human
development where values are obviously involved (in
all aspects of development) are instructive. For
instance, how far can one get in comparing individuals
or cultures in respect to moral development, if we
have no agreement, however difficult to reach and how-
ever precariously maintained, about what is virtue?

(In extended parenthesis, I ought to say that it is my
intention from time to time to look at other strands
of development, notably moral and linguistic, in order
to get a different slant into the problems of artistic
development. Parsons et.al (1978) note the "autonomous
character of aesthetic experience; i.e. a belief that
it is 'sui generis' in an important sense" (p. 83) and
philosophers (e.g. Hirst and Peters, 1970) regularly
distinguish, for instance, science, morality and
aesthetic experience as being basically different modes
of experience. Nevertheless, bearing in mind the facts
that:

a) all experience (moral, aesthetic, whatever) has
 common roots in the largely undifferentiated
 activities of the new-born baby;

b) aesthetic experience (certainly as I have accepted
 it in this account) embodies a number of different
 processes (Child) or roles (Gardner);

c) the pattern of development in the different art
 forms (music, visual arts, literature, etc.) is
 also likely to vary significantly;

it seems likely that at least some of the artistic
processes in some of the art forms will have a lot
more in common developmentally, with similar processes
in other areas of experience, than with other artistic

processes in the same or different art forms. In
particular, it seems to me that <u>moral</u> and <u>aesthetic</u>
development have a lot in common, related to the
issues of values and feelings).

Secondly, if one accepts that aesthetics can be about
a number of different processes or roles then, given
limited ability, time and space, one has to choose
what to talk about in developmental terms. Arnaud
Reid chose to look through the work of Parsons (1976),
Parsons et. al. (op. cit.) and D'Onoforio and Nadine
(1980) at the development of children's responses to
pictures. Gardner (op. cit.) concentrates particularly
on the development of the child as creative artist.
(This area interests me too, and I want to talk
briefly about this later in terms of motivation). But
the thing that intrigues me most is the relationship
which exists between the various processes or roles
in developmental terms.

A lot of questions arise immediately. For instance,
given the largely undifferentiated activity of the
neonate, what are the factors which lead us all to
adopt the different specialised roles - developing the
abilities, acquiring the skills, - to take on some or
all of the roles in any one or more of the particular
art forms?

Or again, what are the forces which deny us the
ability or the skill?

And what developmental theories best illuminate the
relationships between the different roles or processes?

Before I begin to elaborate a bit on these and other
questions, I think I have to say something about the
notion of 'development' and 'theories of development'.
Considering the nature of <u>aesthetic</u> development
obliges me to ask a lot of <u>questions</u> about development
itself.

<u>Development</u>

The developmental theory which has dominated child
psychology in recent years and which has been the most
thoroughly worked-out, both in terms of theory and
empirical studies, is the cognitive-developmental one.

I suppose Piaget's theory of the development of
knowledge is the prototype and all of us by now are
familiar with his attempts (with thousands of replic-
atory studies) to establish stages of development,
basically in the child's understanding of scientific
and logical concepts. (Varma and Williams, 1976,
present a useful educationally-orientated account of
his theory and some of its applications). Kohlberg
(see e.g. Kohlberg, 1976) has used a similar approach
in the attempt to establish developmental norms in the
field of moral development. And, as Arnaud Reid points
out in his paper, a few investigators are beginning to
apply a similar model in the field of aesthetic
development. (To a degree, Erikson's (1963) account
of personal-social development would also have things
in common with the above theories).

These theories seem to have in common some basic
assumptions: see Feldman (1980) for a more detailed
account.

First is the notion of universality). Simply stated,
this assumes that there are certain advances in
thought which all children will achieve; the main
purpose of Piaget's work might be said to be the
documenting of common achievements in thinking by all
individuals in all cultures. Kohlberg attempts to
show the same for intellectual-moral development.

Secondly is the notion of 'spontaneous acquisition'.
This is the notion that no special environment is
required to ensure that any individual will achieve a
particular function, operation, structure. It is
suggested - and Piaget presents this point of view
most strongly - that children possess intrinsic
tendencies to construct a view of the world and that
sufficient environmental conditions in all cultures
guarantee that, over time, each child will move through
all the stages, achieve all the basic cognitive
operations without specific interventions. (Currently
there is strong support for the view that the develop-
ment of language is similarly pre-determined). It is
clear - isn't it? - that this assumption plays down
the role of learning and instruction in development.

A third assumption is that there are certain sequences
through which all individuals must progress towards

some final cognitive system (e.g. Piaget's formal
operational level, Kohlberg's stage six). One does
not skip stages, one does not move backward in the
sequence.

Finally, there is the notion that earlier stages of
development are incorporated into later ones; and an
attempt is sometimes made to describe transition rules
or mechanisms to provide an explanation of how the
incorporation occurs. This integration of earlier into
later stages is often referred to as hierarchical
integration.

Feldman (1980) suggests that the insistence on the
first two notions, i.e. universality and spontaneity,
as being essential to a theory of development makes it
difficult to apply a developmental model to many
important regions or domains of knowledge. It also,
as noted above, tends to play down the importance of
learning and instruction. He then suggests that a more
useful model, a model capable of wider application,
would be achieved if we retained the notions of
sequentiality and hierarchy as being essential in all
development but kept the notions of universality and
spontaneity only at certain levels of knowledge. He
proposes the idea of 'developmental regions' ranging
from the universal along a continuum to the unique.
This continuum (see op. cit. Chapter 1) is as follows:

Developmental Regions from Universal to Unique

Universal	Cultural	Discipline	Idiosyncratic	Unique

Briefly:

Universals. These are the focus of traditional
developmental theory and need no further elaboration
at the moment.

Cultural. These are domains of knowledge that all
individuals within a given culture are expected to
acquire. In our culture, reading and writing would be
good examples.

Discipline-based. These are developmental domains
that are based on mastery of a particular discipline.
One difference between cultural and discipline-based
domains is that fewer people learn discipline-based
domains than cultural ones. But Feldman suggests that
the primary differences between these two lie in the
extent to which the individual can exercise a choice
in selecting a domain to master and the extent to which
one comes to share a distinctive way of thinking about
the complexities of the domains. As with the cultural
region, learning, instructions and a technology are
much more part of this domain.

Idiosyncratic. I don't find this category particularly
helpful. I think Feldman is simply pointing to the
fact that disciplines can be broken down into more and
more specialised domains (an example he gives is the
mastery of the art of ice-sculpture), all of which
retain in their development the attributes of
sequentiality and hierarchy.

Unique Achievements within Domains

This I do find an interesting category because it
leads into the notion of creativity which I want to
touch on briefly later. He suggests that unique
developmental achievements represent a form of organ-
isation within a domain that has never before been
accomplished in quite the same way. He is not talking,
of course, as he points out, about the sense in which
all behaviour is unique including all development
changes (in the same sense as each of us is a unique
physical organism) but about a kind of achievement
going beyond this uniqueness.

> "We propose that individuals may at times
> fashion out new levels of organisation
> within a domain or, in the most extreme
> case, establish a new or radically altered
> domain by transcending the constraints
> of an existing field or discipline to
> establish a major new order. Those
> unique achievements that reorganise a
> body of knowledge are identified in
> our scheme as creative ones. From the
> many unique reorganisations of knowledge
> that occur, a small number which are

perceived as particularly useful may
eventually become incorporated into domains
which enjoy wider popular exposure."
(Op. cit. p. 11.)

This latter notion is useful, I think, because it helps
to remind us that 'discipline-based', 'culture-based'
and, indeed, even 'universal' knowledge have a history
of their own and that "as a psychological novelty moves
from being an original unique response towards becoming
a universal characteristic of all members of the species
it comes to typify the species" (ibid. p. 176).

DEVELOPMENTAL RELATIONSHIPS BETWEEN PROCESSES OR ROLES

I want to return now to the discussion about the
developmental relationship between the various
processes or roles in artistic development and ask some
questions and make some cautious comments about the
part of the art educator in all this.

In terms of roles, I want, in particular, to look at
the relationship between 'the critic' and 'the viewer
(audience)' and between the 'creator' and 'the viewer
(audience)'.

Perhaps of all the relationships, the clearest is
between the critic and audience member or viewer.
Presumably the spectator or viewer can just enjoy,
just be disturbed or whatever - or, if we can accept
Gardner's notion of 'the communication of subjective
feeling', understand at least to some extent, the
message of the communication? Presumably this can be
at a completely intuitive and/or unverbalised level?
Whereas the viewer as critic has to be able to communic-
ate his reactions to others, usually in verbal terms.
A number of interesting questions arise here.

First, as Gardner points out, the critic is the only
one of the roles in which there is a necessity to
reason in propositional form and express oneself in
logical language and so one can then accept that in the
development of the critic, one goal might be the attain-
ment of Piaget's formal operational level! - and that
a Piagetian model of development might be quite a use-
ful one. One might ask, of the art educator, whether,
in some limited sense, he is trying to make children

critically aware? Studies of children's responses to
art (e.g. like those cited by Arnaud Reid) might
suggest we are. For instance, take the Parsons et.
al. study cited earlier. They showed children of
different ages a number of visual works of art and
attempted to classify their verbal responses to the
investigator's questions about their preference, etc.
So what we are testing is, to a largely undeterminable
extent, their level of verbal ability. This, of course,
is not a problem that is peculiar to the study of
aesthetic development even though it might be the most
worrying. For instance, a typical approach in moral
development is to present children with hypothetical
moral dilemmas and ask them how the characters or they
themselves should behave and why; we are asking them
to give verbal reasons and this clearly is one reason
why one often finds a significant gap between moral
judgements and moral behaviour. So, any interpretation
of studies like the Parsons et. al. one, particularly
if we propose to use their findings in some way to
help our teaching, must take this problem into account
and recognise that verbal explanations by children of
how and why they like certain pictures (or any other
work of art) - and how and why they don't like others -
may not truly represent their aesthetic response
simply as viewers; it may provide a much better
estimate of them as critics!

Secondly, I would like to speculate a bit about the
relationship between the development of the spectator/
viewer and the creator of the work of art. Clearly,
as Gardner points out, the creator and his audience
need not possess the same skills and may have little
empathy for one another's roles. But, presumably, the
more the viewer can empathise with the creator and,
possibly, the more skilled he is in that art himself,
the 'greater' will be his appreciation of that work?
Following on from the Parson's et. al. study (op.
cit.), it would be quite interesting if one could
first establish clear developmental trends in child-
ren's responses to pictures (bearing in mind some of
the problems that beset us when we try to do this -
some noted above) and then try to determine if, other
things being equal, the better performer in painting
pictures would be at a more advanced stage in
aesthetic appreciation than his less creatively-skilled
classmate. This ought to be testable. Perhaps it

has been resolved?

At this point I am becoming particularly self-
conscious about the fact that I am neither a skilled
practitioner in the arts, nor a teacher in the arts.
The only way in which I can speak with any kind of
authority - a personal authority - is to attempt some
very crude analysis of my own aesthetic development;
I know a bit about that. I'll stick to paintings and
music. I obtain considerable aesthetic pleasure from
looking at paintings - especially of a traditional
representational kind - and listening to music
(especially orchestral, not later than say early
Bartok!). I am very aware of the huge gap between my
'skills' (I have recently begun to paint again, the
first time since I was at school) and my appreciation.
What in my development made for this gap?

Let's start with the technical skills of drawing and
painting. I am fairly clear that I could have been
taught these and that I wasn't. I think this was
partly a reflection of an art-teaching philosophy,
perhaps now rather less strong, which advocated not
teaching the skills. It is also a reflection, one
supposes, of the lack of value placed by our society
on artistic ability; art is still an optional extra.
Let's be fanciful at this point for a moment.

There is a frequently employed test of creativity
('consequences') which goes like this: 'Suppose that
...' and then the subject is asked to speculate,
creatively, about all the possible consequences of an
unlikely hypothetical situation. For instance, -
'Suppose the whole world were covered, permanently in
a three feet thick layer of fog? What would be the
consequences?' Well, what about - 'Suppose the whole
of civilisation lost all its linguistic (understanding
and utterance) ability? What would be the conse-
quences?' Perhaps one clever child might speculate
that art forms might become more popular for communic-
ation purposes; and that then all children would be
expected to become artistic, as now all children are
expected to become literate; the non-artistic would
be treated as educational failures and obliged to have
remedial help; perhaps the place of artistic skills
and the role of the teacher in teaching artistic
skills, would be automatically assured. In Feldman's

terms, artistic development would cease to be a
discipline-based one and move along the continuum
towards a culture-based one. Perhaps then we might
even begin to use a concept popular in linguistic
development, i.e. the notion of <u>competence</u>. Let's
stay with this for a moment. The possession of
linguistic competence implies a general structure and
some general rules for using language, language use
here being intended to include <u>utterance</u> and <u>under-
standing</u>. Would it be interesting to think of <u>artistic</u>
competence in the same sense, i.e. as being the
general structure, the general rules for producing and
appreciating art? One's guess is that if art did
become more necessary, then the gap between creating
and appreciating, which is certainly true in my case,
and indeed between both and their underlying
competence, would be diminished.

But obviously there is more to artistic creativeness
than 'just' technical skills. So even if I had been
given all the skills necessary as I developed, what
more should I have been given? There is a body of
opinion - perhaps it's linked to a developmental view-
point like the Piagetian one - which plays down the role
of learning and instruction; it is linked probably to
the concept of child-centred, informal education too.
Professor Arnaud Reid <u>appears</u> to subscribe to this
view when he makes the point that "as far as education
goes, development of artistic creativeness (whatever
that may mean) cannot be taught (though the conditions
of its learning may be safeguarded and children given
all the technical help they may ask for or need.) Of
artistically creative children (or adults) it may be
said, after Bo-Peep, 'Let them alone and they will
come home'". I am still trying to work out why I
didn't! Was it just that I lacked the skills or was
it more, i.e. lack of artistic creativeness? I think
the suggestion here is that artistic creativeness is
either innate or, at the very least, determined in
early childhood. The next question for me is whether
this lack in me (if it's the case) would be a <u>general</u>
one or one which is very discipline specific? I note
that in the realm of ideas - verbal ideas - I have a
certain creative ability. I note that some art
practitioners though skilled in painting in a certain
style never or rarely move beyond that style. I also
note that in my own appreciation of painting and

music, I am somewhat reluctant to 'progress' beyond a
simple, sensuous enjoyment of colour, rhythm and so
on. But in the verbal field, I welcome readily,
almost need, the novel and the difficult. I enjoy
problem-solving. In trying to sort out these
observations and to get into the question of these
differences, I find the ideas of writers like Berlyne
particularly helpful. He is discussing two basic
motivational conditions. Here they are, set out in
an extended quotation:

> "One of them corresponding to diversive
> exploration, inclines the subject to
> seek out patterns that are judged
> 'pleasing' or 'beautiful' which appears
> to mean that they are relatively lacking
> in the discomforting or puzzling
> properties that make for a steep rise in
> arousal or an intense orientation
> reaction. On the other hand, conditions
> of 'perceptual' or 'epistemic' curiosity
> bring specific exploratory behaviour or
> epistemic (knowledge-seeking) behaviour
> to the fore. Curiosity occurs when the
> subject finds himself exposed to novel,
> surprising, ambiguous, problem-raising
> or otherwise conflict-inducing patterns.
> It impels him either to seek external
> stimulation containing the information
> that he needs to remove his uncertainties
> and resolve his conflict or else to
> engage in ideational processes that will
> lead to a solution of the problem. He
> may well deliberately expose himself
> to troublesome patterns for the sake of
> the challenges with which they present
> him if the difficulty of assimilating
> them and the satisfaction from over-
> coming the difficulty are properly
> balanced. In other words, he will choose
> those that are academically 'interesting'".
> (In Child, 1966, op. cit. p. 899.)

A number of points relevant to my theme seem to stem
from these notions of Berlyne.

First, the notion of 'balance' between difficulty of
problem and satisfaction of solving the problem, is

found in various writers, in various guises. It's
there in Piaget with his notions of assimilation/
accommodation in dynamic equilibrium, and again in
Festinger (1957) with his concept of 'cognitive
dissonance' and the motivational value of tension
which accompanies it.

Then there are some questions related to individual
differences.

For example, to what extent are individuals consistent
in their choosing - if they are in a position to
choose - as between the two basic motivational
conditions. We know for instance, that severely
retarded individuals find great difficulty in
adapting to the challenge of change, they can't cope
with disturbances in routine, a great deal of their
life has to be lived at an habitual, non-challenging
level; they avoid problems. (And one of the problems
facing the educator of such children, whether it is
parent or teacher, is having to decide at what points,
how often in helping them to develop, it is necessary
to deliberately arrange conditions which are
disturbing).

We know too, that even within the normal spectrum of
individual development, there are wide individual
differences in the degree of passivity/activity in
new born babies - and this is probably related to the
differences in curiosity, drive, inventiveness,
willingness, even eagerness, to solve problems and so
on which are evident in early childhood and beyond.

But it seems unlikely that such differences are
entirely innate and in recent years there have been
attempts first to try to identify those environments
which particularly favour the development of a
personality which, in Berlyne's terms, 'deliberately
exposes himself to troublesome patterns for the sake
of the challenges, etc.'; perhaps a short-hand would
be 'a problem-solving attitude': secondly, to see if
it is possible to teach directly the skills, abilities,
attitudes involved in creative problem-solving. I
want to say something about both these points.

A number of writers have pointed to the fact that an
authoritarian structure in family and/or school is

more likely to <u>discourage</u> a question-asking, problem-
solving approach than a structure which actively
encourages discussion, questioning, independence of
action and so on. In the area of language acquis-
ition and environment particularly Bernstein (e.g. 1965)
and others have pointed to the way in which certain
parents encourage question and answer explanation
rather than one-way, instructional communication.

On the second question, i.e. can problem-solving
skills, abilities, attitudes be deliberately taught,
particularly, as it were, from <u>outside</u> the subject,
there is a wide literature (e.g. see Evans and Murray,
1969). What I want to discuss briefly here is the
extent to which a social system (including a school
system) can tolerate an increase of 'constructive
discontent' in its members, especially if it does not
remain safely within the confines of a subject or a
discipline. This point was brought home to me very
sharply in some work I was doing aimed at 'improving
the creative thinking abilities of approved school
boys' (Evans and Murray, op. cit.). We were trying to
make the boys, within limits, constructively
discontented. We didn't succeed particularly (outside
of some improvement in performance on some paper and
pencil tests of creativity). But what if we had; and
what if the increasing 'discontent' - even if con-
structive - had generalised to discontent with school
rules, discipline, etc? I think I would have been a
very unpopular researcher! (A cynical interjection
here might be that a large number of experimental
action researchers would be unpopular if they turned
out to be successful in their interventionist
attempts!)

THE USES AND MISUSES OF DEVELOPMENTAL THEORIES

Finally, I would like to discuss briefly some of the
uses and misuses which are made of developmental theory
in schools. This important question came up in
discussion at Dillington in relation to stage theory
in development.

Let us start with the attempts of people like Parsons
et. al. (op. cit.) to establish developmental stages
in children's appreciation of, response to, visual
art. Let's suppose that they got over many of the

problems inherent in this task and finished up with
some reliable developmental norms. What use would be
made of these by art educators? And how might they be
misused? Some parallels from other cognitive-
developmental areas might be illuminating. Take the
Piagetian stages in the development of knowledge, for
instance. How have these been used?

Well, ideally one determines which cognitive stage a
child is at and then one gears one's particular
instruction to that stage. But a few difficulties
arise.

First, stages tend to be very general ones - they
perhaps have to be if we are to meet the criterion of
universality. And, if they are very general, they do
not offer much immediate help to the educator framing
a particular individual programme. If a child is said
to be at the 'concrete oporational' stage or to have
achieved 'conservation of weight', what kind of guid-
ance does this offer to the teacher framing the next
lesson for a class, let alone for the individuals in
a class. To adapt a metaphor trom Feldman, it is a
bit like offering someone a small scale map of the
world when what they want to know is the best or the
quickest way to get from Exeter to Dulverton.

If we follow Feldman and accept the notion that the
criterion of universality is not essential to all
domains of knowledge and settle for more culture-
specific or discipline-specific patterns of development,
then we can offer more specific, more precise, smaller
developmental stages. But then another problem arises.
One then starts getting really confused - and this
confusion is very marked I think in the attempts which
have been made to bring together developmental psycho-
logy and curriculum studies - about whether we are
talking about development in the child's mind (Piaget
is clearly talking about mental structures) or the
logical progression within the discipline or subject.
Feldman (op. cit.) points out that in the past we
have tended to confuse the logic of a discipline with
its developmental levels.

> "Thus, physics and biology and
> mathematics were broken down into their
> principles and theories but not studied

in terms of the ways in which
individuals move from initial encounter
to engagement, from engagement to
mastery of early levels, from apprentice
to journeyman, and so on. In other
words, the developmental aspects of
these fields were generally not
incorporated into the curricula. <u>Nor</u>
<u>were relationships between the</u>
<u>capabilities of children and the demands</u>
<u>of these disciplines transmitted to</u>
<u>teachers in ways they could use</u>."
(My emphasis, p. 168.)

This last task which Feldman mentions is a very
difficult one. I realise my failure to do this
adequately every time I give a lecture to prospective
teachers, psychologists, social workers, on child-
development. For my purposes here, just two aspects
of this task will be mentioned.

The first concerns the nature of the relationship
between <u>capabilities</u> and <u>demands of the discipline</u>.
It must <u>not</u> be a match - but a mismatch. But the
mismatch has to be an optimum one - too large a mis-
match equals discouragement, perfect match equals
boredom, (see Berlyne earlier).

The second relates to the <u>capabilities</u> of the child.
Every educator is searching for some reliable measure(s)
of a child's capabilities (as opposed to achievements),
potential as opposed to realised talent. We seem to
need some pointer for predicting progress, some yard-
stick for measuring achievement against. Subjective
assessments of children's potential (e.g. 'he could do
better') are made by all of us. Measures of general
intelligence have been used in the past - and are still
around in our thinking. The determination of children's
developmental levels seems to offer another possibility
linked to a concept of readiness; perhaps this might
be a good use of developmental norms. But one would
have to be very careful to use such an approach
positively and constructively. I have seen it used,
particularly in first schools in the past, negatively
and destructively. (Because a child is at a certain
stage, <u>therefore</u> he can't be taught material which is
normally learned at that stage). Perhaps the reader

would like to speculate about the possible misuse
that might arise from the application of aesthetic
development norms in the same way.

One final point about developmental norms and their
use: we tend to forget that we constantly have to up-
date norms; perhaps Feldman is right and we should
stop looking for universality (across cultures) in our
developmental norms; equally we should stop looking
for universality across generations, i.e. in time.
Because of changing resources, educational technology,
expectations, values, and so on, it seems unlikely
that developmental patterns will remain the same from
generation to generation. But in collecting develop-
mental data from which we make generalisations about
development from which, in turn, we derive predictive
and prescriptive norms, we do tend to behave as if we
believed there should be this stability.

I should have liked to finish this somewhat rambling
account with some elegant punchline or a pertinent
quotation. I can't find one. So I'll finish on an
apologetic note. I do realise that throughout I have
ignored, almost entirely, the importance of feelings
(and the development of feelings) in aesthetic
development. Professor Arnaud Reid points out that
philosophers and psychologists have allowed their
preoccupation with cognitive development to blind
them to the 'cognitiveness of feeling which is an
essential factor in all aesthetic understanding'
(op. cit.). I have done this too and, moreover, find
myself doing the same in my own particular research
area, i.e. moral development. It is an omission
which I plan to rectify in the future, despite the
'messiness' which its inclusion will inevitably bring.

REFERENCES

Berlyne, D.E. (1966). Les mesures de la preference
 aesthetique. Sciences of Art, 3, 9-22. (In
 translation. Taken from Child (1969) see below.)
Bernstein, B. (1965). A sociolinguistic approach to
 social learning. In U. Gould (Ed.), Social Science
 Survey. London.
Child, I.L. (1969). Aesthetics. In G. Lindzey and
 E. Aronson (Eds.), The Handbook of Social Psychology,
 853-916. Addison-Wesley Publishing Co.

D'Onoforio, A and C.F. Nadine, (1980). Parsons'
 model painted realistically. Journal of Aesthetic
 Education, Vol. 14, 4.
Erikson, E.H. (1963). Childhood and Society.
 Norton, New York.
Evans, D. and J. Murray, (1969). The improvement of
 creative thinking abilities of approved school boys.
 Approved Schools Gazette, 213-222, August.
Feldman, D.H. (1980). Beyond Universals in Cognitive
 Development. Ablen Publishing Co., New Jersey.
Festinger, L. (1957). A Theory of Cognitive Dissonance.
 Row Peterson Evanston, Illinois.
Gardner, H. (1973). The Arts and Human Development.
 Wiley and Sons, New York.
Hirst, P.H. and R.S. Peters, (1970). The Logic of
 Education. Routledge & Kegan Paul, London.
Kohlberg, L. (1976). Moral stages and moralisation -
 the cognitive-developmental approach. In T. Lickona
 (Ed.), Moral Development and Behaviour. Holt,
 Reinhart and Winston, New Yrok.
Parsons, M.J. (1976). A suggestion concerning the
 development of aesthetic experience in children.
 Journal of Aesthetics and Art Criticism, 305-314.
Parsons, M.J., M. Johnstone and R. Durham, (1978).
 Developmental stages in children's aesthetic
 responses. Journal of Aesthetic Education, Vol. 12,
 1, 83-104.
Reid, L.A. (1982). The concept of aesthetic development
 (This volume.)

The Concept of 'Development' in Aesthetic Education

ROBERT W. WITKIN

The ideas of development and progress are intimately
linked with one another in educational thinking.
'Children developing', 'children making progress',
'course work progressing', 'curriculum development'.
What is more, a great many of the most influential
ideas about progress and development are taken for
granted and only rarely called into question. Most
of us believe that society has progressed, that the
modern and technological represents progress relative
to the traditional, the 'primitive' and non-techno-
logical. We believe too that children progress; that
the thinking of the adolescent represents progress
with respect to that of the child. We claim to
organise curricula progressively in order to develop
the growing capacities of the child.

How well founded any of these assumptions are is a
matter for debate and I offer no judgement on them
here. Well founded or not, however, they form the
backdrop against which questions about development in
aesthetic education are formulated. In this paper I
make no attempt to answer the larger questions about
aesthetic development or to reflect on stage develop-
mental theories. My aim is simply to put in a little
of the approach work that I consider necessary to
clarify these larger questions.

It is possible to see the curriculum in developmental
terms that owe little or nothing to concepts of child
development. In any curriculum there is some degree
of developmental sequencing of content in the obvious
sense that material introduced later presupposes

familiarity with that introduced earlier. An art
teacher may consider it necessary that children go
through a series of preliminary and preparatory
exercises before attempting a technically demanding
piece of three-dimensional work. Similarly, a
mathematics teacher will need to be sure that his
pupils have already acquired knowledge and operational
skills in dealing with 'functions' and 'equations'
etc., before he can begin to teach the calculus. Of
course, no such scheme of cumulative sequencing is
sacrosanct. Rather, the steps are logically
necessary because of decisions made at the outset
about how to approach the subject and its teaching.

The sequencing of the contents of a curriculum in the
minimal sense described above may actually be achieved
on the basis of considering what an adult novice would
require to go through in order to master a discipline,
an art or a craft and may take little account of the
development of the cognitive and perceptual outlook
and interests of the child. Indeed, it might be
argued that subjects as traditionally taught in our
schools were ordered in just this way. The logic of
the curriculum implicitly presupposed the same
cognitive outlook and interests (but not the same
knowledge or know-how) at the outset as at the
conclusion. While concessions to the immaturity of
the cognitive capacity of the child were explicitly
made, these took the form of making the mechanical
acquisition of the knowledge and operations concerned
somewhat easier to acquire.

In a minimal sense, all curricula must take some
account of child development. Certain tasks in
drawing require the requisite degree of hand-eye
co-ordination and the learning of place names or
dates presupposes a certain development in memory
function. However, if motor skills and memory
function are the only cognitive developmental con-
straints on the structuring of the curriculum then
the likelihood is that the curriculum will emphasise
the storing, repetition and reproduction of knowledge
and technique at the expense of understanding. The
latter presupposes that knowledge and technique are
integral to the child's cognitive functioning at
every stage of development. How many of us learned

to solve quadratic equations without ever being able
to think in them? It may come as something of a
surprise to discover eventually that mathematicians
can actually think in equations. For knowledge and
technique to be integral to intellectual functioning,
its formulation and dissemination must be assimilated
to the cognitive and perceptual interests of the
individual, to his mode of functioning. In terms of
schooling, this means that ideas about personal and
intellectual development become increasingly important
in determining both the structuring of material and
the management of classroom practice. Curriculum
development in mathematics and science teaching, for
example, is typically justified in terms of its
appropriateness to the 'natural' modes of mathematical
and scientific thinking obtaining at any given stage
of the child's cognitive development.

For arts teachers, however, the problem of development
is something of an embarrassment. There are no
clearly agreed criteria of what constitutes personal
or mental development in the context of the arts, nor
agreed notions of stages of development in what might
be called art-think to correspond to the support given
to the academic curriculum by Piaget's developmental
psychology. Where a developmental sequence is
constructed, as in Lowenfeld's stages for visual art,
the theory is only successful in influencing practice
in a relatively minor way and is not, in any case,
generalisable to other arts, nor even sufficiently
comprehensive to encompass the visual area fully.
Certainly, the arts teacher seeks to establish a line
of development in the work children do but his or her
criteria may differ substantially from those of
colleagues teaching the same art and be hardly
comparable with those of colleagues teaching different
arts. The relative freedom of the individual arts
teacher to use his own initiative in developing
curriculum, which is probably due to the lack of
educational importance attached by others to what he
teaches, may serve to widen these differences and to
encourage the suspicion that aesthetic development
can be all things to all children.

The problem is exacerbated somewhat by what outsiders
may see as the arts teachers' sacrifice of skill and

technique on the altar of 'self expression' or the
'process of discovery' or whatever. The hyper-
inflation in the use of these and similar terms in
modern education has relieved them of much of their
value and they are now looked upon by many as the
rhetoric of shoddy workmanship, lack of skill and
even of self indulgence. While the criticism may
appear to many to be unfair, it has to be admitted
that advocates of self expression and personal
development through the arts have not always been
careful to point out that being 'skilful' is as
fundamental to self-expression, at any stage of
development, as it is to any other intellectual
achievement. In their instinctive opposition to a
mechanistic technique-ridden pedagogy, arts teachers
were left without a positive way of stating their
interest in skilfulness, simply because of the lack
of consensus about expression, cognitive development
and their relationship to skills in the arts.
Ironically, the opposition of many arts teachers to
skills-based curricula is often mounted out of a
concern for creating the conditions where a genuine
organic skilfulness of a perceptual and cognitive
kind can occur. Skills-led curricula appear to such
teachers to develop a mechanistic competence which
may inhibit rather than enhance the use of the arts
as a mode of knowing and understanding by the child.
Even without a general theory of aesthetic develop-
ment many teachers recognise the need to build the
curriculum into the general cognitive and perceptual
functioning of children at each stage of development.

We can think of skilfulness in arts work in terms of
three integral aspects, the intellectual, the
realisational and the appreciational. The intellectual
aspect concerns the contribution that arts practice
makes to the development of modes of knowing and
feeling which are part of one's general intellectual
functioning. The realisational aspect concerns
development in the skills and techniques of art-
making, the skills of the composer, the instrumentalist,
the wordsmith, dancer, potter or whatever. Know-how
defines the realisational aspect of skill. Finally
there is the appreciational aspect, the development
of interpretive and discriminative skills together
with specialist knowledge in respect of works of art
and forms of expression. While it is the

'realisational' and 'appreciational' aspect of arts
skills that are the most visible in classroom practice,
the very meaning and success of that classroom
practice depends upon its relevance to the real cognitive
interests and capacities that define the general
intellectual functioning of the child throughout his
development. Isolated from the intellectual functioning
of the individual, the development of 'realisational'
and 'appreciational' skills, makes as little contrib-
ution to art as it does to understanding. Real skill
in the arts means that arts products and aesthetic
judgements are fully minded. How we think of general
and intellectual development in respect of the arts
must therefore have a profound influence on practice.

Theories of cognitive development are inevitably centred
on the progression of abstraction which characterises
the higher mental operations, but developmental theory
has been very one-sided. Piaget's work, which has
dominated the field, has provided the foundation for
a theory of cognitive development in the sciences and
in mathematics which has had some considerable impact
on curriculum development and curriculum thinking. But
Piaget's theory offers nothing of direct assistance to
the arts precisely because his idea of development takes
thought further and further away from the sensuous and
sensory world in which the artist is interested. Indeed,
the artist's thought moves in the opposite direction,
taking him deeper and deeper into the sensuous aspect
of experience. The movement towards abstract 'thinking'
is as important for the artist as it is for the
scientist, however, and the problem is to develop a
theory of abstraction that is rich enough to encompass
the mental operations of the artist as well as those
of the scientist.

Two problems arise at the outset in our use of the
term abstraction. When we apply it to the mental
operations of the child we tend to think of abstract
thought as characteristic of older children rather
than younger children. However, it has to be
recognised that the process of abstraction, which
culminates in the abstract thought of the late
adolescent, has been occuring

from the outset and is as much a part of the young
child's mental operations as it is of the older child.
To go beyond immediate appearance, to make an
inference, indeed to think, is synonymous with the
process of abstraction. What we know of the world is
something we construct or make of our experience. All
such constructions are abstractions. Just as the
mental constructions of the young child discovering
relationships in the object world involve abstraction,
so too do the discoveries of the same child concerning
relatedness of a sensuous kind which he achieves
through expressive or artistic construction.

This brings us to the second problem. Just as we tend
to identify abstraction with the later development of
the child, so that term tends to be used of recent
rather than traditional art. More particularly it is
a term applied to the development of non-figurative
visual and plastic art during the past hundred years.
Again the term is misleading because the process of
abstraction is involved in all art from the most
representational to the least. Construction in art,
like any form of ideation, in science or whatever, is
synonymous with abstraction, with the process of
making something of experience. Nevertheless, the
term 'abstract' when applied to painting or sculpture
is not entirely a misnomer, for the evolution of
abstract modes of visual art really does represent an
important development in the possibilities for abstract
ideation.

A work of art is a significant pattern of events, a
pattern of changes, variations and contrasts in light,
sound, gesture or whatever. In and through the
changes that constitute the work we sense a continuity,
a relatedness or invariance. The meaning or signifi-
cance of the work is bound up with this relatedness as
realised in the events that constitute the work.
However, this relatedness is not the product of
mechanically adding or combining constituent elements.
Rather, each so-called element is perceived as it is
because of the relatedness of the whole. Each
individual movement of a dancer presupposes the whole
movement in which it participates. The relatedness
of the whole is thus present at each instant in the
balance of pressures and tensions that is the

perceptual focus for the dancer. The graceful
movements of the gazelle or the ordinary human acts
of walking or running have a coherence about them
that owes nothing to ideation, to abstraction. Not
so the movements of the dancer. The dancer 'speaks'
with movement, breathing relatedness into ideas and
feelings that can only be brought together through
deliberate acts of expression. The dancer creates
meaning out of movement and his dancing is an act of
knowing, a sensuous act which owes as much to the
process of abstraction as any piece of logical or
analytical thought.

The topic of abstraction is fraught with difficulties
and pitfalls for the philosopher of art as well as
the cognitive psychologist. The word is applied in
so many different ways to so many different processes
and products of mental life that some degree of
semantic confusion is inevitable. At the root of
various concepts of abstraction is the notion of
invariance, of the discovery of relatedness-in-
difference. A typical generalising abstraction such
as the category of 'mammals' is constituted of those
characteristics that are held to be common to a
variety of animals otherwise very different from one
another. Those differences are thus subsumed, within,
or encompassed by, an homongeneity or sameness. While
this view of abstraction as a process of discerning
invariance or relatedness among the variegated
elements of experience is sound enough, there is more
to the process which requires emphasising. As Piaget
has shown, the process of abstraction has a develop-
mental history. In Piagetian psychology it begins
with establishing links between very concrete and
physical behaviours as, for example, in relating the
effects contingent upon actions such as rubbing,
throwing or squeezing things. The abstractions
(discoveries of invariance) then become themselves
the experience out of which new higher order
abstractions or invariances are discovered until the
most complete and comprehensive level of abstraction
is reached. Each level in the hierarchy reorders
the levels below from which it arises so that when
the highest level is reached it is linked to the
variegated contents of experience through all the
levels below.

What appears, therefore, to be a simple abstraction
such as the class of mammals, must be seen in reality
to be a complex nesting of abstractions, (of invari-
ances) through which each element of concrete reality
is constituted just as each separate movement of the
dance is constituted by the relatedness (invariance)
of the whole movement. Abstraction is then more than
the process of simplification involved in drawing out
commonality, continuity or invariance from events.
It is also the process whereby the differentiated
elements of form are actually constituted.

Every visualisation of an object or thing, a cup, or
a flower, presupposes a process of abstraction which
realises an essential continuity of the thing with
everything from which it is differentiated. It is
that continuity which is the very ground of its
uniqueness as a thing.

The uniqueness of the thing is a difference within a
continuity or sameness. Two people differ in height
if they share height and in mood if mood is an
attribute applicable to both. Without a 'tacit' sense
of this relatedness we cannot 'explicitly' differentiate
things.

To paint or draw 'realistically' or in a 'represent-
ational' way presupposes a developmental history of
visual abstraction (provided such representation is
not merely mechanical), and the 'likeness' to the
world of things is achieved only at very high levels
of abstraction. In Art, as in all ideation, to see
the world as it is is to make something of experience
through abstraction. It may seem paradoxical to
assert it, but the very highest level of formal
abstraction is required for the most veridical
representation in visual art; just as in music, the
capacity for complex formal realisation presupposes
high levels of abstraction in experience with sound.

To summarise, the idea of abstraction that I have
offered here can be expressed as follows: from the
invariance or continuity that is tacitly perceived in
the undifferentiating perception of sensuous events,
the differentiated elements of experience are con-
stituted in explicit awareness, such that each is a
realisation of that invariance or relatedness. The

very uniqueness of each element in a work of art
presupposes its continuity with other things from
which it is differentiated. Continuity of space,
time, substance and so forth are just some of the
more general ways in which we conceive of that
relatedness at a formal level. Those who write about
art or science have many more specialised ways of
referring to formal relatedness. Continuities of an
affective or sensuous kind, continuities of attitude,
feeling, mood, atmosphere and so forth are at the
very heart of aesthetic creation.

How then are we to account for the idea of abstraction
that is common among those who make reference to
modern painting where abstraction is sometimes held
to be a flight from representational likeness? A
clue to the answer may lie in the formal kinship that
has sometimes been recognised by artists themselves
between their own work and the pictures of young
children. The kinship has an interesting parallel in
respect of the Piagetian discoveries about the
evolution of mathematical thought. Historically,
Euclidean and projective geometries precede topology
but in the development of cognition the order is
reversed and the child's concept of space is essenti-
ally topological before it is Euclidean. But just as
the topology of modern mathematics is not a return to
the consciousness of early childhood but is a province
of minds that 'inhabit' Euclidean space, so modern
abstract painting is not a return to the consciousness
of childhood but a reordering of a visual world that
is already representationally known.

In the brief account offered here only the fragmentary
outline of a theory of abstraction has been offered.
From this, however, it is possible to begin considering
implications for a theory of aesthetic development.

To experience a situation in a sensuous way is to be
attentive to the stream of sensuous events that
constitute one's being-in-that situation. To ride a
bicycle or drive a motor car demands that attentive-
ness to events. Movement and events are not explicitly
differentiated from one another. Rather, at each
instant we sense the relatedness, the dynamic symmetry
of the event world as the dancer senses the relatedness

of the whole in every individual movement. If we had
to think of each thing in turn we could not possibly
accomplish a skilled activity like riding a bicycle
or driving a car. Indeed, the problem that the novice
has is precisely that. He must think of each thing
in turn and the relatedness of the whole movement
eludes him. He attends separately to steering, gears,
brakes and signals when what he needs to do is to be
aware of each movement in its continuity with others.
Such an awareness is tacit not explicit and
undifferentiating not differentiating. In the context
of the aesthetic, such an awareness is an act of
appreciation.

Aesthetic development is the development of
appreciation of the world, our sense of relatedness
in events. But this sense of relatedness develops
only through acts of realisation, of formulation,
through which we abstract events and work on them.
The forms made by children, in word, gesture, pigment,
sound or whatever, together with their mental counter-
parts in 'image' life are integral to their discovery
of relatedness, of invariance, that is, to their
appreciation of the world. Each of them is potentially
a way-station on a journey that takes the child to a
fuller and more comprehensive sense of his being in
the world. Thus each phase in the development of
appreciation is fixed in a formal realisation which
then becomes the basis for a further act of appreciation
and so forth until the highest levels of refinement
in appreciation are reached. We are continually
moving out of tacit appreciation into formal realisa-
tion and back again as part of the ordinary business
of seeing the world as it is.

Appreciation and realisation are thus integral to one
another and development of skill in the one is bound
up with the development of skill in the other. This
does not mean, however, that everyone requires the
skills of the artist in order to appreciate art.
Realisation which is possible 'covertly' through the
vision of the 'mind's eye' is not necessarily overtly
reproducible. With visual imagination most of us can
picture the tossing of a horse's mane but few of us
could take our picturing from the head onto canvas
and pigment. The point being made here is that even
the ordinary acts of appreciation do require

realisation, albeit realisation which is not necessarily overtly produced.

It is not possible, therefore, to provide an aesthetic education in appreciation which does not involve realisation, though it is entirely possible to provide one in which overt realisation, that is practical art making, does not occur. But such an education would nevertheless be deficient in a most important sense, for the skill of overt realisation enables the individual to enter actively and creatively into the shaping of his experience. Such overt realisation provides the individual with a medium in which experience can be made, one that can be manipulated at will, so to speak. It gives the individual a control over sensuous events and ideation that is not possible without it.

In this brief exploration of the concept of development in aesthetic education I have sought in a very crude and preliminary way to emphasise the integral character of skill in the arts, that is the skills referred to here as intellectual, realisational and appreciational. There are no suggestions offered as to how arts curricula should be organised to take account of aesthetic development nor explicit criticisms of current practice. It seems to me that much more yet needs to be done in thinking about the integral nature of arts skills before a substantive theory of aesthetic development can be formulated.

Knowing Face to Face: Towards Mature Aesthetic Encountering

MALCOLM ROSS

I concluded my paper written for the last volume in this series (Ross, 1981) by quoting some lines from Thomas Traherne's Second Century. I am going to repeat them - for I find them increasingly apt for what I want to say about aesthetic education: I can think of no other statement that so richly evokes and so precisely identifies the essential character of the aesthetic dimension of human being.

> "When I was a child my Knowledge was
> Divine. I knew by Intuition those things
> which since my Apostasie, I collected
> again, by Highest Reason ... The Corn
> was Orient and Immortal Wheat, which
> never should be reaped, nor was ever
> sown. I thought it had stood from
> Everlasting to Everlasting. The Dust
> and the Stones of the Street were as
> Precious as Gold. The Gates were at
> first the End of the World, the Green
> Trees when I saw them first through one
> of the Gates Transported and Ravished
> me; their Sweetness and unusual Beauty
> made my Heart to leap, and almost mad
> with Extasie, they were such Strange and
> Wonderful Things ... Boys and Girls
> Tumbling in the Street, and playing,
> were moving Jewels. I knew not that
> they were Born and should Die. But all
> things abided Eternaly as they were in
> their Proper Places. Eternity was
> manifest in the light of the Day, and

and some thing infinit Behind everything
appeared; which talked with my Expectation
and moved my Desire."

This passage testifies to a special kind of
perception of the world: the familiar objects of
everyday (fields, dusty streets, stones, trees,
children playing) become, somehow, strange and
wonderful. Objects of wonder charged with such rich-
ness and beauty as to make the heart leap and the
senses reel in ectasy. The child, knowing nothing of
death, senses their essential propriety or fitness in
the world while, at the same time reaching beyond
their imminent presence to a perception of eternity.
The identification of the infinite with human
expectation and desire brings the experience of
ravishment within the realm of love - a concept which,
as I hope to show, is essential, not simply to
aesthetic experience but, more particularly to
aesthetic education.

In his poem 'The Ancient Mariner' Coleridge makes an
aesthetic response central to spiritual regeneration:
he offers us a similar experience of ecstatic
perception and the ensuing upsurge of love is all
that is needed to break the mariner's spiritual
bondage:

 "Beyond the shadow of the ship,
 I watched the water-snakes
 They moved in tracks of shining white,
 And when they reared, the elfish light
 Fell off in hoary flakes.

 Within the shadow of the ship
 I watched their rich attire:
 Blue, glossy green, and velvet black
 They coiled and swam; and every track
 Was a flash of golden fire.

 O happy living things! No tongue
 Their beauty might declare:
 A spring of love gushed from my heart,
 And I blessed them unaware:
 Sure my kind saint took pity on me,
 And I blessed them unaware.

> The selfsame moment I could pray;
> And from my neck so free
> The Albatross fell off, and sank
> Like lead into the sea."

It would be easy to go on citing examples of the kind
of thing I have in mind. (From the writings of
Stanley Spencer, William Wordsworth, William Blake,
David Jones, Eric Gill, J.J. Rousseau, H. Thoreau,
G. Bateson, G. Bachelard, Mercia Eliade). The point
I want to make is this. Aesthetic experience is our
experience of the world transformed by and transfused
with love - our love, the love of the beholder or
maker. Such experience occasionally reaches the state
of rapture and ecstasy as commonly understood. It
always implies some degree of standing outside the
merely mundane and the sensing in some degree of
'something infinit', of the heart's leaping in wonder
as expectation and longing are somehow felt to be
satisfied - beyond our dreams and hopes.

This account, perhaps, sounds all too remote from
everyday experience and the perceptions of ordinary
people to serve as a basis for a discussion of
aesthetic education. And yet it seems to me that I
in no way overstate the case. To look upon, to handle,
to delight in the phenomenal world - cherishing its
particular character for its own sake, as its rightful
due, worshipping the world - such action, of itself,
refreshes the human spirit, revives consciousness and,
in consequence, makes us feel that our life is worth
living. By encountering, embracing and acknowledging
what we love we experience ourselves as unique and
individual (indivisible, one, whole, hale, healthy).
We sense ourselves as unique, holy, sacred beings.
By the same token, if this assertion of mine is
accepted, our inability to bless the world leaves us
increasingly alienated, caloused and in our own
estimation worthless. I am suggesting that love is
the vital connection between aesthetic experience and
self-esteem. We, all of us, are constantly threatened
by the fate of the un-dead whose destiny is to
terrorise the living.

As Traherne suggests in the passage quoted above we
have to face up to the consequences of "Apostasie".
It is inevitable that as a child grows up the primacy

of aesthetic perception, characterised by the sense of
strangeness, wonder and transcendence, is challenged
by what has been called 'pragmatic perception'. By
which is meant that habit of mind which tends
increasingly to deny the sensuous impact (content) of
phenomenal experience and to handle percepts as
concepts: once objects are named they quickly acquire
generality and we come to attend to the world
abstractedly, indirectly, as mediated and mediating
experiences pragmatically or instrumentally valued.
The sense of the infinite is sacrificed for the drive
for immediate comprehension, possession, gratification.
Encountering gives way to controlling, using and
exploiting in the interests of increasingly insistent
pragmatic needs. Mind and calculation usurp the
earlier supremacy of intuition and sensibility, and,
perhaps for the great majority of men and women in
our own culture, the universal aesthetic principle
becomes all but extinguished and the singular and
privileged principle of art - itself something of an
aesthetic mutant - is all that survives the onset of
adolescence. In referring in this way to art what I
have in mind is the peculiarly western concept of
high-art - the limited range of favoured artefacts
prized by a small fraction of the population and for
the most part completely insulated from the people as
a whole. I'm not, in this instance, taking art to
mean what David Jones (1959) meant when he called art
"man's natural and defining activity". It would be
very much my hope that one of the principal outcomes
of aesthetic education would be the rehabilitation
of Jones's concept and a re-appraisal of high-art in
that context.

Aesthetic Education in my view seeks to sustain and
enhance the direct link between the child and the
phenomenal world. More particularly it seeks to bring
the child in to loving relationship with the world
sensuously perceived, to provoke experiences of
rapture and joy through such encounters and to build
the child's self-esteem as a creative and unique human
being. Rudolph Arnheim (1981) in a talk to a
conference of art therapists, has something very much
to the point to say about perception:

 "Perception is the discovery of structure,
 which tells us which are the components of

things and by what sort of order they
interact. A painting or sculpture is
the result of such an inquiry into
structure. It is a clarified, intensi-
fied, expressive counterpart of the
artist's perception. Even more important
for our present purpose is the fact that
all perception is symbolic. Since all
structural qualities are generalities,
we perceive individual appearances as
kinds of things, kinds of behaviour.
The individual percept stands symbolically
for a whole category of things. Thus
when poets or painters or your patients
perceive and represent a tree as
struggling to reach the light or a
volcano as a fearful aggressor, they
rely on the normal habit of perception to
see generality of wide significance in
any specific case."

This passage neatly presents the relation between
perception and meaning. Aesthetic experience is
about a very special kind of meaning: sensuous forms,
to paraphrase Traherne, "talk with us". They enter
into conversation with us about our expectations and
desires - in other words, about those things in life
which we value. Aesthetic activity is inextricably
bound up with values and valuing. When we attend to
sensuous forms aesthetically we are bound to
experience them symbolically - as evoking that which
we value. Feeling is a term we use to refer to both
physiological and psychic experience. We cannot as
perceptive human beings separate the two - except by
a brutal act of self-immolation, self-division.

If the aesthetic of everyday seeks the linking in love
of the sensuously immediate with the spiritually
infinite, perhaps we might usefully conceive of art
(of artefacture) as man's creative response to the
condition of mortality. It was an idea Shakespeare
frequently dwelt upon:

 "So long as men can breathe, or eyes can see,
 So long lives this, and this gives life to thee

The realisation of death, dawning in childhood (again, see the powerful reference in the Traherne piece) and endlessly encountered and struggled with throughout life, demands, so it seems, the transformative vision, the transcendent act of art, which realises alternative worlds that come "closer to the heart's desire" than mortality will actually allow. Certainly there can be no denying man's "immortal longings", nor the artist's unfailing commitment to what Herbert Marcuse (1979) has called the "revolutionary vision". In that brilliant essay he mounts what seems to me a quite unassailable argument for art as man's answer to mundanety - incidentally relieving art from the more limited roles of political agitation and propaganda.

Art then, born of man's awareness of his own mortality, reaches out to gratify expectations and desires that death would otherwise deny him. And art is simply the aesthetic response of everyday given expressive significance in human artefacts. Art is, as Louis Arnaud Reid has pointed out, the making of objects having aesthetic intensionality - that is to say, as given over to aesthetic perception and its attendant outcomes. There is an important sense in which the human artefact is continuous with all phenomenal objects in the world perceived from the aesthetic point of view. There are of course more complex definitions of art to be had (e.g. Herbert Read 1932 and Richard Wollheim 1979) - however, in the simple distinction between art and aesthetics which I favour we have a perfectly adequate basis for talking about the educational function and relation of both concepts.

Robert Witkin (1982) has said that aesthetic development must permit the recovering of more and more of sensuous life and of the order in it. This may be achieved by directing children's attention to the phenomenal world, by making them see and hear the order in it, by restoring sight, touch, gesture and vision where these have been blocked, inhibited or stunted. More particularly it is to be achieved through what Witkin calls expressive action. By enabling children to use art - to get access to art as David Jones saw it - which might include taking them to galleries, museums, theatres and concert halls but

would above all evoke their personal judgements in
their own acts of artefacture and of artistic choice.
Art offers us the possibility of complex sensuous
structuring - and so complex symboling - (that is to
say of expressing and encountering complex human
values in symbolic form). Following Arnheim, we admit
all perception to be symbolic.

One way of establishing the relation of the aesthetic
to the artistic in education would be to see the
aesthetic as a cross-curricular function of the arts.
It would be nice to think that a better balance could
be struck within the curriculum as a whole between
factual knowledge and the valuing that is the essence
of being. Art teachers should take a serious interest
in the role of the aesthetic across the curriculum and
be invited to advise non-arts colleagues. Specialist
arts teachers would concentrate their efforts on
realising each child's potential in each individual
arts subject, recognising that although the arts form
a single aesthetic discipline in education, the
character of aesthetic experience is unique to each
art or medium (i.e. music may not substitute for
poetry, nor art for dance). We would however expect
children to manifest aesthetic preferences and so must
allow for choice and specialisation.

Wollheim (1979) maintains that all aesthetic
experience involves projection. Broadly speaking he
characterises the aesthetic response to natural phen-
omena as the perception of "correspondence", between
natural order and order in the world of feeling: art
goes beyond the mere recognition of correspondence in
acts that are "expressive" in the sense that they
always involve the subject in new experience, in
cognition (knowing) rather than re-cognition (knowing
again). My own view is that projective acts of
correspondence and expression are equally applicable
to all aesthetic objects whether man-made or not.
The distinction between projective acts is, neverthe-
less, a useful one, since it allows us to give equal
respect to the creative, exploratory-type aesthetic
experience and the more contemplative experience of
reiteration and savouring (these two modes are not of

course to be rigidly identified with the making of art
as against its appreciation). Aesthetic meaning rests
in the order (orderings) to be discerned in sensuous
life - in what Witkin (1974) has called the perception
of "sensate structures".

It will be recalled that much of his book The
Intelligence of Feeling is devoted to the idea of
"expressive knowing" - his term for the projective act
that is, in so far as it corresponds with and follows
feeling, subject-reflexive. Subject-reflexive action
is the aesthetic intelligence in operation and if we
wish to understand how and evaluate how well the
aesthetic intelligence works then we must know about
subject-reflexive action. In particular it is crucial
to recognise that self-expression in this sense has
nothing to do either with a narcisistic introspection
or with the hedonistic self-indulgence of the merely
emotional. It is above all an act which respects and
preserves the otherness of the object or medium in
conjunction with which it achieves its realisation.
For us to know feeling we must achieve the kind of
distance from it that projection through a medium
makes possible. The sensuous medium (structure, form)
that, as we have seen, inevitably triggers the symbolic
response, in the sine que non without which intelligent
feeling would be impossible. Aesthetic experience
allows its practice and development: subject-reflex-
ive action is the heart of aesthetic education. Work
on the development of subject-reflexive behaviour is
still very much in its infancy, despite Witkin's own
speculative outline with which he concludes The
Intelligence of Feeling. There is no doubt in my mind
that this is an area in urgent need of research: we
need to know much more about the ways in which we
recover the order in sensuous life - particularly,
perhaps, how strategies change and performance is
altered with age and experience.

For my part I want to suggest that there is a direct
parallel between the way loving develops - especially
the way we come to love people as we grow from
infancy and childhood through adolescence to mature
adulthood - and our aesthetic capacity to order the
sensuous life. In other words I am suggesting that
if we could make out the history of human loving we
would also have the secret of aesthetic development.

This is not the place to develop this idea, even if I
had the evidence that would be necessary to such an
endeavour, however, I shall indicate broadly the way
my own thinking is developing. It has to be insisted
however that what follows is no more than the merest
speculation. Why bother with the apparent digression
into human loving? Well, because, as I've argued
already, there does seem an interestingly close
relation if not total identification between the
loving of persons and what has been called the
"enlightened cherishing" of works of art - and because
we all have experience of such relationships in life
long after, in a great many cases, we have lost our
feeling for what Wordsworth called the "splendour in
the grass".

In a recent paper already referred to (Ross, 1981) I
drew a parallel between the factors identified by
Kohlberg as evidence of mature moral reasoning and
those likely to constitute mature acts of aesthetic
judgement. Mature moral (and by extension aesthetic)
judgement has the following characteristics:

1) uniqueness and individuality
2) authenticity and integrity
3) openness, creativity
4) fittingness, propriety
5) empathy, fellow-feeling, kindness

Moral development moves from an egocentric,
undifferentiated perception of right and wrong towards
behaviour characterised by these more altruistic,
more highly differentiated and individualised concepts.
That these factors are also, in their way, highly
characteristic of mature aesthetic judgement, is
pretty clear. It occurred to me to compare this
'profile' of mature moral/aesthetic judgement with
the only comprehensive taxonomy of loving behaviour
that I am aware of: St Paul's first Epistle to the
Corinthians, Chapter 13. The extensive nature of the
overlap is immediately apparent (I leave readers
unfamiliar with the passage to look it up for them-
selves):

1) the knowing "face to face"
2) the "seeking after truth" (the "rejoicing" in it)
3) the disinterested and unfailing commitment
 (generosity and endurance)

4) "seemliness"
5) "kindliness"

Here we find Kohlberg's five major factors central in
an account of mature human loving (see also the
Traherne passage). But there are additional elements
that are also apposite to any consideration of
aesthetic judgement, in particular what St Paul has to
say about bearing, believing, hoping and being faith-
ful in "all things". He is reminding his readers
that suspicion, doubt and feebleness of spirit spell
death to love - and there is, I would maintain, the
same destiny awaiting any aesthetic enterprise
similarly tainted. If, as has been suggested, science
is a "doubting game", art, like love, has to be
conducted upon the premise of belief, faith and hope.

If we say these are the distinguishing characteristics
in the mature loving of people and things in the
world, the question arises as to whether the signs of
immaturity are some kind of falling-short in respect
of these characteristics, on the analogy with other
areas of development (e.g. skill in playing games)
where better means more (skilful) and worse means less
(including less discerning). I suppose we might want
to say that refinement and discernment were important
indicators of maturity in loving and in aesthetic
judgement - but would we expect to discover degrees
of authenticity, of openness and propriety for instance?
I would have thought certainly not. What the
categories just listed give us is an account of what
it is to act lovingly. They anatomise the thing,
love, itself. Although we do, I'm sure we shouldn't
speak as if love were susceptible of grading or of
being parcelled out, offered in instalments or by
half-measure (i.e. half-heartedly). Like the concepts
of newness, creativity, freshness, there are no degrees
or fractional proportions. Every creative act is
unique: we cannot sensibly say that we are now being
more creative than we were, except in the narrowest
of senses of being more frequently creative or in
creating things which attract a higher level of
extrinsic reward. A new thing is a new thing. So,
too, with the word 'unique': there are not degrees of
uniqueness. And acts of love are all or nothing.
Incidentally loving further resembles the aesthetic

in its commitment to uniqueness. We cannot compensate
for the loss of one loved-one by loving another.
Every act of love is particular and individual.

It seems reasonable to suggest that the elements of
all loving are to be found in St. Paul's account.
There is a qualitative difference between the loving
of the adult and the loving of the child but full
satisfaction and full expression are possible at each
stage. The child does not sense, in respect of his
or her loving or being loved, that the experience will
be more complete, more satisfying, better, when they
are older. So, I suggest, it is with the child's
aesthetic experience.

We would suppose that there lies a whole world of
difference (of development) between the loving of the
child - in ignorance, dependance and general physical
and mental immaturity - and the "greater love" of the
man capable, for example, of laying down his life for
his friend. Acts of love and aesthetic judgement may
well be absolutes at each stage of development but
men and women undoubtedly become capable of more
complex if not more satisfying actions in both realms.
Loving and aesthetic development are a matter of
being capable of acting in the way described by St.
Paul towards people and objects in the world despite
the increasing difficulty of doing so, given our
gradual awakening to the complexity, contradictions
and pressures inherent in adult human being. That
awakening, one senses, is accompanied by regular
advances in the 'equipment' provided us for acting in
and coping with the world. An account of aesthetic
development would indicate in what ways the world was
perceived as structually more complex (would reveal
the "hidden orders", not just of art but of all
sensuous experiences), and the complementary
increments in perception awarded with the years as a
means of coping and of achieving satisfaction. Which
would mean that the Pauline factors, cited above,
would have to be interpreted differently for each
developmental stage and might not all be discernable
in the early stages.

I make no claim whatever for the following tentative
hierarchy of loving/aesthetic behaviours - apart from
the fact that the model below is to serve as the basis

for study and investigation. I shall do no more than baldly present it, leaving the reader to ponder - or pass by!

Infant:	Objects in the world 'loved' as part of the self	Basic 'aesthetic' experience (union)
Young Child:	Objects become separated but subject to the child's will: love of other emerges	Stage of improvisation (play)
Older Child:	Objects assume identity and authority of their own and dominate the child	Stage of impressions (mimesis)
Adolescent:	Objects assume symbolic quality and serve as idealised forms - a transitional stage	Representational crisis: dawning of fully symbolic operations
Adulthood:	Objects loved for themselves - as real, separate and continuous with the self.	Stage of composition

The phases are understood as developing in sequence but not as logically connected or as replacing each other in turn. In theory at least there is the assumption that earlier behaviours will persist and remain valid alongside later developments. The next phase of model-building should provide (1) information about aesthetic coding (sensate structuring and symboling) for each stage, and (2) conceptualise more fully the different developmental stages in terms of the loving/aesthetic attitudes and perceptions that characterise them.

I believe that what really matters in aesthetic education is the quality of aesthetic encountering

This conference has seen much discussion of the content
of the arts lesson and Dorothy Taylor provoked some
controversy in proposing a somewhat academic approach
to the analysis and appreciation of music and that
music clearly identified with what Christopher Small
calls the classical European repertoire. Some
conference members protested that such a curriculum
paid no heed to the obvious musical interests of
young people and the implication was that a musical
curriculum that didn't properly respect pop music was
doomed to failure. My own view is that neither of
these points of view is itself either wrong or right:
what matters is how musical experience is presented
to the children and the kind of experiencing - that
is to say whether direct and immediate or whether
remote and academic - the children actually have.
The arts lesson will necessarily deal with practical
skills and knowledge (about art, its uses and its
processes). But above all it will enable the child
to participate, at the appropriate level of
complexity, in the believing game that is the
aesthetic encounter - in moments of loving, of joy,
of waiting and frustration but ultimately of ecstacy
experienced in making, listening and looking on
(attending). For such moments are the touchstones of
aesthetic life and without such experiences in school
it will be very difficult not to lose one's way as
life seems increasingly to heed and reward the human
and mechanical processor. It is through such moments
that the habit of loving is formed and in the
continuity of loving acts that we come to know "even
as we are known".

REFERENCES

Arnheim, Rudolph. (1981). Art as Therapy, The Arts
 in Psychotherapy. Vol. 7, pp 247-251.
Jones, David. (1959). Epoch and Artist. Faber.
Laing, R.D. (1953). The Divided Self. Tavistock.
Marcuse, Herbert. (1979). The Aesthetic Dimension.
 Papermac.
Read, Herbert. (1932). The Meaning of Art. Faber.
Ross, Malcolm. (1981). Curriculum Issues in Arts
 Education. Vol. 2. The Aesthetic Imperative.
 Pergamon.
Witkin, Robert, W. (1982). This volume.

Witkin, Robert, W. (1974). The Intelligence of
 Feeling. HEB.
Wollheim, Richard. (1979). The Sheep and the
 Ceremony. CUP.

SECTION III

Curriculum Issues

Introduction

Each of the contributors to this section focusses on particular arts subjects, and gives a personal view of what development means.

Dorothy Taylor sees music as lagging behind the other arts in recognising the importance of the creative and compositional modes. She favours a broad approach to the teaching of music as a language, as a 'structure of knowledge', and insists that children's experience of music should always be enjoyable and relevant to their present needs and interests.

For Alfred Harris the most acute problem for visual art teachers is how to intervene positively in a child's learning 'without imposing limiting dogma'. He proposes an approach that while respecting the problematic nature of the creative process could provide a secure structure for truly artistic development.

Sarah Rubidge is also interested in art as language: in the case of dance, the 'organising principles' must be taught if children are to make 'an informed response'. She accepts that, although development in dance might be sequential it need not be linear. Her analysis concludes with an account of what it means to be aesthetically mature in the dance.

Gavin Bolton senses some distance between his own view of the educational functions of drama and the particular concerns of the Dillington Conference. He does not minimise the importance of aesthetic considerations in making his case for a multi-faceted

view of the role of drama, but remains unpersuaded as
to their overwhelming priority - a claim made by
<u>Malcolm Ross</u> in a postscript to the paper.

Aesthetic Development in Music

DOROTHY TAYLOR

MUSIC AND FUNCTION

To begin this paper in a very personal way, there are
no words to adequately express the deep effect which
certain pieces of music have on the writer. Any
attempt to describe such individual feelings of
extreme emotion which result from hearing, for
example, a performance of Kodaly's Peacock Variations,
would do justice neither to the music itself nor to
the response of the listener. Might this quality
which music possesses to move or stir the emotions and
the ability of the listener to respond to whatever
degree, be the closest approach to 'perfection or
happiness'? As Polly Devlin states:

> 'I find that there is a way to look at
> happiness, to perceive its shadow; and
> that is to read the great poets, or
> listen to the great musicians. These
> creators of word and music illuminate
> through the vivid transparencies of
> their genius the ways and the means of
> happiness' (Devlin, 1981, p.35.)

This subjective, individual response and one which is
so intimate and difficult to share, is discussed by
Blacking and neatly encapsulated by him:

> '... Can anyone else hear these notes
> as I do, or as Mahler did? Is the
> purpose of musical experience to be
> alone in company?' (Blacking, 1976, p62.)

If the supreme height of musical response is a highly
individual act, culminating from years of musical
activity and experience, is it not interesting that
the experiences leading to this state have, more often
than not, been shared experiences with others in
classroom, orchestra, band or group?

And yet we have learned that in Ancient Greece and
earlier civilisations the function of music was
closely related to ritual. It is only in compara-
tively recent times that music has come to be regarded
as a highly personal art form.

Small (1977) has expressed concern that music, as we
know it in western society, is essentially without
function. Conditioned as we are to music principally
composed between 1600 and 1910, with the exception of
Church music, even music loosely associated with ritual
is often performed regardless of time, season or
setting. There is little or no audience participation
such as would be normal in Balinese or Indian society.
Again, in support of the ritual function of music,
Jane Harrison (1978) puts forward the thesis that art
and ritual share a common root:

> '... and that neither can be understood
> without the other. It is at the outset
> one and the same impulse that sends a
> man to church and to the theatre'
> (Harrison, 1978, p.1).

She goes on to explain:

> 'a rite is ... a sort of stereotyped
> action, not really practical but yet
> not wholly cut loose from practice, a
> reminiscence or an anticipation of
> actual practical doing' (Harrison, 1978, p.10).

Harrison sees ritual as a representation, a copy or
imitation of life but always with a practical end.
Art too is seen as a representation of life and of its
emotions yet seen to be cut loose from immediate
action. As she states:

> 'the end of art is in itself. Its value

is not mediate but immediate. Thus ritual
makes, as it were, a bridge between real
life and art' (Harrison, 1978, p.72).

It would be difficult to argue with her statement that
the impulse which art shares with ritual is the desire
to give out a strongly felt emotion, or desire by
representing, by making or doing, by enriching the
object or desired act.

Considering music from another angle, one might take
account of its play or ludic function. Ross (1981,
p.112) has already drawn our attention to the arts as
an aspect of pure play and to the necessity for
educators to value 'play' as a vital process in
handling the material or in 'kneading the dough'. So
too Huizinga (1970) devotes a complete chapter to
'Play Forms in Art' where he states that:

> '... play, we said, lies outside the
> reasonableness of practical life; has
> nothing to do with necessity or utility,
> duty or truth ... Musical forms are
> determined by values which transcend
> logical, visible or tangible ideas'
> (Huizinga, 1970, p.182).

And again Seashore describes music as:

> '... essentially a play upon feeling
> with feeling' (Seashore, 1967, p.9).

Whatever concepts are held of play, such as its being
a therapeutic activity or release, a kind of game or
an infantile pursuit, far too little attention has
been paid to the notion of play as a positive and
vital life's necessity; one which is an enhancing and
potentially balancing out factor in healthy human
development.

THE MUSICIAN

Let us turn now from the origin and function of music
to the person who engages in it. What kind of
behaviours characterise a musician or musical person?

He or she is often thought to live in a world of
images, imagination, fiction and fancy. The musician
is deemed to be an emotional type, whose job is to
play upon feeling. As Seashore puts it:

>'... to appreciate, to interpret, and to
>create the beautiful in the tonal realm'
>(Seashore, 1967, p.174).

and
>'... The composer creates, the performer
>recreates and interprets, and the musical
>listener responds musically within the
>limits of his creative power' (Seashore,
>1967, p.373).

We are indebted to Carl Seashore for his masterly
study of the musical mind, regarding as its most out-
standing attribute the capacity to hear music in
recall, by what is termed auditory imagery. This is
reinforced by imagery through other senses: visual,
tactile and particularly through the motor sense in
which we act and feel the music. As he states:

>'... it is clear that the mental image,
>and particularly the auditory and motor
>images, operates in music in the following
>three ways: 1) in the hearing of music;
>2) in the recall of music, and 3) in the
>creation of music ...' (Seashore, 1967,
>p.169).

At this point we should remind ourselves that the act
of hearing is not a passive registering of sounds but
an active process of reconstruction in the mind of the
listener. In fact, in order to possess the musical
memory which is vital for musical behaviour, musical
imagery is essential, not in the sense of memorising
repertoire, but in the sense of schema making in what
is a temporal art form. For whenever musical memory
is particularly vivid, we relive the music in a very
concrete way. Seashore has presented us with a
classification of types of musical imagination which
is helpful in that it takes in the notion of person-
ality and temperament. Thus there is the musician
who inclines to the sensuous, another to the
intellectual, to the sentimental, the impulsive, or

the <u>motor</u>. Any given individual may be dominantly of
one of these types but more usually a musician
represents the integration of two or more. If
integration is well developed then the ideal musician
possesses and can be typed as the <u>balanced imagination</u>.

MUSIC EDUCATION

Against this background, how then are we to view the
task of music educators? And, at this point, the
writer must declare her stance. This is that, whether
or not we are considering the general music programme
or any form of specialised music education, there
should be at the core a vital, imaginative and
comprehensive music curriculum which would benefit all
learners and better equip those who wish to pursue a
professional career in music.

Let us take as a goal for music educators that, to
educate for music, is to develop aesthetic
responsiveness in accordance with the uniqueness of
this particular art mode, developing every individual's
innate response to music and nurturing his or her
potential for aesthetic experience (see Taylor, 1979).
What then are the broad areas which delineate musical
experience? Several music educators have analysed
the three main modes of musical experience: the
<u>receptive</u>, the <u>productive</u> and the <u>reproductive</u>. Most
useful, however, is the conceptual model put forward
by Swanwick (1979, p.45) in which he shows five
parameters of musical experience, easily remembered
by the simple mnemonic C(L)A(S)P. The two bracketed
parameters are seen to have supporting and enabling
roles in contrast with the three parameters
<u>composition</u>, <u>audition</u> and <u>performance</u>, which relate
<u>directly</u> to music:

C	Composition	formulating a musical idea, making a musical object;
(L)	Literature Studies	the literature of and the literature about music;

A	Audition	responsive listening as (though not necessarily in) an audience;
(S)	Skill Acquisition	aural, instrumental, notational;
P	Performance	communicating music as a 'presence'

Fig. 1. Five parameters of musical experience (Swanwick, 1979).

It is clear that, in many ways, music education has lagged wearily behind art education and has only recently begun to value children's composition as an essential feature of the educational process. (This is not to ignore the work of individual teachers such as Peter Maxwell Davies at Cirencester Grammar School in the late '50's or of earlier pioneers such as H. Caldwell Cook and Yorke Trotter). Too much so-called 'listening' or musical appreciation in the classroom has been diffused into anecdotal stories of the 'great' composers or has dwelt heavily on programme music, without coming to grips with the essential 'lifeblood' of music itself. Some teachers have made literacy such a prerequisite to musical experience that it has often become a goal in itself, a formidable barrier between the learner and the essential quality of the musical experience. Again, a curriculum which is myopically centred on performance and skill acquisition runs the danger of producing an automatic response, a kind of 'barking at print' rather than providing the basis for a thinking, feeling, spontaneous re-interpretation of composed works.

Lest the foregoing should suggest that the writer does not value each of these activities, it must be stressed that, at all times, it is the relevance of the particular activity which is crucial and the imagination of the teacher in pursuing each activity in a wholly musical and pedagogic way. This will be taken up again at a later stage.

So very much of what passes for music teaching is characterised by its unthinking adherence to what is conventionally thought of as music teaching: singing

for the sake of singing, listening for the sake of
listening, etc., in other words going through the
motions where an activity is seen to be an end in
itself and a way of accounting for time spent. This
may sound to be a rather cynical view yet, on those
occasions when one sees purposeful, structured and
thoughtful teaching, the difference is not only
striking but a revealing process for teacher and
taught. As Reimer states:

> 'There is no substitute, when all is said
> and done, for a general music teacher ...
> who possesses a high order of musical
> training, aesthetic sensitivity and
> pedagogical expertise, and who is
> devoted to sharing the enjoyment of the
> art of music with all children.'
> (Reimer, 1970, p.115).

At this point it would appear relevant to remind our-
selves of many factors which could be thought central
to the learning process under the general heading of
balance. In western society we have often accepted
certain hierarchies and temporarily lost sight of the
Greek ideal of the 'whole' man or woman. In
educational circles, the work of Bloom and his
associates which produced a Taxonomy of Educational
Objectives has been influential (Bloom, 1956). The
extent of its influence is seen in the seemingly tacit
approval of a hierarchy which acknowledges the
supremacy of the cognitive domain (knowing that,
knowing how) over the affective (feeling that, feeling
how) over the psychomotor (acting that, acting how).
Indeed the last area, the psychomotor domain, although
recognised by Bloom and his associates as an important
area has not yet been dealt with in detail, although
a very useful analysis and application has been made
by the music educator Regelski (1957, pp.207-231). It
is only fair to say that Bloom does stress the inter-
action of one domain with another yet it seems
important to question continually unhelpful splits or
hierarchies which tend to demote certain ways of
knowing to inferior positions within the curriculum.

To give an example; we may know, in a factual sense,
that a piano' has approximately eighty-eight keys, the

construction of a major scale and recognise a piano'
piece as a sonata by Haydn. In the <u>affective</u> sense
we may know and feel that piano' music is our preferred
musical medium and that Haydn's music does something
for us to the extent that we value the experience.
And then, in the <u>psychomotor</u> sense, if we respond
physically to the Haydn sonata, we know the music
through 'being' it, in sympathetic vibration as a
biological creature. One might call this the muscular
sense or even the 'sixth' sense. There is inevitably
a delicate balance to be borne in mind in our
educational work between these different, fundamental
ways of knowing.

There are other balances to be made too, for example,
the balance when teaching between the artist and the
teacher. As stated by the writer elsewhere when
describing the teacher's need to provide a model for
his pupils:

> 'This presents the teacher with a dual
> task. He must be a model educator and
> a model musician, or artist. He needs
> to respond to the learner in such a way
> as to reinforce and develop his
> conceptual processes, skills and
> techniques. At the same time he must
> pave the way for the learner's aesthetic
> response and musical feeling by his own
> behaviours as a musician. This is quite
> an undertaking yet one which is vital to
> the process of valuing music, the subject
> itself. Ideally he must perform the
> simplest folk song with the same care,
> musicianship and sense of occasion as he
> would a Beethoven violin sonata' (Taylor,
> 1981, p.27).

Apart from this, there are other balances and dial-
ectical relationships to be kept between, for example,
tradition and innovation, the historical and the
contemporary, between method and discovery:

> 'Method inevitably gives a sense of
> direction to both teacher and learner
> by presenting an orderly sequence of

teaching elements. Guided exploration,
on the other hand, provides opportunities
for problem solving and enables the
learner to play a fuller part in his own
music education. It may also reinforce
and make relevant those very principles
which one seeks to establish through
methodology' (Taylor, 1981, p.33).

THE TEACHER'S TASK

Much of the foregoing has discussed music education
in general terms. To be more specific, let us take as
our premise Bruner's theory that the most important
content of any subject is that subject's 'structure',
its core of interrelated conceptions and modes of
behaviour which make it a distinguishable discipline.
His hypothesis (Bruner, 1960, p.52) is that any subject
can be taught to any child in some honest form.
Bruner's theory of a curriculum in which the same
basic concepts are consistently presented in increas-
ingly complex forms, better known as the 'spiral'
curriculum has been examined and rigorously applied
in the USA by the Manhattanville Music Curriculum
Project Team. They have produced a detailed programme
of activities, through graded levels, which treat the
concepts of sound, rhythm, pitch, harmony, timbre,
dynamics and form, according to the age and needs of
the learners, through the differing aspects of musical
behaviour outlined earlier.

In tune with the work of Bruner is the idea of
encompassing the reception of music and the practice
of music through structuring appropriate experiences
which come to grips with music itself, what might be
termed the musical encounter. A forthcoming public-
ation by Swanwick and Taylor (1982) sets out in detail
an approach to curriculum building which stays very
close to first-hand musical experience for teacher and
pupils. It aims to foster the ability to perceive
what is going on in a wide range of music, to respond
to it with enjoyment, and possibly delight. If we can
accept that the main goal of all music education is to
enable people to appreciate music, to value it as a
life-enhancing experience, then we may feel that we

have the only really satisfactory justification for
music education that exists.

A large proportion of music teaching is devoted to
knowing how or knowing that, often to the neglect of
knowing it, the musical object. Part of the
difficulty of approaching this kind of knowing is the
problem of finding suitable metaphors to illustrate
what Cooke (1959, p.204) so aptly describes as
emotion-in-musical-form. Suitable metaphors obviously
exist in other art forms, in graphic art, sculpture,
dance, for example, and these could be applied when-
ever appropriate. Yet, in the interests of arts
educators in general and music teachers in particular,
our aim has been to develop verbal metaphors, a
vocabulary or workshop language which enables us to
talk with one another about music and its basic
elements.

There are, we feel, two essential elements to be
taken into account, namely expressive character and
structure. When speaking of expressive character we
might describe music as being active or passive, light
or heavy, spiky or smooth. The structural character
of the music is fundamentally the relationship between
different materials and ideas, being aware of the
significance of change, the scale on which events take
place, a sense of norms and deviations. For example,
if we took the Farandole from Bizet's L'Arlesienne we
find a movement based on two distinctive ideas:

Theme A. Full Orchestra.

Theme B. Woodwind

Fig. 2.

<u>Structurally</u> we would, by suitable questions, guide
our pupils to discover:

> (a) that there are two basic ideas A and B;
>
> (b) there is a strong statement of A in
> unison before the strings go on to play a
> 'follow-my-leader' game (canon);
>
> (c) the contrasting idea B is played by flutes
> and clarinets with a tambourine
> accompaniment;
>
> (d) the alternation between A and B with
> gradual crescendo and final accelerating
> statement of A and B together in the major
> mode.

<u>Expressively</u> they should be able to describe theme A
as firm or emphatic, strong rather than weak, taut
rather than loose. The music has a spiky, detached
quality. The flow or rhythmic bond seems controlled
rather than free. In contrast theme B is light and
flaccid, more weightless in quality, more suspended,
with a feeling of free flow.

From here we could focus on first the opening theme A,
then the B idea, proceeding to experiment in movement,
perhaps, to discover ways in which we might move to
the music. Hence the musical experience would be
probed and reinforced through a concrete and active
medium, the muscular sense and through the visual aid
which movement provides; one might say a human score.

Work could be guided by such considerations as:

1) How should we move? ... in terms of weight
 (heavy or light) to what degree (sustained
 or detached) in terms of time (fast/slow),
 in terms of flow (free/controlled);

2) Which parts of our body should we move?
 (kinds of movements, metrical rhythm,
 interpretation of general flow);

3) Where are we moving? (direction, space,
 level or height and depth);

4) Who with? (alone, with partner, group, size
 and structure of relationships.)

This particular piece would appear to lend itself to
interpretation in pairs or groups, on account of its
canonic treatment and clearly contrasted themes.

Further exploration of these expressive and structural
elements could be a focus for composition. Assign-
ments might be set such as: compose a piece with two
contrasting sections, the one having a strong, driving
quality and the other light and airy with a feeling of
free flow. More experienced pupils might devise
pieces based on the idea of echoes or take it further
to compose themes which work in canon.

Another approach might be to take a familiar
rhythmic figure such as ♩ ♫ (which features so
frequently as an ostinato) and structure an
integrated lesson from it. Such a lesson might
start with the easily learned song Five Hundred
Miles:

If you miss the train I'm on, You will know that I am

gone, You can hear the whis-tle blow five hun-dred

miles._____ Five hun-dred miles, five hun-dred *etc.*

To which we could add ♩ ♫ as finger clicks or
percussion accompaniment. Other simple rhythm
patterns might be employed for interest and variation
and then notated on board or overhead projector. By
combination and by treating this exercise as a round,
using different bodily actions or percussion
instruments, simple rhythm sight-reading is absorbed
in a game-like atmosphere. Not losing sight of our
♩ ♫ ostinato figure, we then play snatches from
three completely contrasting pieces of piano' music
based on this elemental rhythmic figure and ask the
children to identify which one we are playing, e.g.
Grieg's Wedding at Troldhaugen, Unite and Unite (the
Padstow Song) and the third piece from Lennox
Berkeley's Five Short Pieces for Piano. The common
bond, i.e. ♩ ♫ , far from imposing rigidity and
sameness is changed and transformed in every new
context. By employing the type of workshop language
already described we may encourage our pupils to
explore their differing expressive qualities - the
joyous, march-like quality of the Grieg and the
characteristics which contribute to its overall mood,
- the processional quality of the Padstow Song and
the way in which the melodic line is at one with the
ostinato. It appears to grow from it and the song is
heavy, robust, strong, stamped into the ground rather
than springing from it, - and then there is the
plaintive, nostalgic character of the Berkeley piano'
piece, derived from its harmonic richness, fuller
chordal texture and dissonance. Connections could
then be made from these examples to a wide range of
styles including 'pop' songs and sixteenth century

music to many other examples lying in the rich
reservoir of every music teacher's experience.

Space precludes the possibility of giving any more
than the barest outlines of just two approaches to
the encounter with an art object or event, be it made
or in the making. However, it is the quality of the
'musical encounter' which should be the music teacher's
criterion, the integrity of the particular and the
imaginative structuring of the experience itself.

And so, we may ask, is there any such thing as
aesthetic development which can be viewed objectively?
If our ultimate aim, as educators, is to teach for an
aesthetic response, that is to say towards a quality
of feeling and image making in composition, quality
of meaning for during active listening, and quality
of interpretation in performance, there are object-
ives to be defined and met. An outline of broad
developmental stages might include the following
general formulations:

 1) Children should be able to perceive
 and express strong characterisation
 in music, i.e. strong/weak polarisation;

before 2) recognising clear-cut differences
 within a time scale, i.e. contrast/
 unity;

before 3) recognising degrees of structural and
 expressive change, i.e. sudden/gradual;

before 4) proceeding to lengthier and more
 complex music, i.e. brevity/length,
 simplicity/complexity;

before 5) appreciating greater refinement of
 expressive character, i.e. making fine
 distinctions/general broad outlines;

before 6) seeking and being open to new
 experiences (music of different
 cultures, styles and periods) i.e.
 seeking/knowing, wide horizons/
 restricted horizons.

In educating for aesthetic development teachers are responsible to their pupils for providing musical experiences which are valid and meaningful to people irrespective of age, rather than those that are superficial or childlike. Their commitment to the art of music must be evident, conveying a sense of purpose, achievement and progress. At the same time, the teaching context should be sufficiently comfortable to allow for the individual contribution of each learner, encouraging her capacity to vary, adapt, change, imbue with personality and individualisation. Stereotyping, mechanistic repetition, unimaginative practice, skills and fact acquisition which bear no relevance to the musical artefact; all these are not only detrimental to aesthetic development but may bar any kind of aesthetic growth.

If we are concerned with the integrity of the particular, the here and now, we would agree with Reimer who states:

> '...the best preparation for more enjoyable musical experience in the future is the most enjoyable musical experience that is possible in the present.' (Reimer, 1970, p.124).

Perhaps the notion of satisfaction with one small success at a time is a clear and attainable goal, as is the notion of an aesthetic education in music which enables the teacher to develop as well as the taught. If, as Blacking suggests, the purpose of musical experience is to be alone in company, we educators need to tackle the task of setting appropriate objectives for aesthetic development which will lead to the ultimate, personal valuing of the musical experience. Given these criteria it is up to us to travel hopefully!

REFERENCES

Blacking J. (1976). How Musical is Man? Faber and Faber.
Bloom, B.S. (1956). Taxonomy of Educational Objectives. Longmans.

Bruner, J. (1960). The Process of Education.
 Harvard University Press.
Cooke, D. (1959). The Language of Music. Oxford
 University Press.
Devlin, P. (1981). 'Happiness without pretending'.
 Sunday Times. 5 July 1981.
Harrison, J. (1978). Ancient Art and Ritual.
 (first published 1913). Moonraker Press.
Huizinga, J. (1970). Homo Ludens. (first published
 1949). Paladin.
Regelski, T. (1975). Principles and Problems of
 Music Education. Prentice-Hall.
Reimer, B. (1970). A Philosophy of Music Education.
 Prentice-Hall.
Ross, M. (1981). 'The Arts and Personal Growth' in
 The Arts and Personal Growth. Pergamon Press.
Seashore, C. (1967). Psychology of Music. (first
 published 1938). Dover.
Small, C. (1977). Music-Society-Education. John
 Calder.
Swanwick, K. (1979). A Basis for Music Education.
 N.F.E.R.
Swanwick, K. and D. Taylor (forthcoming 1982).
 Discovering Music. Batsford.
Taylor, D. (1979). Music Now: A Guide to Recent
 Developments and Current Opportunities in Music
 Education. Open University Press.
Taylor, D. (1981). 'Towards a Theory of Musical
 Instruction' in Issues in Music Education.
 Bedford Way Papers No. 3, University of London
 Institute of Education.

The Challenge of Art Education: the Role of the Teacher and the Role of the Student

ALFRED HARRIS

This paper argues that there is confusion about the role of the art teacher; it questions the nature of the authority which is attributed to him and with which he operates. It looks at conventions in Art Education, questions many of the assumptions on which they are based and links them to popular concepts of art. It goes on to suggest a structure for grouping projects, which recognises that art can be approached by different routes and which clarifies the context of art work. It proposes a more assertive and responsible role for the student and a more neutral but positive role for the teacher.

Gordon (1970) said:

> "Through the arts, man has discovered
> a language which least distorts the
> original message and which is as closely
> as possible analagous to the essential
> nature of the original message."

I shall begin by describing a situation which you will not find difficult in imagining. A large, light and airy room; about twenty pupils in their early teens, some painting, others drawing, perhaps as a preliminary to painting. Some talk to neighbours for a while then return for a spell of silent, crouched activity. Others, seemingly more casual in attitude, talk while making large gestures of arm or wrist across their paper. Others seem to be more deeply involved in conversation. A boy is carefully, slowly sharpening a number of pencils to delicately

tapered points. When he finishes one, he positions it
in a loop in a wallet made to hold pencils. An adult,
slightly stooped over a girl's picture and watched by
a black boy, is making a gesture towards the girl's
picture as he talks.

I shall in this essay, focus on the role of the adult
in this situation; more precisely, what knowledge and
understanding he may have and what knowledge and
understanding he cannot assume to have. I am
attempting to cover in this paper what would require
a number of volumes of a prudent philosopher and
psychologist. It begs many questions, some of which
I am aware of; of others, no doubt, I am not.

There is a large body of research which argues the
justification for art as a vital element of the
curriculum for schools. Given understanding of this
research, the main cause of any erosion of time given
to art in schools may be the confusion in the minds
of many educationalists about the role of the art
teacher and the content of art education. It might
be said: we know art is worthwhile, but most second-
ary school pupils have little talent for it.

This paper offers for discussion a view of the art
teacher's role. It particularly focuses on increasing
involvement in making and appreciating art. Although
in principle, much of what I have to say applies to
teaching at all levels, my focus is on the Secondary
School stage of Education.

The art teacher is often seen as a benign figure,
encouraging creativity and having some knowledge of
and skill for manipulating materials in a more or
less specialist area of art, and with a knack for
spotting talent. Art teachers have for a long time
been disenchanted with psychological theories of
creativity as their main focus. It is recognised that
theories of creativity throw the same light on art as
they do on mathematics. Enthusiasm for new materials
and techniques for shaping them was an attempt to
make 'creativity' more operational: this is now being
allocated more reasonable attention.

Recognising that art is essentially personal, art

teachers wish to be considered as being liberal in
their teaching. Those occasions when art teachers
admit to being illiberal are defended on grounds of
preparation for examinations. The problem today is
how can an art teacher be positive in his teaching
without imposing limiting dogma? The notion that art
is personal can be misleading: it is idiosyncratic
but for it to be recognised as art is to identify its
being within a tradition.

Osborne (1970) has said:

> "In order to be of value, innovative
> art must retain intersubjective appeal
> and remain comprehensible and if there
> is to be communication at all,
> comprehension at all, creative art must
> be innovative within the framework of
> a shared tradition. What is original
> all the way is completely incomprehens-
> ible ... Those artists of the past
> to whom the world pays highest tribute
> have been creative by modification,
> enlargement, adjustment, adaptation of
> an inherited artistic tradition."

Working within a tradition, as we know, presents
problems, as Matisse (1942) observed:

> "Undoubtedly the instruction given at
> the Beaux Arts ... is deadly for young
> artists."

Other artists have expressed the same view. Spencer
(1926) wrote in a more dramatic style:

> "It's awful, after four years at the
> Slade to find oneself not in possession
> of an imaginative capacity to draw but
> instead to find that one has contracted
> a disease."

I have been talking about extremes of operational
hazards in teaching art: at one end the inapprehens-
ible, at the other the stagnant traditionalist. Each
is not valued by itself: shades of both however are
present in imaginative teaching. At this stage, a

point of reference about work in art is essential.
For this purpose I will go to Reid (1980). Art
requires, he says,

>"aesthetic intention, the perceived
>artifact contemplatively enjoyed for
>its own sake as an embodied expression
>of ideas."

The value of work in art is relative to the extent
to which it represents the pupils' conception of the
subject. Indispensable though these values are, art
teachers have no clear and agreed methods for involving
students in activities which will satisfy these
criteria: research in Art Education has not come up
with an answer.

Turning to artists also proves fruitless: Francis
Bacon (1978) and David Hockney (1976) believe that
abstract art is boring: Hockney believes that frequent
"drawing from life" is essential. Bacon never makes
a "drawing". The linear structures in the very large
paintings which Patrick Heron has made over many years,
were fixed in the first three seconds of working and
would not be altered during the subsequent, often
weeks of painting before completion. The structures
in John Hoyland's (1979) paintings however, are not
settled until the last moments of usually many days
of constant change.

There are no procedures in art which all artists
would find helpful for their creative work. There
are cultural, developmental and personality
differences existing amongst artists. Likewise there
are differences amongst any group of children. We
would expect that with any project in art, the
standard of attainment of individual pupils will vary
considerably. It is understood that childrens'
potential for achieving high standards also varies:
though it would be reckless indeed to say of any
child that he would never achieve a high standard of
work in art. Often the least skilled pupils do the
most personally creative work, while the 'talented'
may be too concerned with conformist rule-following,
demonstrating their skills. In order to teach well,
teachers must assume that in terms of the values
which I have described, all children have potential

for achieving high standards.

Children bring with them personality and experiential
differences which make learning in a particular
context more or less difficult. Generally teachers
have no control over this matter. The context of
projects however, is to a large extent sensitive to
the teacher's influence. The teacher has to operate
within a theoretical framework which takes account of
the differences amongst children, and which provides
an alternative to judging the suitability of
procedures for childrens' work, against the teachers'
own preference.

There is a need in Art Education for a term which
will unify the elements over which we have control
and which affect art work. It is important that we
avoid the confusion which arises from separating what
goes on before, what goes on during and what goes on
after 'hand work'; the elements operate as a
continuum. The importance of the different elements
continually shifts, and varies with each person. I
use the term 'procedures in art' to cover any action
taken, or intentionally or unintentionally avoided,
in order to proceed in a desired direction or manner.
In the context of work in art, the action taken or
avoided may be concerned with: idea, subject,
evaluation, judgement, preparation, materials, tools,
equipment, techniques, furniture, location for
activities, timing and psychological orientation.
The categories are not exclusive nor the list definit-
ive. Some of these will be given little attention
because the teacher will feel his pupils already
understand the alternatives. This may or may not be
the case: furniture, for instance, may be seen to be
concerned with physical convenience but it could be a
contributory factor in another sense. Paul Klee
(1914) said to a student who was sitting, drawing a
model:

> "stand up (while drawing), you will then
> get more movement into your work."

Any of the factors I have mentioned could be very
important, but it is obvious that the logistics of
teaching prevent the teacher from dealing adequately
with many of these in any one session.

All meaningful directives and suggestions which an
art teacher may give to a group of pupils, will
relate to certain artists' procedures and conflict
with others. For children as with artists, there is
probably no directive for work in art which is
appropriate for all individuals in a group. For those
children in a group for whom a particular procedure
is inappropriate problems arise which can be
described as follows. The child believes that what
the teacher has asked him to do is reasonable, because
the teacher has expertise in art and in teaching.
Therefore, not being able to work in that particular
context means the failure is in him. Failure is a
potent obstructor of motivation and curiosity. Most
people carry all through adult life a sense of failure
in making and perceiving art.

> "Sometimes I see it then paint it, other
> times I paint it and then I see it, both
> are impure situations, and I prefer
> neither."

This statement by Johns (1975), illustrates a concept
central to art: there are an infinite number of
procedures for experience, but there are no rules.
Work in art concerns the realm of the unknown, rules
can only lead us to that of which we are aware.
Procedures are arrived at by intuition, the repetition
of which is working to rule and negates art.
Different procedures are useful for different people
or in different circumstances. There are no
procedural decisions for work in art which are
indispensable. And there is more controversy and
bewilderment about art amongst those who are
experienced in the field than children are led to
believe.

So far I have proposed that in the light of the
infinite number of variables of procedures for work
in art in any one lesson a proportion of children in a
group will develop inhibitions. Art teachers appear to
understand the problems of teaching groups of children
and therefore concentrate mainly upon giving children
individual attention. Talking with individual pupils
can help them to evaluate their work, give them
confidence and realise challenge. I would question
the assumption which some teachers take for granted.

This is the notion that art teachers can know the most
fruitful direction for an individual pupil's work. It
is assumed that from looking at work in progress and
perhaps talking with the pupil, a teacher knows the
most fruitful direction for that particular pupil.
All a perceptive teacher is able to deduce is something
of the attitude the pupil has adopted. Knowing what
might prove to be a fruitful direction for him, is in
the realm of clairvoyance. Bachelard (1971) has said:

> "I've long suspected that in the subtle
> aspects of voice and gesture one could
> see the underlying nature of the person."

Often it is not in the general concept of a pupil's
work that quality is seen, but in small areas which
might be overlooked if the teacher did not respond to
them. The problem of narrowness of approaches to art
can be concealed by a 'child-centred philosophy'. It
may shield the teacher from examining the restrictive
notions he may have, indeed a child-centred
philosophy may make any study of procedures in art
appear to be irrelevant. It could be a question of
the ignorant leading the blind. Art Education is
dominated by teachers who prescribe ways of working in
art, goals for art work and concepts of art as if they
were sacrosanct: as if they were essential for art
and for art education. In fact they are essential for
neither.

I have tried to build a case for disqualifying any
adopted or invented directive for art work in
Secondary School I believe that only on this basis
can we begin to construct a framework that will not
conflict with our understanding of art and the place
it should occupy in the curriculum. Because there
are no agreed procedures in art, there has been a
strong tendency to project misconceptions about art
and education. Manifestations of the tacit under-
standing that there are no rules for art work, are
seen in the conceptually woolly programmes for art
education which now operate, and the reluctance of
some teachers to expose children to the abundance of
research in art, evident in artists' work. And some
teachers will be rather casual in their teaching: a
'play safe' ploy. Of course procedures cannot be
avoided. If a teacher starts 'blank', he must have

some idea of what he is going to do, in a purely
physical sense. Teachers always employ procedures
for involving pupils in art. If a teacher believes
in not having a procedure, it's on this theoretical
base that he formulates his procedure. Some of the
things children may be learning from art activities
in schools could be:

1) A painting made in 1½ hours is better than one
 made in ½ hour.

2) The more parts there are to a painting the better
 the painting.

3) The more patience shown and physical care taken
 with a work, the better the work.

4) The quality of a drawing or painting from a model
 is relative to the extent to which it resembles the
 model, and proportion is a question of measurement.

5) Appreciating art is a talent.

6) The art teacher is an expert on all matters
 concerning art.

These come close to popular views of art. For each
of these, we could imagine a range of art which might
be inaccessible to children holding that view.
Without the teacher's and learner's awareness that
procedures for work in art are idiosyncratic, we are
destined to confuse the learner, and revealing what
we do not know contributes to avoiding dogmatism. I
believe there is a correlation between the extent to
which a person desires that ho uses clear procedures
and the extent to which he projects restrictive dogmas.
Procedures carry with them concepts of art, how we see
ourselves and the world. Restrictive notions about
art will be a barrier, inhibiting access to much of
the art in museums and galleries, restrictive notions
about man will alienate people from each other.
People have difficulty in appreciating works of art
when they attempt to marry them to inappropriate
procedures, hence the comment about some works "that's
rubbish". All procedures in art are at the same time
an aid and a straightjacket: on the one hand helping
pupils give shape to their ideas and on the other,

restricting their vision - a positive contains a
negative. It is therefore important for art teachers
to recognise restrictive procedures and plan a
programme to give a balanced view of art.

Morris (1974) has said:

> "Subconscious drives and intuitive
> methods are not a sound enough basis for
> art education. Intuition does not
> always lead us in the desired direction."

The reason for designing a structure for Art
Education is in order that those insights which we
regard as essential in art are not neglected and
controversial questions are seen as such. An
important factor would be that the structure should
not take initiative in teaching away from the teacher.

The description of a structure can be precise and at
the same time prescriptive only in a limited sense,
for instance: the description of a triangle would be
i t s reference to the number of sides and angles the
structure should contain. It is totally free with
regard to scale and proportions. A triangle may sit
in the palm of your hand or it may contain the
universe. It may have a side almost touching the
opposite angle, therefore it would be like a rod with
points at each end, or it could have a spacious
interior. The structure for Art Education which I
propose, takes account of the following assumptions:

1) There are many conflicting procedures in art.

2) The various procedures in art are not equally
 appropriate vehicles for all students' involvement
 in art and the teacher has no means of matching
 procedures to students.

3) Students should be introduced to different
 procedures: it is educationally desirable
 for these to be made explicit.

4) Knowledge about work in art is context-bound and
 judgement in art is essentially subjective.

In principle what I am about to propose, should form

an important part of a programme for art education.
If students are to understand that any given procedure
is not a sacred rule, the structure would have as an
intention the demonstration of this principle. The
kind of structure I have in mind would bring two
lessons or projects together, one following the other,
and with its own distinctive and conflicting procedures:
together these would make a 'unit of study'. The
principle is not new, art teachers to a greater or
lesser extent do something like this now. For instance
sometimes when drawing from a model, the teacher gives
pupils half-an-hour to make a drawing. Afterwards, he
would ask the pupils to make another drawing but this
time only three minutes are allowed and the teacher
might say: "You have a very short time; don't worry
about details, draw the main shapes". It is likely
that the teacher is directing the group in order to
orientate the pupils to the model in different ways.
In my terms, the structure is loose: instead of
clearly seeing that there are two opposing concepts
here, the three minute drawing is understood as a
'sketch' and the other a 'finished' drawing. In the
second drawing no doubt, many would have been trying
to 'complete' it as far as they could in the short
time available. For many in the group, the lesson has
fostered the popular dogma about the rough 'incomplete'
and the carefully 'completed' work. These concepts
are not helpful to them, they are useless as points
of reference in art appreciation and they do not
indicate useful criteria for directing their energies
in future art work including evaluation. In what ways
might this be different?

I do not wish to prescribe a method of teaching, the
examples are intended to elucidate principles.
Considering the drawing exercise, the principle
underpinning the structure for a positive and liberal
art education would operate as follows: for each part
of the study the concept would be made clear and
other factors which may interfere with the pupils'
understanding of the question would be avoided. In
this case one concept should not be seen as easier to
grasp, and, most important, <u>nor a less legitimate
pursuit in art</u>. Therefore in this instance, perhaps
there should be no discrimination in the time allowed
for each drawing. Clarifying the attitudes would be
essential if pupils are to understand that art is

idiosyncratic. This is best done by using reference
material from those who have worked with these
attitudes. For example: Raphael and Bomberg drawings
would be suitable for contrasting analytical drawing,
which calls for careful construction, with Gestalt
attitudes which seem to call for a process of change
and refinement. Immersion in the ideas would be aided
by statements by artists, critics and historians.
Bomberg talks about the "wholeness of form" and
"attitude of the model", about "gesture and movement".
Bomberg admired and learned from Matisse who has also
written about his own attitude and described his
methods of working.

A teacher will need to overcome the problem of pupils
trying to provide "what the teacher wants", - this
phenomenon is sometimes called "anticipatory
reaction".

("Anticipatory reaction" refers to the practice of
predicting the reaction of another person and to acting
in the light of the prediction: usually to gain
approval.)

Art is an area where judgements are in essence
subjective, therefore, if pupils reject their own
sensibilities and attempt to take on the teacher's
view, they will be exercising superficiality and
undermining self-esteem. It is essential that the
teacher's 'taste' does not cloud the pupil's
imagination, undermining his intellectual and
personal integrity. In order that the teacher's
'taste' does not interfere with the pupil's personal
ways of working it would be helpful if the teacher
identified the authorities who have pursued approaches
being explored and gives the pupils, for discussion,
the unedited quotations. A 'unit of study' would
consist of a procedure in the form of a project,
followed by another conflicting procedure in the form
of a project: the two elements would be discussed as
a whole.

In art there are conflicting procedures of many kinds.
In portrait painting Francis Bacon does not want the
'sitter' to be present while he is working, he prefers
to use photographs. Clashing with this attitude, and

for different reasons, Walter Sickert and Frank
Auerbach had the 'sitter' in front of them, in their
respective studios. They have spoken about their
ideas and their paintings are available to elucidate
their concepts and their individual personalities.

Comparing Henry Moore and Reg Butler we find conflict
of a different kind. Moore (1979) said:

> "I often worked direct on a piece of
> stone or wood, a random shape found in
> a stonemason's yard, or a log of wood
> which was a natural shape. I'd make a
> sculpture trying to get as big a
> sculpture out of that bit of material
> as I could."

In removing as little material as possible, Moore is
making fullest use of the 'natural shape'; he is
using his ingenuity to impose on the form of the
resulting work as little as possible of himself.

In contrast, Reg Butler (1979) said:

> "I want to possess the material. So
> when I wanted a flat sheet of metal, I
> would weld a great number of strips
> together, and when I wanted a circle I
> would take a strip and heat and hammer
> it bending it on an anvil."

The juxtaposition of these attitudes highlights the
different relationships of man to objects (the
exterior world). In one instance, respecting its
character, in the other, making it fit the artist's
idea. This is my personal interpretation: I give it
to indicate the possible significance of procedures.

I have argued earlier that all works of art have
correspondence with a tradition. It is also my view
that all attitudes to art to which pupils are intro-
duced are related to attitudes which artists have
adopted and developed. With regard to the attitudes
of Moore and Butler, there would be no need to be
restricted to three dimensional work: the principle
which Moore demonstrates, the acceptance of something

which already exists, can operate for example, by
changing a printed photograph with paint and/or
collage. As always, the teacher's ideas in 'setting-
up' and organising projects appropriate for his
pupils, continues to be an essential qualitative
factor in lessons.

After the pupils have worked with procedures in two
separate projects, they will have two works or sets
of work to evaluate with the related procedures. It
is understood that the teacher's judgement about
procedures is not called for. The teacher would be
quite impartial, i.e. he should not impose his
preference for Moore's concept of creative work, nor
argue from Butler's position. The teacher's aim
would be to encourage pupils' awareness of the level
of interest and degree of searching which the
different procedures precipitate. This will help them
to develop their own sense of values.

Authorities other than the teachers' and the
procedures being in conflict with each other, will
help to foster respect and trust between pupils and
the teacher, in an open relationship. No doubt there
will be as much controversy amongst the pupils as
there is amongst artists and critics about what is
valuable in art and which works demonstrate these
values most clearly. The students' growing reservoir
of contextual knowledge of procedures in art, none of
which were deemed essential, would encourage intuiting,
curiosity and personal inquiry with a sense of
adventure. Fostering these attitudes is the challenge
of Art Education.

REFERENCES

Auerbach, F. (1977). Interviewed by C. Lampert,
 Frank Auerbach. Arts Council of Great Britain
 (1978).
Bachelard, J. (1971). The Poetics of Reverie.
 Beacon Press.
Butler, R. (1979). Interviewed by B. Robertson.
 Artists in Great Britain. Open University BBC radio.
Gordon, R. (1970). A very private world, in
 D. Sheehan. The Nature of Imagery. Academic Press.

Heron, P. (1978). Patrick Heron Painting.
 Unpublished lecture. Institute of Education,
 University of London.
Hockney, D. (1976). Hockney on Hockney. Thames and
 Hudson.
Hoyland, J. (1979). Six Days in September. B.B.C.
 film.
Johns, J. (1975). interviewed by D. Sylvester.
 Jasper John's Drawings. Arts Council of Great
 Britain.
Klee, P. (1914). The Thinking Eye. Lund Humphries.
Matisse, H. (1942). in J.D. Flan, (1978). Matisse
 on Art. E.P. Dutton.
Moore, H. (1979). Henry Moore. B.B.C. radio.
Morris, B. (1974). New horizons and lost horizons:
 the role of feeling, in J.B. Annand (1977).
 Education for Self Discovery. Hodder and
 Stoughton.
Osborne, H. (1970). The Art of Appreciation.
 Oxford University Press.
Oxlade, R. (1977). David Bomberg. Royal College of
 Art.
Reid, L.A. (1980). The intrinsic value of the arts
 in the education of children, in Journal of the
 National Society for Art Education. Vol. No. VII.
Spencer, S. (1926). Unpublished letter to Desmond
 Chute. Stanley Spencer Gallery, Cookham-on-Thames,
 Berkshire.
Sylvester, D. (1975). Interviews with Francis Bacon.
 Thames and Hudson.

Aesthetic Development in Dance

SARAH RUBIDGE

To speak of aesthetic development in dance implies
that there is a condition of aesthetic maturity which
can be identified as a continuum of growth in aesthetic
understanding, and that aesthetic maturity in dance is
distinct from aesthetic maturity in, say, the visual
arts, or literature, or music. In this paper I will
try to identify the "aesthetic behaviours" unique to
dance, and to examine the notion that there is a
growth of aesthetic understanding which can be
monitored. The term dance can be used in three ways:

As danc<u>ing</u>: the act of purposively organising
patterns of movement in time and space
with the intent of giving form to the
impulse which motivated the act.
Dance-like activities which are
spontaneous 'reflex' reactions to events
in the physical and/or emotional
environment can be said to be dancing
only in a metaphorical sense, (e.g.
dancing with rage, for joy, with excite-
ment).

As <u>a</u> dance: a specific instance of an act of dancing
performed by an individual or individuals,
either for themselves or for an audience,
which has intrinsic significance and/or
aesthetic value. Such an act may be
improvised or previously choreographed.

As <u>The</u> Dance: the generic term under which are subsumed
such categories of dance as ritual dance,

theatre dance, social dance, therapeutic
dancing, choreography, performance, etc.
Each of these categories is part of the
concept of dance, but none is paradigm-
atic of The Dance itself.

It is also important in any discussion that the
participants identify the functions or purposes of
the dance with which they are specifically concerned.
Many functions have been attributed to the dance.
They range from its social function, which is
designed to enable people to engage in some form of
communion with each other through dancing (e.g. folk
dancing, ballroom dancing, disco dancing, etc.) to
its therapeutic value, created by the opportunities
inherent in dancing to expel emotional tension
(cathartic) or to objectify emotions in symbolic form,
thus rendering them susceptible to conscious analysis.
Dance can be seen as an instrument of communication,
its content, social, personal, political 'messages'
articulated in the expressive form; it may be used as
a method of perpetuating socio-cultural attitudes,
behaviours or beliefs; as a means of influencing the
behaviours or thinking of individuals and groups; or
as a vehicle through which one might protest against
a society or culture. It might have a pragmatic value,
or it might be 'impractical', having little relation
to the 'real' world; it might function as a means of
altering consciousness, directly or indirectly; it
might serve to initiate a process of self-extension in
an individual, or to confirm their current self-image
or self-concept. Any or all these functions may be
present in the various categories of dance, although
it is more likely that only a small number of needs
can be satisfied in any one form.

As this paper has been written within a specific con-
text, one in which a consideration of the arts is
paramount, I intend to take Contemporary Dance in the
West as my paradigm. I have chosen to concentrate on
Contemporary Dance specifically because, due to its
emphasis on individual expression, it is able to ful-
fil many of the needs (psychological, social and
transcendentory) which I have identified above. It is
also possible to identify several styles within
Contemporary Dance which are distinguishable in terms
of intention, physical characteristics and presentation.

However, we must also recognise that dance as an art
form is not specifically concerned with fulfilling
these functions, with the practice of skills in social
interaction, with self-realisation, with cognitive,
affective or emotional development. It is an aesthetic
activity whose primary function is to encapsulate,
embody and manifest a deeply felt impulse in a dancer
and/or choreographer, thus giving that impulse
expressive form. The emphasis on the aesthetic nature
of the activity does not deny that the benefits
described above can accrue through engagement in the
activity for,

> "A dancer cannot create and continue
> creating, and remain at a standstill
> from an individual growth point of
> view; the dancer cannot work with
> others in composing a dance and remain
> insensitive to good group relations ..."
> (Sheets, 1979.)

neither can s/he move and develop dance skills without
confirming and reaffirming their identity. But it is
through the aesthetic nature of the activity that such
developments take place. In the context of this
discussion such benefits are implied even when not
explicitly stated.

If we accept that aesthetic development may occur in
one art form, but does not necessarily take place in
another simply because of this, we imply that the mode
of expression in each art form has distinct
characteristics, that each has a unique 'language'
which must be learned if the meanings inherent in the
expressive forms are to be apprehended. In that each
art form uses a different medium in order to fulfil
essentially the same purpose it would seem reasonable
to suppose that it is in this area that the 'language'
is sited. In Contemporary Dance defined thus, the
'language' lies in the patterns of movement: the
meanings and significances of the dance are communic-
ated through this particular medium.

It is often maintained that the language of dance is
universal. The rationale behind this belief seeming
to be that, because the instrument of expression is
the human body and every human being, regardless of

cultural or racial origin has such an instrument, then
the language of dance must be a shared language in the
most fundamental sense. 'Movement', it is said, 'speaks
for itself'. This implies that translation and inter-
pretation are not only unnecessary but also spurious.
However, I would like to suggest that the language of
dance is not universal, that various forms of dance
even within the same culture and tradition (especially
our own with its emphasis on individual expression)
employ different languages which must be 'learned' if
their significances are to be understood.

In dance the vehicle of communication is movement, and
movement is inherently expressive. To accept this
however, is not necessarily to accept that the
expressive contents of the movements are understood
by all who perceive them. The misapprehension that
'inherent expressiveness' in dance movements is
synonymous with a one to one correspondence between
movements and meaning is a common one and seems to be
founded in a failure to recognise logical differences
between 'functional expressive movement forms' and
'aesthetic expressive movement forms'. In the first
category one might include spontaneous gestures,
postural configurations and facial expressions, which
betray our attitudes and reactions to phenomena and
events in the lived environment. Such movement tends
to be beyond the conscious control of the individual,
and might contain stereotyped responses which were
once authentic but which have now become habitual.
It also includes those gestures which have acquired
fixed meanings in a culture. (E.g. the handshake,
nodding, pointing, etc.) Such gestures communicate
specific meanings to those familiar with that
'language'.

'Aesthetic expressive movement forms' however,
although designed to be vehicles of communication,
are an entirely different kind of language form. They
too are 'inherently expressive', but of subtle
sensations, of inner feelings, of un-named and perhaps
un-nameable impulses. They are deliberately formed,
according to implicit and explicit structural
principles, and are the result of reflective responses
to encounters with the environment rather than
instinctive reactions to it. It is in this sense
that aesthetic forms are logically different from

<u>functional</u> forms. It is true that the latter might
comprise the fundamental movement material from which
the dance is formed, but this does not necessarily
make them dance movements in themselves. The
aesthetic form transforms the significance of its
model, and endows it with new meanings and signifi-
cances, and with new and deeper implications.

From the above one might conclude that whilst
aesthetic forms might need their significance
'explained', functional forms can be universally
understood. I feel that this conclusion would be
erroneous, for the meanings and significances of
functional forms also have to be learned by the
perceiver, even though such learning takes place at
a very early age and is implicit rather than explicit.
Both functional and aesthetic categories are part of
the language of movement, and, in that they <u>are</u> part
of a language, share the fundamental characteristics
of any language, i.e. deep and surface structures of
meaning. The organising principles of these structures
in the language of movement must be understood, either
tacitly or consciously if the meanings inherent in the
expressive forms (e.g. gestures, sequences, etc) are
to be apprehended.

The deep structures of the language of dance lie in
the psycho-biological structures of the human
organism, more specifically in the complex inter-
actions between the muscular, skeletal and nervous
systems, cognitive structures and unique physical
characteristics of the body itself. The early funda-
mental responses to the environment are manifested
first in motor behaviour, which itself affects
ensuing responses, resulting in modifications and
refinements of the earlier movement patterns. Other
influences on movement patterns, and consequently on
perceptions of the world and the self, lie in the
cultural and social milieu in which the movements
occur. Such influences form the matrix which
determines the implicit meanings and significances of
movement patterns, the 'inherent expressiveness' of
which we have spoken. Different cultural and social
environments hold different attitudes to the world,
to inter-relationships with other people, to man,
which create different psychological orientations to
experience. This implies that the meanings and

significances inherent in movement are not necessarily
innate, but may be culturally determined. Any move-
ment form which generates from a culture contains
within it implicit significances which might not be
available to persons from different cultures. Such
significances are revealed in subtle qualitative and
spatial patterns which form the deep structures of
the language of movement, the inarticulable elements
which are barely susceptible to analysis, and which
form the premises upon which we base our interpretations
of the meaning of movement.

The surface structures of the language of dance are
easier to identify. They are the 'grosser' physical
characteristics of the movement patterns, (for
example, spatial characteristics, rhythmic structures,
dynamic quality and phrasing, choreographic principles,
'motifs', gestures, etc.). The form these patterns
take is obviously affected to some degree by their
underlying deep structures, especially in the choice
of elements which predominate in any one movement form
or style. Both personal and socio-cultural elements
conspire to guide a dancer or choreographer towards
certain selections, made from the range of material
available, and colour the surface of the language, or
style, formulated.

Surface structures in the Dance can be learned, their
meanings are relatively explicit. Deep structures
however can only be learned by immersing oneself in
the social or cultural milieu from which they were
generated until the implicit meanings and significances
which inform that culture's perception of the world
become part of the fabric of the understanding of the
individual himself.

If the meaning of the language of dance is to be
apprehended, certain organising principles, which
generate its underlying expressiveness, must be
learned. These principles are obviously different
from those contained in the 'languages' of other art
forms (e.g. of shape, or sound, volume and substance).
In dance the predominant perceptual mode is the
kinaesthetic, although the subsidiary modes of aural
and visual perception are also engaged. Development
of sensitivity in kinaesthetic perception enables
increasingly subtle meanings and significances to be

'intuited' in dances seen or performed. Such
intuition, which could be called 'informed intuition',
is the result of the integration of experience and
understanding accumulated by an individual during his
engagement in the Dance. An appropriate intuitive
apprehension of the meaning of a dance is the result
of an informed response to the dance.

We might at this point consider the notion of the
aesthetic response to dance forms. Here, as with the
other concepts I have examined, I shall forward a
clear definition in order to avoid confusions which
arise in discussions on the Dance. Aesthetic responses
to dance are those which react directly to the
aesthetic qualities of the movement patterns and whose
underlying attitude to the kinetic form is not pre-
dominately functional. Non-aesthetic responses to
the 'character' or mood of a piece, whilst neither
inappropriate, in certain circumstances, nor invalid,
are not 'pure' aesthetic responses, for they draw on
material which is extraneous to the form itself. The
insights and implications made available by such
responses are limited in their range by the associ-
ative imagination itself, and the life experience of
the individual, rather than by the expressive form.

The aesthetic response in dance comprises three
distinct facets, all of which must be employed if the
significance of the form is to be revealed to either
dancer or spectator. Reimer (1970) identifies these
facets (in relation to music) as the sensuous response,
a necessary but by no means sufficient condition of
aesthetic understanding, the perceptual response, and
the imaginal response. The sensuous response, without
which there could be no perception, might be crude and
generalised, an amorphous sensate disturbance which
might gratify some immediate personal requirement, or
it might be finely differentiated and perceptive,
tuned to detect the minute 'tremors' of feeling
responses in which lie the deeper significances of
the expressive form. The perceptual response is both
the perception of the aesthetic qualities of dance
(spatial and rhythmic structures, qualitative elements
of movement, their speed, use of space, tensions or
softness, release or containment of energy, etc) and
the reaction to the expressiveness of those qualities
or properties. One without the other cannot be

properly called aesthetic perception, for it is the
integration of perception-of and reaction-to which
endows it with its special character, and incidentally
absolves it of charges of emotionality or intellectual-
ity. The final facet of the aesthetic response in
dance is the imaginal response. As the art object is
only gradually revealed in the 'time-space' arts, the
spectator, and dancer in this case, must to some
extent follow the process of decision-making taken by
the choreographer in the making of the dance. S/he
must anticipate changes, inclusions, progressions,
reversals, etc., in the development of the movement
sequences, must 'choose' a line of development from
the many probabilities revealed by the events just
enacted, must continually 'imagine' new forms or
progressions in the kinetic line, and be prepared for
these lines not to be realised and for new possibili-
ties to be presented. The imaginal response is the
core of aesthetic perception in the temporal arts. For
its successful employment it must build on the
sensuous and perceptual responses which precede it.

Aesthetic maturity in dance then might be tentatively
described as the ability to percieve the uniquely
aesthetic qualities in a dance and to predict or
imagine possible lines of development in the kinetic
form from the clues made available by this perceptual
sensitivity. We must also include in our criteria the
ability to transcend the impressionistic (sensuous)
and associative responses evoked by the surface
qualities of the dance. Such an ability might be more
difficult to acquire in dance than it is in the other
arts for the instrument of its expression is the body
and its medium, human movement. Both the sensations
in the body and the kinetic forms themselves are
likely to evoke memories and associations with life
experience in an individual, and these may or may not
have a great deal to do with the expressive form which
generated them. I would suggest that aesthetic maturity
in dance might be recognised by the ability to
register these responses and then, with these as a
matrix, to attend to the aesthetic qualities which
reveal the 'sub-text', the delicate fluctuations of
the feeling life of the expressive form rather than
the emotional life of the choreographer.

The notion of aesthetic maturity in dance is however

further complicated by the fact that it displays itself
in three distinct realms of aesthetic behaviour,
namely those of the choreographer, of the dancer, and
of the spectator. Each engages in the dance in a
different capacity (although they may be one and the
same person) and thus each set of behaviours must be
considered separately if a clear understanding of
aesthetic maturity in dance is to emerge.

The aesthetic behaviour of the choreographer, in that
s/he is the creator of the expressive form, is
relatively easy to identify, for it is displayed in the
dances themselves. The choice of qualitative elements,
the manipulation of temporal and spatial structures,
the organisation of the kinetic material are all
evidence of the aesthetic behaviour of the chore-
ographer. The appropriateness of the movement forms
to the 'theme', the variety of materials used within
the limits imposed by the sensate impulse, the avoid-
ance of cliché or habitual patterns of movement and/
or interaction between dancers, all these aspects of
the art enable a (mature) observer to evaluate the
aesthetic maturity of the individual choreographer.
An immature choreographer will not include in his work
the range of possibilities inherent in mature works,
and will display more of his wares and meanings on its
surface, rather than imply that there are other
significances available should one wish to find them.
The presence of such implications can only be achieved
if a choreographer is familiar with a full range of
qualities and structural possibilities, and if s/he
is sensitive to the smallest tremor of sensation
engendered by the feeling impulse which motivated the
work.

The aesthetic behaviour of the performer is different
from that of the choreographer. (We will, for the
purposes of this discussion, differentiate between the
two whilst acknowledging that many choreographers
perform their own works.) The function of the
performer is not to create but to interpret the
expressive form which is the 'given' in dance. One
of the major pre-conditions of aesthetic maturity in
the performer then must be a high level of physical
skill in the particular style of moving demanded by
the choreographic form. Without this no performer
can interpret the expressive form with any degree of

success. (The physical skills of which I speak are
not necessarily those one normally associates with
'dancer', for not all dance styles demand the high
level of gymnastic skill which accompanies a dance
training, although such skills might prove to be help-
ful.) In addition to this the aesthetically mature
performer has the ability to perceive the relevance
of the qualities and movement patterns they are asked
to perform, and is aware of the significance of the
qualities and elements which have been <u>omitted</u> from
the dance, for meaning is contained as much in the
absence of elements as in their presence. S/he is
sensitive to implications inherent in the movement
patterns as well as to the overt meanings; is aware
of alternative lines of development in the kinetic
form, for the performance must imply that the choice
to follow a particular line <u>was</u> a choice; is committed
to performance of the movement itself, to serving the
demands of the choreographer. Personal expression
must be subsumed to the requirements of the dance form,
for if a performer once begins to display his or her
'self' in the dancing, the integrity of the movement
is lost and with it the real significance of the dance.
(Of course, if the dance form has been created to
display the dancer's self then the problem does not
arise.)

The spectator, like the performer, must be able to
perceive the aesthetic qualities of the dance, to
differentiate subtleties in quality and form, and to
react to their expressiveness. S/he must be able to
intuit the significance of the elements present in
the expressive form and the significance of the
omissions the choreographer has chosen to make. The
aesthetically mature spectator will be aware of the
existence of a vast range of elements and qualities
and will be an 'active participant' in the event itself.
The level of active participation (i.e. not just
<u>rec</u>eiving but <u>per</u>ceiving of the dance) to some extent
determines the depth of the aesthetic experience
engendered. The extent of the familiarity with the
materials of the Dance determines the extent of the
ability to transcend the associative/impressionistic
response and attain the insights contained in the
aesthetic response itself. The aesthetically mature
spectator must, then, be experienced in the dance, and
knowledgeable about the dance. Evidence of aesthetic

maturity in the spectator might be displayed in the
needs s/he sees as being satisfied through engagement
in the dance. The more 'meta-physical' those needs
are, the more divorced from personal concerns and
human problems, the more mature (aesthetically) the
spectator could be said to be. Such maturity can only
be achieved through engagement in the art of dance
itself, either in the role of dancer or spectator.

Aesthetic maturity in dance is evidenced by the
ability to perceive the inherent expressiveness of the
formal properties of dance, and the ability to trans-
cend the surface structures which might seduce the
dancer or spectator with their sensuousness and which
may mask the deeper significances inherent in the work.
These formal properties might be organised in such a
way as to encourage such seduction, by presenting
narratives, or themes relating to human emotional life
and relationships, or to interaction with the phenomenal
world. They might, however, also be presented 'naked',
designed not to tell a story, or to evoke emotional
responses, but to realise a barely felt sensate
disturbance which has no overt meaning, no 'human'
association, no mood or character apart from its own
expressiveness, but merely a manifestation of pure
energy, the fundamental energy which motivates man to
live, to breathe, to be-in-the-world. The aesthetically
immature might perhaps be tempted to impose some
meaning, or association with which s/he can identify,
upon the form, the aesthetically mature will be able
to receive the form, and will allow it to exert its
inherent power on his or her own feeling impulses, in
other words will accept it on its own terms.

Whilst it is tempting to plot a course of aesthetic
development in dance and possible to draw parallels
with stages of cognitive development, one must be wary
of using such a model as a basis for a programme
designed to facilitate the development of aesthetic
sensitivity in the art form. It may be true that
certain types of dance activity tend to succeed each
other as a child develops in and through the dance.
For instance, one of the first dance-like activities
one observes in children is a spontaneous, exuberant
movement response to encounters in the environment;
this tends to be followed by a desire to stylise the
movement patterns which express responses to events

in the physical and emotional environment, and to
situate them in coherent expressive forms (assuming
that a 'dance environment' is available to them).
Much later increasing pleasure is obtained from
engagement in dance activity in and for itself, rather
than as a means of expressing oneself in a personal
sense.

But development in aesthetic maturity is not
characterised by the nature of the predominant thematic
material used, or by the nature of the benefits seen
to accrue from engagement in dance as an aesthetic
activity (although one's attitude towards them
undoubtedly changes as one develops aesthetically).
It is characterised by the degree of refinement one
achieves in one's aesthetic responses to the material
of the dance, and in the nature of the insights one
gains. If engagement in dance begins at an age when
an individual has attained relatively high levels of
maturity in other spheres of human development the
notion of a chronological progression through the
'stages' may become redundant, for aesthetic maturity
can be achieved through processes more suited to the
levels of understanding, the modes of operation employed
by the mature human being.

We might conclude, then, that there are identifiable
behaviours which display aesthetic maturity in dance,
and that such behaviours can be developed through
engagement in dance as an aesthetic activity, either
as dancer, as choreographer, or as spectator. Amongst
these behaviours are the ability to reach beneath the
overt elements of a dance in order to perceive the
inherent expressiveness of the aesthetic qualities of
the dance form; the ability to appreciate and under-
stand the significances of works in the various styles
of dance, including ballet, which form the fabric of
the art form in our culture; and the ability to
transcend one's immediate personal needs and concerns
when interpreting the meaning of dance. Also,
aesthetic development may take place on several fronts
simultaneously (e.g. dancer, choreographer, spectator)
although not necessarily at equal rates in each sphere.
If aesthetic behaviours in dance can be identified it
would seem probable that development of such
behaviours could be facilitated through an educational
programme. Such a programme would need to take

account of the highly complex nature of aesthetic
development in dance, its potentially 'non-linear'
developmental patterns, the unpredictable variables
brought to bear on the developmental process by the
nature of the artistic process itself, and the
ultimate aim of individuals in their engagement in
the art, that is whether they wish to develop
predominately as a choreographer, as a performer or
as a spectator.

SELECTED BIBLIOGRAPHY

Banes, Sally. (1980). Terpsichore in Sneakers.
 Houghton Mifflin.
Blacking, John. (1973). How Musical is Man?
 University of Washington Press.
Bloom, B. et al., (1956). Taxonomy of Educational
 Objectives I Cognitive Domain. Longmans.
Bloom, B. et al., (1964). Taxonomy of Educational
 Objectives II Affective Domain. Longmans.
Brown, Jean, M. (1980). Visions of Modern Dance.
 Dance Books.
Brown, Jean, M. (1980). From 'Graham 1937' in Visions
 of Modern Dance. Dance Books.
Foster, Ruth. (1976). Knowing in my Bones. Black.
Harrow, Anita, J. (1972). Taxonomy of the Psychomotor
 Domain. David McKay.
Hulton, Peter, and Steve Paxton. (1975). The Small
 Dance. Dartington Theatre Papers.
Reimer, Bennett. (1970). The Philosophy of Music
 Education. Prentice-Hall.
Sheets, Maxine. (1979). The Phenomenology of Dance.
 Dance Books.
Steinberg, Cobbett. (Ed.) (1980). Interview with
 Merce Cunningham, The Dance Anthology. Plume Books.

Drama as Learning, as Art and as Aesthetic Experience

GAVIN M. BOLTON

A few months ago I met for just one drama lesson a
class of very bright 14 year old Manchester boys who,
when asked by me what they would like the drama to be
about, after some considerable deliberation, chose
'A city preparing for a nuclear holocaust'. Eagerly
they chose roles from a range of expertise: army
experts; scientists; doctors and city councillors.
In separate groups they discussed the task: 'From the
point of view of your expert knowledge list the
priorities you intend to put later to a joint meeting'.
They tackled this task energetically and with some
imagination, one or two groups improvising charts and
diagrams in order effectively to communicate the
points they wanted to make. The joint meeting,
(chaired by the 'city councillors' whose main concern
was to build shelters on the cheap!) raised issues to
do with such matters as the number of minutes between
the warning signal and the nuclear blast: the depth
of the shelters and the best material for building
them; and the effect of radiation on animal, plant
and human life. It was in connection with the latter
that the 'doctors' observed it would be necessary to
furnish each shelter with a supply of suicide pills
so that (to use the doctors' own words) "they could
be offered by the respective families to those family
members who were still alive but too mutilated to be
looked after". This piece of horror did not stand
out as I have singled it out here; it was just dropped
in among a list of requirements for a first-aid kit.
The discussion achieved a level of liveliness,
purposefulness and articulateness that can be expected

from a group of intelligent, well-informed and highly
motivated young people.

This anecdote may worry those of you who are
interested in the arts because however valid it may
seem to have been as an educational exercise, it does
not fit your conception of an art form. Its purpose
seems to be a clarification of issues, some real and
some hypothetical, related to the objective world of
events and objects. It required the pupils to draw
on prior knowledge and to apply it through rational
discourse to the logistics of a problem. In other
words, dramatic role-play was being used to stimulate
a high degree of focussed attention at that imaginative
and intellectual level necessary for most good
subject-learning. You may feel, as Witkin (1974) does,
that this should not be regarded as drama. He writes:
"The role play becomes the central exercise for many
drama teachers. There is no doubt that drama has a
lot to contribute to role simulation and furthermore
that role simulation is one important form of drama.
It is not synonymous with drama, however, and a great
many of the role-play situations improvised in drama
sessions in schools have nothing whatever to do with
drama although there is no doubt they are a good
basis for practical sociology" (p. 92). My own view
is that, limited as this learning experience may be
in terms of an art form, it would be perverse for a
drama teacher to exclude it on these grounds. It
does, after all, give practice in the skill that is
basic to all kinds of acting, which is: an ability to
engage with something outside oneself using an 'as if'
mental set to activate, sustain or intensify that
engagement. I am using the word 'engagement' as a
central feature because it implies a relationship at
an affective level between a person and the world
outside him. The dramatic 'as if' modes implies
release from contingencies of the present into the
logical rules of a hypothetical present. These two
characteristics combined suggest a mental activity
that is both dynamic and rational. Such a description
is not far away from Warnock's (1977) view of
imagination:

> "For the imagination is the power to see
> possibilities beyond the immediate; to

perceive and feel the boundlessness of
what is before one, the intricacies of
a problem, the complications or
subtleties of something previously
scarcely noticed. To work at something
to begin to find it interesting, this
is to begin to let the imagination
play on it. To begin to see it
stretching out into unexplored paths,
whose ends are not in sight." (p. 155)

One way of activating the imagination is to use the
dramatic mode. It is a pity that all teachers do not
recognise this. But we are discussing drama teachers
and although I have given strong support to the notion
of using this dynamic, rational activity towards
intellectual ends, as in the Manchester pupils'
illustration where they were required to make
propositional statements about the world of facts, I
also acknowledge (as Witkin suggests) that this is to
deny drama as an art form.

Let us now look at the second half of the Manchester
lesson. The discussion finished with an air of self-
satisfaction among the pupils - they had displayed
considerable competence in sustaining their 'expert'
roles, in engaging in rigorous debate and in bringing
some sense of order to their understanding of the
subject matter. I suddenly switched roles and
addressed them as if I were a charge-nurse of an
institution for people 'mutilated' by radiation and
they were the patients. The shock of the switch and
their awareness of what demands were now going to be
made on them was almost too much for some of them.
They giggled in embarrassment. But these mature boys
only needed a little help from me to regain their
concentration. The result was spell-binding. When I
as nurse started to 'feed' one of them with a spoon,
first carefully placing a bib under his chin and
somewhat patronisingly complimenting him on how well
he was managing today as I removed some 'gravy' from
the side of his mouth, most individuals could be
observed adjusting to the situation. By the time I
role-played a journalist trying to get an inside story
on that day five years ago when Manchester had been
within 50 miles of a nuclear disaster, they responded

with a poignancy that, remarkable in itself, was
further enhanced by the memory of the recent demon-
stration of their natural debating skills, which they
now sensitively held in abeyance. They stammered out
their words, failing to make sense, trying with their
eyes to say what their lips could not formulate.
They were no longer the decision makers; they were the
passive victims.

So what is happening here? The basic skill has not
of course changed. What has changed is their
perspective on the subject matter. One could describe
it as 'experiencing' as opposed to making observations;
they were 'within' the subject matter rather than
outside it; they were involved in 'knowing this'
instead of 'knowing that'; their understanding
remained implicit rather than propositionally explicit;
they were speaking from their guts rather than from
their minds. Are they then just as concerned with
'something outside themselves'? Yes indeed they are
identifying with a cripple in an institution. The
direction of the engagement is the same - it is, to
use Dewey's (1958) phrase "an active and alert commerce
with the world", (p. 19) but I would suggest that the
quality of investment has changed. They can no
longer rely solely on their prior knowledge of a
factual kind and on their verbal skill. To be
effective they may have to recall feeling memories
and motor memories and to acknowledge, adapt and submit
to the rules of the new context. Although there was
engagement with the material when they were 'experts',
their very form of discursive expression simul-
taneously detached them from that engagement. This
notion of submission to the experience suggests a
more personal and more sustained attachment. What is
the nature of the learning? This is difficult to
answer because if we are prepared to recognise any
learning at all it is not the kind that educationists
are used to talking about. Fleming (1981) in a thesis
on drama and education in his chapter on Drama and
Learning points out that to acknowledge this kind of
dramatic activity as having learning potential we have
to accept that "Not all learning is necessarily
preceded by attempts to learn". He quoted from
Dunlop (1977) "The passive side of learning is itself
highly important since a great deal of what is ever

learnt is unspecifiable and hence has to be picked up
or acquired at a less than fully conscious level".
(P. 246) This brings us to an important feature of
dramatic activity in relation to learning. It seems
that if learning at this experiential level is to take
place the participants must be both passive in the
sense of holding in abeyance any intention to learn,
and active in the sense of focussing attention on
creating an 'as if' context. In the Manchester
illustration the teacher also had a hand in focussing
attention by deliberately imposing a structure.
Indeed I unashamedly manipulated the situation so that
learning might take place. But I could not be specific
in terms of what was to be learnt - my intervention
changed the mode of experiencing and thinking, an act
of faith that the switch from the pupils' being out-
side the subject matter to inside it had some kind of
learning potential. The nature of the learning
process is akin to one's attention being engaged by a
poem. It is to do with experiencing the poem rather
than learning about it. It is perhaps not unlike the
experience of interacting with another person - coming
to know another in a way that requires a degree of
personal investment. In neither case could one
define precisely what one had learnt.

I am convinced that dramatic activity used for
personal knowledge of this kind is educationally
significant and is consequently more central to my
work than the drama for intellectual stimulation
described earlier. But does this particular usage
also deny drama as an art form? Given that one
accepts the educational potency then one might answer,
"who cares?"

Well this conference cares. And it may be that you do
not really want to hear about this kind of dramatic
activity for it may not fit in at all with a develop-
mental theory of aesthetic education you have in mind.
For here I am spelling out a usage that is directly
concerned with understanding the objective world, its
facts and its values, a function which when placed
against, for example, music as an example of the arts,
makes it very difficult for one to conceive of arts
subjects as one discipline.

I think if I am pressed into answering the question
was this example of a drama lesson also an example of
drama as an art form, I have to say no. The
experience was no more than an episode of dramatic
playing with sufficient sophistication of structure
and poignancy of subject matter to guarantee an
engagement by the pupils of some depth and
concentration. I do not want to undervalue the
experience in any way but to say that it was an
instance of dramatic art would be to give the
impression that the art form is something that can be
created by a few deft strokes of teacher-structuring
and an obliging commitment on the part of the class.
Let me reiterate however that the basic skill of
drama as I have described it also applies to the
participants in an art form, so that although we may
not want to give even the second half of the
Manchester drama lesson that superior label, at least
we can recognise that the kind of personal engagement
required was dispositionally right for a dramatic art
experience. If we had the opportunity to develop the
'nuclear disaster' work we would have found that a
great deal of the psychological spade-work had been
done.

But drama as an art, although incipiently present in
the Manchester episode is on a different plane of
experience to do with consciousness of form. However
let us leave the psychological perspective and switch
to drama as a product. Let us look at 'the thing
created'. Some of you may have been expecting me to
say that drama does not operate as an art form until
there is an audience. This is not the case. Most
drama in schools in this country is enacted without
an audience in mind. The history of drama in
education had polarised between the two camps, between
what was called 'creative' or 'child' drama and
'performance', the teachers of the former camp
stressing the importance of play, free expression,
sensitivity, spontaneity and social health; the
latter teachers stressing acting skills and theatre
crafts. It seems to me that these factions, in
emphasising differences at a rather peripheral or
surface level of skills, are failing to recognise the
common ground between them. Indeed I would like to
argue that most drama teachers of whatever persuasion

are at a fundamental level using the same dramatic
form. The 'clay' of drama is the same for the
teacher, the pupil, the playwright, the director and
the actor. It's just that they handle it differently.
Regrettably we do not train our teachers to know the
basic feel of that clay and yet this is what they
should be passing on to their pupils - the essence of
dramatic form.

The principal elements of dramatic form are focus,
symbolisation and tension. I will briefly consider
each in turn. Focus is the particularisation of a
theme or topic. Themes and topics are abstract ideas.
Drama is concrete action operating in time and space.
For the action to occur in the here and now focussing
has to go through two stages: (a) the selection of an
angle (in the Manchester drama lesson the topic was
nuclear holocaust - it was focussed down to
anticipations of the 'experts' and the experience of
the 'mutilated') and (b) the selection of a moment in
time and/or a particular action (for example the
'experts' beginning their meeting with the 'city
councillors'; and the 'charge nurse' placing a bib
under the chin of one of the invalids). Dramatic
action is a particular instance of a more general idea.
The test of focussing is whether the instance conveys
the meaning intended by the idea.

Which brings us to symbolisation. I am well aware of
the dangers of using the word symbol at all. I do
not want to be trapped by the academic discussions
that have been pursued in the name of clarification.
I am using the term here in a special way. By
symbolisation I am referring to a process whereby
certain actions or objects accrue meanings for the
audience or for the participants (in a non-performance
mode) during the playing out of the drama, a process
of evolution of meanings rather than 'given' meanings.
The action of putting a bib under a man's chin is
evocative. Pupils sensitive to such meanings in
drama could build on this so that the bib becomes a
symbol of helplessness, humiliation, subservience,
loss of individuality or a symbol of institutional
life. A drama could proceed that centres round a
patient's attempt to refuse the bib. Thus, the
original focus initially acknowledged as an adequate

concrete instance of hospitalisation gains in
significance because of its symbolic potential. A
playwright is of course also concerned with the
selection of evocative images through language as
well as through objects and actions. "Put out the
light, and then put out the light" whispers Othello.
And we, the audience, see Desdemona asleep in her bed,
a symbol of her refuge, her innocence, her sexuality,
her trust and her vulnerability and we yield to a
sense of inevitability as we witness a candle snuffed
out.

Tension is the third essential element of drama which
at its crudest is displayed as conflict between
protagonists. At its most fundamental it is a tension
between virtual and actual time and between virtual
and actual space. Langer (1953) identifies tension
between the present and the future, a present loaded
with "commitments and consequences". O'Neill (1978)
noted the tension in the rhythmic rise and fall of a
scene or episode. A group of Durham School of
Education's Drama Diploma students (1981) recently
published a hand-out for inexperienced drama teachers
which classified fourteen different kinds of tension.
Such tension, however, must be integral to the drama
itself. There was certainly tension in the Manchester
exercise but it had more to do with the psychological
tension related to the reaction to the subject-matter
and to the responsibility of creating the difficult
'patient' role than to anything inherent within the
fiction.

I now would like to suggest that for dramatic action
to qualify as an art form not only should these three
basic elements of focus, tension and symbolisation
inhere within the form, there should also be a
consciousness on the part of the group that a form is
being created. It seems there should be two kinds of
significance involved: (a) the participants must be
engaged by the subject-matter (b) there must be a
sense of responsibility towards the form itself. It
is not enough for individuals to be conscious of the
'form' of their acting for the basic elements of
focus, symbolisation and tension are related to group
product. It is not enough for a teacher, fully alert
to formal significance, to structure the dramatic

experience so that the pupils are caught unawares in
a dramatic form: when I worked recently with a class
of six year old children on the theme of a wicked
witch, I consciously used all three elements to give
them an exciting experience. But the responsibility
was mine. This latter is a fairly typical example of
certain contemporary drama teaching with young child-
ren (Bolton, 1979) where the teacher-in-role is using
the very clay of the art form in order to promote
engagement and learning. In my view this can be fine
education but not art. That, (with some qualification
I shall make later) is how I also see the Manchester
drama lesson.

You must be thinking that I am spending an
unconscionable amount of time on something that turns
out to be not an art form! There are two reasons for
this. One is that dramatic method is potentially so
educationally rich that experience falling short of
art can still be hugely beneficial. And secondly,
linked with the first, it is possible that pupils even
at secondary level may not acquire the necessary
skills to create a group artistic product and yet
still have a worthwhile course. Some teachers, in
directing their pupils in productions of classical or
contemporary scripts, delude themselves into thinking
their pupils are necessarily experiencing the art
form. Unless the pupils are consciously manipulating
focus, symbolisation and tension in their interpret-
ation of the playwright, they will merely be puppets
operating within the teacher's sense of theatre.
Teacher and pupils may mistakenly conclude that
practice in acting to an audience leads to insight
into the essential nature of the dramatic clay. There
are exciting ways of handling the performance mode so
that pupils gain that insight, but emphasis on the
acting techniques required of naturalistic theatre,
still so popular in schools, often inhibits progress.

But how then do pupils develop an understanding of
the art form so that they might achieve it? There
are one or two clues to the answer in what I have
already described. I pointed out that in the second
half of the Manchester experience the degree and
quality of personal investment with the subject-
matter was dispositionally appropriate. Certainly

children need to have practice in engaging themselves
in this uninhibited way throughout their schooling.
But this in itself does not account for development
of insight into dramatic form.

It is here I have to rely on the term 'aesthetic'. I
am using it to mean 'a sense of form'. Now I have
already made the point that a good teacher of young
children working in drama will be conscious of form
and will be harnessing focus/tension/symbolisation to
that end. The children are experiencing their drama
within a formal structure. Their concentration is on
substance (the drama is about a wicked witch) but
their aesthetic sense may help them to feel in their
bones that somehow the incident is heightened,
sharpened, condensed etc. Although the latter part of
the Manchester lesson could not justify the term art
form, it was nevertheless an aesthetic experience. I
am suggesting therefore that children can 'absorb'
form. Gradually, as and when they are ready, some
aspects may be made explicit, so that they consciously
inject, say, the tension of contrast into their work.
They can learn it is form that makes the simple action
significant. This is the nature of aesthetic under-
standing. In the past teachers have often misdirected
their pupils' attention towards climax to a story or a
surprise ending to a plot, confusing form and outer
shape.

The conscious creation of an art form is a sophisti-
cated group responsibility that requires tacit or
explicit agreement on choice of focus, injection of
tension, and sensitivity to shared meanings that may
resonate from the continual focus on a particular
object or action or language image. We want children
to acquire those very skills previously used by their
teacher on their behalf. This is what C.S.E. or G.C.E.
Drama Courses should be about so that within both the
dramatic playing and the performing mode of drama,
pupils, in engaging with the content, also work with
a sense of form to create a dramatic experience.

Within the context of this conference however, I
suspect that what I have said lies somewhat uneasily.
It is true that the notion of 'aesthetic' sense may
be the common link among all the arts, but I cannot

yet find a place in my theory and practice of drama
education, for the arts as 'education of the senses',
as 'self-expression', or for "gaining access to the
drama each carries within him" (Ross 1978). All
these are present to some extent but I prefer to heed
Murdoch's (1970) warning against subjectivity:

> "The chief enemy of excellence (in art)
> is personal fantasy: the tissue of self-
> aggrandizing and consoling wishes and
> dreams which prevents one from seeing
> what is there outside one."

It is this emphasis on the world outside that provides
the logical connection between the different forms of
drama work in school. At its most profound, through
the art form, our deepest levels may be touched as we
engage with what is outside ourselves.

REFERENCES

Bolton, Gavin. (1979). Towards a Theory of Drama in
Education. Longman.
Dewey, John. (1958). Art as Experience. Capricorn
Books, New York.
Dunlop, F. (1977). Human nature, learning and
ideology in British Journal of Educational Studies,
Vol. XXV, No. 3, October 1977.
Durham University School of Education Diploma
Students (1981). Tension in Newcastle Drama, 3,
Winter 1980/81.
Fleming, Michael. (1981). Ph.d. thesis in progress,
University of Durham.
Langer, Susanne. (1953). Feeling and Form.
Routledge.
Murdoch, Iris. (1970). The Sovereignty of Good.
Routledge.
O'Neill, Cecilie. (1978). Drama and the Web of Form.
M.A.(Ed.) Dissertation, University of Durham.
Ross, Malcolm. (1978). The Creative Arts. Heinemann.
Warnock, Mary. (1977). Schools of Thought. Faber.
Witkin, Robert. (1974). Intelligence of Feeling.
Heinemann.

Postscript to Gavin Bolton

MALCOLM ROSS

Gavin Bolton's lecture provokes a personal response
from me, not least because it closes with a reference
to my own work and with the expression of his partial
if not extensive disagreement with my (and perhaps the
conference's) main concerns. The issue revolves about
the centrality, in drama in education, of the related
ideas of drama as expression and art-form, Gavin pro-
posing a much wider range of functions for drama in
education than I would wish to endorse. Indeed he
seems ready to settle for any learning, any educational
outcome that genuinely benefits the pupil - rather than
the concentration upon, and (in his estimation) likely
failure of, purely aesthetic outcomes. On the
contrary, I would wish to see an exclusive commitment
to the aesthetic (though 'failure' wouldn't satisfy
me in this endeavour any more than 'success' on other
counts would be acceptable compensation). In my view,
the aesthetic is the only necessary as it is an
entirely sufficient objective for any form of arts
education, drama included, and if drama has,
traditionally been unable or unwilling to admit this
over-riding obligation, then that might be one reason
behind the persistent problems of drama education.

After some discussion with drama teachers on the course
I persuaded a small group to work with me in a
practical situation. As the work developed other
drama teachers watched and commented - and, together
with a handful of casual by-standers, formed the
audience for the brief closing presentation. Apart
from my dissatisfaction with non-arts outcomes (e.g.
drama informing the mind, changing attitudes, building

self-confidence, etc.) I have the greatest misgivings
of the kind of activity Gavin describes at the
beginning of his lecture. I find the selection of
the 'holocaust' situation unhappily typical of much
work in drama, with its catastrophic dimensions and
potential for engendering strong emotion (and I don't
accept that the theme is somehow made legitimate by
the fact that children chose it). Gavin's account -
illustrated by action during the lecture - of his own
role also left me feeling uneasy, not least because
of the powerfully 'suggestive' quality of his presence
and actions. Every such manipulative act takes away
something of the child's freedom and responsibility
for his own actions: too many drama teachers I feel
are too ready to jump into role to heighten the
tension, thereby running the same risk as the art
teacher who takes his brush to the child's painting.
But there are other dangers also - not least, the
flooding of the situation with emotion at the expense
of feeling (a distinction that Professor Reid touches
on in his paper in this volume). Drama in education
is, as Gavin's example well illustrated, very prone
to teacher intervention of this kind. I feel drama
in education is often too dominated by concern with
themes and topics to the neglect of medium control;
is too extravagant and excitable, often on account of
some commitment by the drama teacher to giving the
children a good (i.e. a 'hot') time in every single
drama lesson. Above all, is too all-embracing and
undifferentiated, too undiscriminating and indis-
criminate of the technical as well as the psychological
issues handled. Drama in my view needs to be much
cooler, and the work much more respectful of the
intensely complex nature of the medium. It needs to
move more slowly and more temperately. For example,
large group work (the normal school drama set-up)
seems to me to be virtually impossible in most school
situations - except at the most superficial and so
educationally pointless level.

To revert to the exercise. My guiding principle was
to keep the medium firmly in the forefront of the
mind, and not to allow reactive expression to obtrude;
to play up the need for abstraction (in line with
Witkin's definition of expression), detachment,
disinterredness, objectivity, control - while at the
same time making it possible for all concerned to _feel_

their way towards the emergent dramatic form. I am,
of course, mainly concerned here, as Gavin was, with
drama-making and although I wasn't working with
children I have no doubt in my own mind that the
technique adopted, if sensibly adapted, would apply
equally as well to youngsters as to adults. This
means that as teacher my task would be mainly to help
the participants see what was happening and what might
happen dramatically when they had missed it themselves,
and to reveal the possibilities of solving the dramatic
problems that the work had thrown up. What I am always
concerned to do no matter where I start from (impro-
visation or text) is to realise a dramatic form (i.e.
an artistic image). Which makes considerable demands
upon any teacher's sense of and feeling for drama.
But I insist, the drama is enough: for dramatic art as
a way of knowing needs neither exegesis nor para-
phrase.

Three people constitute a good working group in drama.
The essential constituents are the actor(s) and
observer(s). The observer can, as circumstances
require, figure much more as director. In our case
we had an observer and two actors. When I work with
a large class in a hall I establish as many such groups
as are necessary to account for everyone - and each
'company' has its own playing area. During the course
of this piece of work (conducted in three one-hour
sessions, perforce on different sites) the partici-
pants continuously exchanged roles: the observer
becoming actor, actor becoming observer, male acting
female, female acting male, etc., etc., - thus rudely
unseating all inherent tendencies to appropriation
and fixation.

I suggested two possible ways of starting: either by
simply 'doodling' (the actors move - silently - in
relation to each other in space) or by taking a text
(6 lines from Dr Faustus). The group opted for the
doodle and the two actors (male and female)
began unprepared exploratory moves with the third
member (female) observing. The walking about was
occasionally stopped (at the suggestion of one of the
group) and 'interesting' shapes or sequences noted and
repeated. I watched and listened and helped them
select what turned out to be the 'holding form' for
the rest of the day's work. This was a simple

encounter situation in which the girl moved towards
the man who prepared to embrace her only to find her
walk on 'through' the embrace. The event occurred
fortuitously and was selected from much else on the
grounds of both actors and observer sensed its
dramatic quality and possibilities. It lacked context
and left masses of questions to be answered but it <u>was</u>
a dramatic feeling-form. The movement was worked on -
especially the moment of contact - and it became more
complex in form and feeling. With complexity came
more acute technical problems of a choreographic kind.
That was the end of the first session. The group felt
animated, involved, happy and ready for the next
stage.

It was decided that the second session should attempt
to draw upon the improvised action in an inter-
pretation of the scene where Mephistophiles presents
Helen to Faustus "Was this the face that launched a
thousand ships ...". At first the text was simply
'laid over' the previously formed action - but there
followed modification of the original encounter as
the meaning of the lines and their significance in
the play as a whole were discussed. Everything was
felt to turn on the idea of Helen as dead (and given
over to Faustus's <u>use</u>) and his wonderment and desire
threatened by dread and apprehension at her approach.
(Would he have known that intercourse with the dead
meant damnation, or appreciated the irony of "Her lips
sucks for my soul"? The original audience certainly
would). The tension of the encounter already
uncovered in the improvisation and fixed in the
holding-form became the basis for the work on the
text. At the end of this session there was some
feeling of frustration and even sadness - the group
didn't know if they'd be able to go on working (lack
of time) and were dissatisfied with the form achieved
as an expression of the feelings aroused. This seemed
a very powerful endorsement of the group's involvement
in the creative, formative process: an adequate
realisation was beyond their reach at that moment and
hence the disappointment felt.

In the event a third session (which included a
presentation to an ad hoc audience) proved possible
and the work was taken up afresh. The crucial
decision now was to cast the piece (no more swapping

of roles) and give the observer licence to direct.
At once the image making gathered momentum and a
fluent and satisfactory sequence evolved. The lines
were spoken partly by the actor playing Faustus and, as
more of Marlowe's scene was drawn into the action,
partly by the director. (This, apparently, did not
disturb the audience). The session ended with every-
one feeling relatively satisfied and, once again,
happy, though aware that there was much work that
might still be done. However, enough had been
accomplished to get over the character of this way of
working (one, presumably, pretty familiar in the
theatre).

Many drama teachers take their lessons and inspiration
from the theatre (the writings of Brook or Grotowski
for example) rather than from educational sources -
and with drama in education in such difficulties
they'd probably be right to go on doing so. It's
certainly high time the wrangle between theatre and
drama was wound up. Drama in education is a doomed
mutant unless it can draw life from theatre (I don't
of course simply mean 'from going to the theatre').
In the work described above we preferred engagement
with the medium to talk about themes and issues; we
felt our way towards dramatic form rather than into
our own emotions, or towards each other as 'real'
people; the formative decisions were taken by the
formers and performers themselves with the assistance
of someone able to report on the image making from
the outside; we raised a number of questions and
problems specific to the medium and to its control,
rather than extraneous to the undertaking as art; we
tested the work as an artefact against the perceptions
and sensibilities of others and realised it as a live
(and hence transitory) image for which we only had
partial responsibility. Above all we staked our work
on the inherent, inexhaustible and sufficient
interest of the dramatic problem.

SECTION IV

Educational Issues

Introduction

The four papers in this last section open up some of
the wider issues of arts education and in particular
touch upon the problem of identifying what counts.
James Hemming considers the range of educative
experiences necessary for the differentiation and
refinement of the emotions, taking into account con-
trasting styles of feeling, and the importance of a
friendly, purposeful school ethos. He deplores the
neglect of feeling in secondary education which
emphasises the academic at the expense of the
affective to the particular detriment of the adolescent.

David Farnell, himself an art teacher, asks why so
many adults and so many children insist they are not
artists. What conception of art encourages such an
admission; more particularly what experience of art
education leaves so many so dissatisfied?

Len Jenkinson writes as a painter and as a teacher.
He is concerned at the way schools undervalue the
aesthetic response - which he defines as the
perception of objects "as subjects realised from
within". He examines the principle of signification
in perception and his own impulse to make art, and
concludes that the experience of art is not to be
reasoned with - it is to be 'recognised'.

Karen Moloney sees the urgent need for more effective
assessment techniques in arts education. In
reviewing current practice she exposes a number of
shortcomings. Her preference for the 'subjective'
principle of assessment in the arts gives rise to a

series of proposals which would increase the
reliability of group judgements based upon what she
calls "esoteric impressions". She concludes her
paper with an analysis of the elements of aesthetic
experience which might form the basis of an assess-
ment procedure.

Emotional Development in Adolescence

JAMES HEMMING

INTRODUCTION

Life is a continuous transaction (interaction)
between the individual and the environment. Feeling
is one component of this interaction. The emotions
generated may be crude, unintelligent and generalised -
like despising foreigners - or refined and different-
iated as in pleasure from listening to Mozart.
Feeling is, therefore, essentially educable. One set
of experiences may leave emotions untutored and
primitive whereas other sorts of experience can lead
to emotional maturity. What I shall be considering
in this paper is the types of experience within
secondary education that nourish positive emotional
growth, by which I mean emotions that are life-
enhancing. I shall be concerned only indirectly with
the control of negative emotions - anger, fear,
jealousy and the like. Emotional control, I suggest,
is the outcome of mature, confident emotionality,
derived from formative experience, not of a deliberate
denial of impulse. That we grow as human beings by
repressing emotions, rather than by using them, is the
illusion of prudery.

NEGLECT OF EMOTIONAL EDUCATION

When considering emotional education, we find ourselves
in a rather untilled region. Educators have always
been nervous of feeling. Even the word 'emotion' is
avoided in prescriptions for the education of
adolescents. Thus, the 1944 Education Act refers to
'spiritual, moral, mental and physical development'

as the proper aims of education. No sign there of a
lively concern for emotional development. The 1977
working paper of Her Majesty's Inspectors,
Curriculum 11-16, shows an expansion of the 1944
perspective but still fails to be specific about
emotional growth. This document names eight areas of
study - the aesthetic and creative, the ethical, the
linguistic, the mathematical, the physical, the
scientific, the social and political, and the
spiritual. A great deal of emotional education can be
incorporated within that scenario but the word
'emotional' is absent. So also is 'practical', a
related omission because positive feeling and effective
doing are dimensions of each other. Later educational
pronouncements, such as Framework for the School
Curriculum (1980) and The School Curriculum (1981) are
also coy about references to 'emotional' although the
latter document does reach the point of stating:
'Subjects like art, music and drama are needed to
develop sensibilities without which the pupil will not
be able to avail himself of many opportunities for
enriching his personal experience.' So far so good,
but this statement is inconsistent with the generally
conformist approach of The School Curriculum.

Why the reluctance to deal with emotional education in
our secondary schools? Three reasons can be
postulated:

1) Emotions in general are seen as unpredictable and
 explosive in operation and are, accordingly, held
 to be best kept out of school life. As Ian Suttie
 emphasised (1935) there is a taboo on tenderness
 operating in our society.

2) The drive of secondary schools is primarily for
 academic attainment compared with which emotional
 education is regarded as an expendable frill.

3) A central source of emotional vitality among
 adolescents is their sexual awakening. Schools
 tend to find this embarrassing and would rather
 ignore it than use it in building the fabric of
 education. It is notable that, whereas a good deal
 of basic sex education is now going on in primary
 and middle schools, many secondary schools switch
 off when faced with issues of sexual feeling.

ADOLESCENTS' NEED FOR EMOTIONAL EDUCATION

After that preamble, I would now like to consider
emotional education during adolescence as an essential
dimension of the complete educational process, seen
not as any sort of inculcation but as the development
of potentialities and the encouragement of growth.
Two points for a start:

1) Adolescence is a period of emotional exuberance.
 Feelings become more intensive and more extensive.
 The range of expanded feeling includes personal
 relationships, social concern, aesthetic awareness,
 a sharpened sense of justice, and spiritual
 yearning. It is also a period of mood swings.
 The girl who said, "Everything is so wonderful I
 could burst", and another girl who announced, "I
 hate everybody and everything", could well have
 been the same girl at different times of a single
 day. Boys have their mood swings too, but are
 often more secretive about them. Of course, all
 people oscillate between ecstasy and despair, but
 adolescents seem to have a particularly wide and
 volatile range of response.

2) My second point is that feeling is the engine of
 human effectiveness. The presentation of Homo
 Logicus as coolly going about his affairs and
 skilfully penetrating the darkness of the unknown
 with razor-sharp intellect is a travesty of
 reality. The good scientist is a good scientist
 because he feels passionately about discovering
 the truth of things; the engineer is enlivened by
 an exciting sense of exploration as he tries first
 one, then another, solution to the structural
 problems facing him; the composer or artist
 agonizes over his work, and the creative writer, as
 somebody said of Shakespeare, 'dips his pen into
 his own heart'.

Education's task, then, is obvious. It is to mobil-
ise the emergent feelings of adolescents in the
service of their own growth towards the attainment of
concerned, involved, effective maturity. As Herbert
Read (1943) pointed out long ago, the best sort of
personal growth follows the mobilisation of the whole

psyche. Traditional education does not achieve that
owing to its obsession with the intellectual and the
academic. This is not only an educational failure
which has to be remedied; it is also one source of
the crisis of motivation that is hitting secondary
education. The hearts of the young are not in it.
Too much schooling is emotionally dead and also -
which comes to much the same thing - aesthetically
inert.

A propos of this, we can observe how eagerly young
people rush from the emotionally dead environment of
school to experiences that are more emotionally alive.
The world of pop music with its pace, colours, sounds,
human contact and psychodelics is so alluring to the
young because it gives pent-up and neglected emotions
an outlet. We may contrast the sight of adolescents
sitting in rows poring over mathematics, or taking
down history notes, with the labile, overt emotionality
of the disco. The task of a modern education is to
get those twain to meet in the process of helping
young people grow up. What modifications of tradit-
ional secondary education are involved?

THE REFINEMENT OF EMOTION

It will be useful, I think, at the start, to make a
first brief digression into brain physiology; the
second will come later. Seen physiologically,
education is about refining and differentiating the
basic systems of brain functioning so that the
individual has at his, or her, disposal an instrument
well tuned to deal with the persistent and varying
challenges of life. That is not a reductionist
statement. The personality is not only the brain in
operation, but the brain is indisputably the
instrument of personality. A ballet dancer operates
through, among other things, a precisely programmed
cerebellum, an educated motor cortex, and a superbly
trained body. All mature human functioning is a
combination of a potentiality and the educated means
to the expression of that potentiality.

Thus, when people speak of a person of refined
intellect they are talking about an individual whose
basic energies of mind, and capacities of brain, have

been nourished and exercised until they operate with
precision and finesse in dealing with the challenges
of the environment. Similarly with the emotions.
Witkin (1974) has written The Intelligence of Feeling.
The title is apt. Feeling, like any other of the
energies of the mind, starts as a sort of explosive
response to stimulation. This is generated in that
extraordinary system of neural functions deep within
the brain known as the limbic area. The output is
then formed into subtle patterns by the operations of
the cortex which render raw all-or-nothing reactions
into finely-tuned, appropriate responses. It is, for
example, the alchemy of cortical refinement that
transforms lust into love, or converts the mere
perception of nature's loveliness into an ecstasy of
delight. What this means is that we have to educate
the neural instruments of appreciation and response
if they are to function at a mature level and that
such education occurs - as does all education -
through the right sort of educative encounter which
transmutes contact into enriching experience.

THE NEED TO TRANSFORM THE SECONDARY SYSTEM

Whether, then, we start with the nature of adolescents,
or with brain physiology, we are inexorably led to
the conclusion that the traditional secondary system -
many schools are notable exceptions - is ill-devised
to assure emotional growth during adolescence. The
system is designed to hammer away, period after period,
day after day, week after week, year after year, at
developing intellectual ability, leaving emotional
education meanwhile largely to chance. This is
doubly damaging. It runs the risk of leaving the
emotions entirely uneducated, producing, all too often,
'clever' people whose emotions are a source of
apprehension and retreat rather than delight and
fulfilment. It also damages the intellectual
functions themselves because, as many leading
innovators have pointed out, great discoveries are
not made by the process of logic alone. The Newtons
and Einsteins do not just think; they also feel and
imagine their way towards the truth. Any study of
greatness clearly shows how the highest human effect-
iveness manifests a powerful amalgamation of thought
and feeling.

If, then, emotional growth is to receive its proper
share in educational provision, we have to transform
the secondary system. What we have to ensure is that
secondary education provides a stimulus and exper-
ience for emotional growth comparable to what is
already assiduously provided for intellectual growth.
It is a matter of providing an educational milieu in
which feelings are constantly aroused, differentiated,
exchanged, and developed. How is this transformation
achieved?

Let us start with the basic issue of what sort of
habitat a school is. We have a large number of
attractive, well-cared-for schools in this country;
we also have many schools that are ugly and some of
them, in addition, battered and squalid. The quality
of the physical environment mirrors the educational
values of those in charge. One can visit colourful,
attractive, vividly alive schools amid the drabness
of inner city areas, or one may find dreadfully flat
and uninspiring swot-shops in opulent districts.
Faced with ugliness or deadness, the only possibility
for the sensibilities of the adolescent mind is to
shut off. This inhibits emotional development except,
perhaps, for increasing the capacity to hate. The
educational importance of a lively and attractive
school environment is frequently ignored.

THE SHARPENING OF SENSIBILITIES

A second general, but very important point, is that
an emotional content - a stimulus to the sharpening
of sensibilities - should be included in all subject
teaching. In essence, this means teaching everything
in the context of the human and the aesthetic. For
example, to teach physics as a parcel of facts and
processes is to neglect educational opportunities.
Great scientists led - lead - dedicated and inspiring
lives. A biographical component, accordingly, should
be included in all physics teaching. There is a
wealth of exciting material here. To take just one
familiar example, the great Faraday was launched on
his career when, as yet only a struggling apprentice,
a certain Mr Dance gave him tickets for a series of
lectures at the Royal Institution by the famous Sir
Humphry Davy. The youthful Faraday wrote up the

lectures in meticulous detail and sent them to Sir
Humphry who, a little later, invited Faraday to be
one of his personal assistants. Thus commenced,
unblessed by examinations, one of the greatest
scientific careers in history. Such real-life stories
enchant the young.

The aesthetics of physics are equally engaging.
Crystal structures are exquisite. The exploration of
light is radiant with colour. The whole of metallurgy
is encompassed in the structure and tuning of a
piano.

Studying the social impact of physics also has
correlates with emotional education. The element of
feeling that can be built into physics applies equally,
of course, to all other areas of study - including
mathematics. We cannot knock the life and loveliness
from learning and then expect young people to grow up
whole.

Another potentially powerful influence on emotional
growth during adolescence is the quality of social
relationships within the secondary schools. The
social influence on personality begins at birth.
Through very early mother-child relationships the
baby and, later, the infant learn to trust or distrust
life, to trust or distrust others, and to acquire, or
fail to acquire, a sense of self-value. An open,
joyful acceptance of self, others, and life permits
an easy emotional reciprocity in dealing with the
world. In such a climate, feelings can be freely
expressed and exchanged which is a main source of
healthy emotional growth.

What is true for early life is equally true for the
schools. Schools should be friendly, open, concerned,
purposeful establishments where there are plenty of
opportunities to express and share thoughts and
feelings and in which every individual learns to
accept and respect himself, or herself, In such an
environment the emotional side of young people will
be constantly exercised, fostered and differentiated.

At this point perhaps I may insert a personal note.
In my work I have to deal, from time to time, with
emotionally arid personalities and emotionally arid

relationships. A notable feature of all the
unfortunate people involved is an inability to share
feelings, often coupled with a resistance to accepting
feelings. These halting personalities are emotionally
stuck because, whereas they _suffer_ from their pent-up
feelings, they cannot find the road to release and
growth by exchanging them in human interaction. These
people are emotional illiterates. They are as
deplorable failures of the educational process as
verbal illiterates.

As a vital aspect of social development we also have
to take carefully into account the assiduous fostering
of self-confidence and self-respect throughout the
years of schooling.

Traditional secondary education is, unfortunately,
prone to generate failure in all but a minority of
academic high-fliers. Education that puts children
down drives them in on themselves and cuts them off
from emotional growth. This is because feelings draw
strength from both inner and outer reality. Isolation
is death to emotional growth. H.G. Wells wrote, "We
cannot see beauty through miserable eyes." Nor can
we see it through self-absorbed eyes. All finer
apprehensions are blunted by misery, rejection,
inferiority and egocentricity. The antidote to all
of these is heightened self-respect.

EMOTIONAL EDUCATION THROUGH ART AND ACTION

Obviously, too, if we are to give emotional growth
its proper weighting in education, the arts and crafts
should have a more vigorous life in all our secondary
schools than obtains, in general, at present. The
arts and crafts are vital means to a profound contact
with reality, to emotional expression and to the
enhancement of sensitivity. Too often, as things are
today, arts and crafts are still treated as less
significant options and their teachers as auxiliaries,
not to be compared, in educational status, with the
mathematicians, linguists or science specialists.
This is all desperately out of date. As Malcolm Ross
(1978) has shown, actually doing things - in painting,
music, movement, drama, design, craft or practical
skill, and sharing such expressive experiences - is

education of the highest order, not only emotional
in its content but total in its effects upon growth
and the comprehension of reality.

All creative work serves to develop and refine the
emotions, provided that it is genuinely creative and
not merely imitative. I cannot here go into the
subtleties of true creative experience except to say
that it has, it would seem, to be rooted in the
personality, and the dedication, of the individual,
and that it carries not only the satisfaction of self-
expression but also of communicating to others. The
artist of four, or four score, feels an inner glow of
achievement and fulfilment when he/she communicates
what he/she wants to communicate in the medium of his/
her choice; but the satisfaction is doubly splendid
if someone else responds to the message. A school
presents endless situations for expressive activities
and for the social appreciation of individual
expression. Some schools are radiant with the energy
and happiness that springs from this; others plod
laboriously along their academic paths apparently
unconscious of the world of experience they are
losing for themselves and denying to their pupils.

Fortunately the niggardly attitude to the arts in
education is beginning to give way to a clearer
understanding that active and expressive modes of
education are vital elements in the education of all
children, not only in the interests of their personal
development but as preparation for effective life as
workers and citizens. Consider this for example:

> "We believe that this imbalance (of
> education) is harmful to individuals,
> to industry, and to society. Individual
> satisfaction stems from doing a job well
> through the exercise of personal
> capability. Acquisition of this
> capability is inhibited by the present
> system of education which stresses the
> importance of analysis, criticism, and
> the acquisition of knowledge and
> generally neglects the formulation and
> solution of problems, doing, making and

organising; in fact, constructive and
creative activity of all sorts."

One might have supposed such a view emerged from some
esoteric conference of advanced educators. On the
contrary, it is from a statement promulgated by the
Royal Society of Arts and is signed by 130 national
leaders in industry, science, education, broadcasting
and the trade unions. Similar ideas were expressed
in the 'Manifesto for Change' which appeared in the
Times Educational Supplement in January, 1981, over
the signatures of men and women from the fields of
science, industry, politics, journalism, the arts,
the church and education. The appearance of such
documents suggests a widening public awareness that
the secondary system of education is seriously lagging
behind personal and social needs.

THE EDUCATION OF ADOLESCENT SEXUALITY

Another area in which the secondary system has a good
deal of catching up to do is in educating for sex,
love and marriage. The simple fact is that, if we
want to stay with the young, and to keep their
confidence in us, we have to accept adolescent
sexuality as a fact of their lives and to use the
curriculum, as appropriate, to develop insight about
sexual feelings. Unless deliberately bowdlerised,
sexual feeling comes naturally into history, English,
languages, R.E., art, music and other areas of
the curriculum. It also calls for its own allotment
of time as sex education and preparation for family
life. In this area a considerable gap still exists.
John Raven (1977) reports on an inquiry in which a
sample of boy and girl adolescents were given a
questionnaire containing 50 items and were asked which
'the school should do more of'. Sixty-four per cent
checked 'Help you understand the implications and
responsibilities of marriage.' In contrast, my own
inquiry (1980) into the experience of sixth form
education, as commented on by first year college
students, showed that 73% had received no guidance
with 'Family life' during their last two years at
school and 62% had received no help with 'sex
education'.

FEELING FOR MANKIND

Secondary education which is concerned with emotional
education has not only to try to move towards the
adolescent's feelingful life and to mobilise its
potentialities for furthering education and heighten-
ing motivation; it also has to aim to arouse and extend
feelings that are desirable in the context of the
modern world, but may be dormant if no approaches are
made to them. Ecological destruction, the injustices
imposed upon the third world, the squandering of world
resources and the conversion of the world into a vast
suicidal arsenal are all issues upon which young
people feel keenly once they have been offered an
informed perspective on the world as it is. I am not,
of course, talking about imposing propaganda upon the
young but about honestly conveying to them the
realities of man's present struggles. All education
directed to developing awareness about the current
problems and responsibilities of mankind is,
simultaneously, emotional education. The challenge of
the immediate provokes the structuring of attitudes
which are, by their very nature, amalgamations of
thought and feeling which stimulate discussion that
further develops thought and feeling.

BI-MODAL CONSCIOUSNESS

At this point I feel we should make another brief
essay into brain physiology. As you will be aware,
we have, during the past twenty-five years, greatly
extended our knowledge of the bi-modal character of
the human brain. Although, since Nature is a great
experimenter, one can never be sure of the precise
neural structure of any particular individual, we can
speak, with some precision, about typical left-
hemisphere and typical right-hemisphere functions.
The left-hemisphere mode of mind specialises in the
logical, the verbal, the analytic, the rational, the
itemised and the sequential. The right-hemisphere
mode has a bias towards intuition, spatial apprehen-
sion, synthesis, patterns, wholes, and the simul-
taneous. (Blakeslee, 1980). The differentiated
expression of feeling also seems to be a role of the
right-hemisphere mode which, in general, manifests

itself as the creative mode. (Ornstein, 1977).

One has only to list the dominant attributes of the
two hemispheres to see that secondary education is
mainly devoted to the growth of the left-hemisphere
mode functions while those of the right-hemisphere
mode have been comparatively neglected. This has two
unfortunate consequences. On the one hand, as the
American neuro-surgeon, Dr. Joseph Bogen (1977) has
put it: "It means that the entire student body is
being educated lopsidedly." On the other, it follows
that pupils who are naturally right-hemisphere
dominants may find their secondary schools alien and
uncomfortable places that under-value their actual
powers while condemning them for failing in areas in
which they have neither aptitude nor aspiration.

The two styles of mind arising from our bi-modal
consciousness account for contrasting patterns of
feeling and response that were described by many
writers prior to the physiological discoveries that
confirmed them. William James wrote of the tough and
the tender minded; Pavlov said that humanity fell into
two main groups, the artists and the thinkers; Binet
described 'subjective' and 'objective' personalities;
Jung, introverts and extroverts and, more recently,
Liam Hudson (1966) referred to divergent and convergent
minds. Educationally our aim should be to accommodate
these differences, leading to the fully attuned mind
which responds appropriately to life situations as
they occur, a well-balanced mind, that is, which has
all its senses awake and educated, ready to interact
creatively and intelligently with the world in its
many aspects.

 THE EDUCATIVE ETHOS

It may seem that the proper education of adolescents'
emotional growth is so multifaceted that it is beyond
the capabilities of the schools. This is not so. It
only seems so because education in the past has been
dominated by the additive illusion. When something
has been found to be missing, the tendency has been to
squeeze periods covering it into the already over-
loaded curriculum. We are not concerned with this

sort of change today but with a qualitative change.
Whichever strand of education we are particularly
concerned with, the answer lies in the same solution:
the creation of a friendly, purposeful school ethos.
This environment should be rich, varied and stimul-
ating with plenty of opportunities for active involve-
ment, personal contribution, significant relationships
and expressive outlets. In such an educational
milieu children of different types, abilities and
aspirations can develop all their powers, capacities
and responses.

Schooling should be about self-discovery, the use of
the self in rewarding and creative activities, and
the discovery of relationships with others, with
society, with nature, with the world and with the
universe. We should no longer be primarily concerned,
in secondary education, with stringing subjects
together into various packages but with a quality and
breadth of experience which pervades the whole, and
which will lay the foundation for life-long education.
It is in such an educational environment that the
emotions have a proper chance to grow to maturity.

REFERENCES

Blakeslee, Thomas R. (1980). The Right Brain.
 Macmillan.
Bogen, Joseph E. (1977). in The Human Brain.
 (M.C. Wittrock, Ed.). Prentice-Hall.
Department of Education and Science. (1977).
 Curriculum 11-16.
Her Majesty's Stationery Office (1980). A Framework
 for the School Curriculum.
Her Majesty's Stationery Office (1981). The School
 Curriculum.
Hemming, James. (1980). The Betrayal of Youth.
 Marion Boyars.
Hudson, Liam. (1966). Contrary Imaginations.
 Methuen.
Ornstein, Robert. (1977). The Psychology of
 Consciousness. Harcourt Brace Jovanovich.
Raven, John. (1977). Education, Values and Society.
 H.K. Lewis.
Read, Herbert. (1943). Education Through Art.
 Faber and Faber.

Ross, Malcolm. (1978). The Creative Arts.
 Heinemann Educational.
Suttie, Ian. (1935). The Origins of Love and Hate.
 Kegan Paul.
Witkin, Robert W. (1974). The Intelligence of
 Feeling. Heinemann Educational.

Everyman – Artist

DAVID FARNELL

I wish to focus some attention for once not on
celebrities and stars, not on the narrow bit on the
good end of the normal curve of distribution, not on
the 'gifted', or 'talented', not on the school
soloists or scenery-painters, but on that great bulk
of people who live 'normal' lives. The ordinary man.
The man in the street. Among his numbers are those
who make up the national character: the dour, the
phlegmatic, the reserved; the readers of the big
newspapers; the anglers, footballers and darts
players - and more. I would be a fool not to include
the rioters, looters and skinhead gangs. They may
not be ordinary but they do occur in bulk. And they
too go through our schools and in far greater numbers
than our star scenery-painters.

The trouble is that the man I refer to does not
sound much like an artist. It is quite likely he
plays a bit of sport, but I would be amazed if he
wrote poetry, painted pictures, made pots or had
ballet lessons. If he did, he would more than likely
make sure none of his mates got to know about it. If
he were to put a title to his identity, I very much
doubt that it would be Artist.

I would like to take a close look at how identities
are formed - perceived and conceived - and to look at
the part arts educators might play in this process.
When I use the word Everyman, I really refer to the
ordinary man and woman; the man in the street: the
great mass of the people of this land. I include
myself in this group.

The word 'artist' is not clear, either. I do not refer
to those who are picked out for their special success
to furnish our galleries and to be studied by art
historians of the future. I mean quite simply a
person who counts among his regular activities the
practice of art - writing, picture-making, forming,
performing. The ordinary man - artist! Have we
grown to see that as a contradiction in terms?

It fascinates me that people cannot settle until they
have you appropriately labelled and pigeon-holed.
The opening gambit of sherry-mornings is frequently,
"And what do you do?" We like to sort each other out.
I am claiming to be first an ordinary man so, by
implication, I am also claiming the title Artist. I
feel therefore that I must explain my claim. However,
before I go into how I come to think of myself this
way, I must decide whether to be an artist is a 'good
thing'. David Jones in 'Art and Democracy'[1] writes:

> "Men are equal in the sense that they all
> are equally judged to be men because all
> behave as artist. Not in the sense in
> which we say 'that is a well-behaved cat'
> meaning that the creature has accommodated
> her cat behaviour to some behaviour
> convenient to ourselves, but, on the
> contrary, using the word to designate the
> behaviour which is hers by nature, and
> hers only.
>
> The more man behaves as artist and the more
> the artist in man determines the whole
> shape of his behaviour, so much the more
> is he Man."

To ask whether to be an artist is a good thing or not
is to ask whether man should exercise his determining
feature. Perhaps it is simpler to ask if man can
afford to <u>deny</u> the artist in him. David Jones (1973):

> "... Schemes and plans and trends within
> a civilization may achieve brilliant
> superficial results, but in the end there
> will be collapse just in so far as those
> schemes violate, or are forced to disregard,
> the kind of creature man is at his deepest

foundations - at his determining
foundations - the foundations in his
nature as the animal-who-is-the-artist.
To lose sight of this first equality
and differentiating quality is to
vitiate in the end all other possible
or desirable equalities and to make
them, in the end, barren and waste.
For instance, what shall it profit a
community of men if it gain the whole
world of political and economic and
social rights and equalities and loses
the 'habit of art'? It will be
instantly objected, and rightly objected,
that such a thing is impossible if this
'habit' is of man's nature, as it is
here claimed to be; nevertheless it is
dangerously possible up and down the
chart of what we call history for men
to be sadly crippled with respect to
this aboriginal equality, just as it is
possible for us as individuals to abuse
and forget and deaden our individual
natures as artists - or to have those
abuses and deaths inflicted upon us, often
by some 'good' scheme of an economic or
political or religious nature."

I had better temper my rash claim that I am an artist
and admit that my individual nature as an artist is
frequently abused, forgotten, and deadened and that I
often feel sadly crippled with respect to this
aboriginal equality. The claim I make for myself is
not grand. Nevertheless, I am making the claim.
However I believe that arts education in schools
manages to cause the great majority of people to make
the counter claim, "I'm no artist". If you have any
accord with David Jones's words, "I'm no artist" is
chilling.

I would like to look a little more deeply into the
matter of identity. By way of illustration, I have
been trying to guess how I came to label myself the
way I do. My first concept of me was as my father's
son. The son of a minister of a Free Church. I grew
up in the kind of genteel and pious poverty that had
all the hardships of that condition and none of the

kudos surrounding children of 'real' vicars. It is
difficult to decide whether the excruciating
embarrassment of seeing your father's name chalked up
outside the chapel, the conviction that going to the
pictures was sinful, the horror of gambling and beer,
were compensated for by other susceptibilities I
caught from the same source; a love of things natural,
an acknowledgement of the power of inspiration,
admiration for good health, and a love of cricket.
The first memory of self-awareness I have is as a
Farnell - my father's son.

At 11 I was bussed to Grammar School 5 miles away and
soon grew to see myself for the first time as a
Hoylander. The kids from Hoyland were rougher than
the kids from Grenoside and Ecclesfield, but not as
rough as the kids from Platts Common or Parson Cross.
I found myself in the 'A' stream and thus became a
Scholar - rather than a Scientist. We 'A' streamers
didn't concern ourselves with sciences, still less
with practical things. We did Latin. I was an Arts
person - definitely a Good Thing. At this stage I
discovered quite by accident that I was 'good at Art'.
Our Art teacher wrote to my father in reply to a
letter requesting his observations on my sister's work.
He added as an afterthought, "David, too, has a flair
for Art"! Of course, I knew I wasn't as clever as a
certain James Grainger, because he was asked to paint
school-play scenery and he could draw cartoons and all
the girls used to go up to him and say, "Ooh, Jim,
aren't you good at Art!" I can think of no other
occasion or cue or hint or confirmation at school
other than my art teacher's chance sentence, "David,
too, has a flair for Art," that so memorably
influenced my self-concept with regard to Art. Can
it be true that self-concepts are formed by such
chancy incidents? I believe it probably is so. What
a responsibility for teachers!

My parents eventually reluctantly accepted that I was
not going to become a missionary and with wistful
resignation approved my entry into the ranks of the
secular equivalent - the teaching profession. When
you pause to think about it, there are many simil-
arities between missionary work and teaching - the
ascetic life, the exposure to hostility and aggression,
the notion of crusade.

So I find myself now an adult who does not say of
himself, "I'm no artist". And if I do actually say,
"I am an artist", that does not suggest delusions of
grandeur.

In addition to the notion of identity, I have recently
become an amateur student of the devices we utilise
to measure ourselves off against the people around us.
Is this the legacy of our educational culture, I
wonder, or is it instinctive? I believe I am asked,
"What do you do?" at sherry mornings so that the
questioner can put himself and me into proper order.
We seem to like to place ourselves and others in rank
order under a whole range of headings: socio-economic,
intellectual, physical, and others.

In the world of some sporting competitions there is
only one champion. If Jimmy Connors falls in the
semi-finals of Wimbledon, he fails. Now I am quite
interested in sport and I cannot decide whether games
are 'symbolic of life itself' - the struggle to be
top - or whether, in contriving a symbolic light-
hearted struggle for supremacy, a game, we spare
ourselves the obligation to make life itself a battle.
I am quite sure it is not as simple as that. But the
sad fact is that schools, the nursery bed of life
itself, culturally strengthen the conviction in us all
that we must measure ourselves off against those
around us, often on a knock-out basis, on the model of
Wimbledon, in subservience to the notion of 'gifted-
ness', especially, it seems to me, in the Arts. What
a huge conspiracy we in schools are party to in order
to prevent most men saying, "I am an artist". A
situation of great danger. To paraphrase David Jones,
"The less man behaves as artist, and the less the
artist in man determines the whole shape of his
behaviour, so much less is he Man".

I am convinced that the organisation of Arts teaching
in secondary schools in general operates around the
notion of talent or giftedness. I recently attended
an Art Teachers' Day Conference. All but half an
hour of the day was devoted to such matters as Art
School selection, placement on B.A. courses, careers
in Art, the need to focus on useful art; illustration,
fashion, furniture, graphic design, etc, and by way of
finale, we received four old scholars who had made the

big time. I tried to work out the proportion of the
population that actually makes it in those terms and
the maths got too much for me when I got as far as 1
in 1,000. I am not claiming that we must not attend
to society's needs for professional artist-designers,
I am suggesting that they can cost us dearly. David
Jones (1973) again:

> "We are compelled not only to applaud
> victories, but to count casualties, and
> they are to be found littering the field
> as after any victory. We must count our
> dead and not pretend they are alive."

I do not want to labour the point too much about
schools thinking and operating competitively even in
the arts. But must competition be warfare - with
casualities littering the field?

I play cricket. I have been quite a good cricketer.
At the staff team level (which is pretty abysmal) I
expect and am expected to be outstandingly good
(frequently a rash expectation, I must add!). On the
other hand, at the other end of my scale, in ten years
in and out of Cambridgeshire's County Team I have
managed only to scratch together a few measly runs
here and there. At my club level, however, there is
an operationally satisfactory balance. I fit in. I
know my depth and gain great enjoyment wallowing about
in it. The competition is not much more than a stage
for the play. For a great deal too many people,
experience of the arts in schools fails to cause them
a satisfying enough confirmation of acceptable level.
It so often seems to me that the effective objective
of arts teaching is to isolate a star or two and in
doing so to force the vast majority of young people
to reject, deny and discredit art as a part of life.
People are quick to accept the confirmation of their
suspicions; "I'm hopeless at art". I speak of
children, but the end product of education is not the
child. All those children who deny themselves art at
school become men and women who believe they have
denied themselves art - probably for life. This is
a frightening thought for, as David Jones (1973) wrote
in 'Art and Democracy':

> "Art is the distinguishing dignity of

man and it is by art that he becomes
dignified, and 'democracy' means nothing,
or means only something bad, if it
misconceives the right of man to exercise
his distinctive function as man, i.e. as
artist, as culture-making animal. It
would seem that, ideally, the first and
abiding mark of democracy should be
awareness of, and anxiety for, the 'rights
of man' in this respect."

I have tried to show that we receive labels from those
around us but, perhaps more importantly, we give
ourselves labels. Where art is concerned, rather than
leave the space empty, we tend to utilise the
negative, incompatible, other version, "I am a non-
artist". These labels are on the sparsest of chance
evidence or cues. In some areas like games, for
instance, we seem happy to measure ourselves and
accept the level, perhaps with some regret, but
nevertheless with a substantial measure of
operational satisfaction. In other spheres the
opposite occurs. Art seems to me a prime example.
People who are not _in_ the Artists' Club make a
positive commitment to the Non-Artists' Club. Art is
for the gifted. Normal people are non-artists.

 "If the art of some man is abnormal, it
 is because most men have been made so sub-
 normal as to have no art to practise.
 No blame to them, it is the nature of
 our times, only it is well that this
 deprivation should be understood to be
 eccentric and not concentric in Man.
 We may be forced to accept the situation
 in the world of fact, but to accept it as
 normal is the final capitulation." (David
 Jones, 1973.)

If it is a distinguishing characteristic of Man to be
Man-the-Artist, then the schools must take some blame
if it is true that "most men have been made so sub-
normal as to have no art to practise." I shall not
spend long on an account of how schools by their very
organisation diminish the arts - circuses, option
schemes, titles (Leisure, Practicals, Design, etc.).
I believe Arts teachers so often fight the structures

of the school that even the best fighters have little
chance of victory. The pervasive teaching culture of
the schools that I know is still one of coercive
authoritarianism in uneasy liaison with a conditional
promise of employment. Children in general go to
their lessons for an hour or so in a week of teachers
who measure up somewhere between Brilliant and
Diabolical at a particular style of teaching. This
style is one which tries to harmonise a particular
personality posture, (one perhaps that constrains, or
one that entertains, or whatever) with an acceptable
explanation of why to get on with the work is best.
At this time - but not for long - the most common
explanations are "If you work you will get a job" and
"if you don't work, school will be a bit of a bind".

If the Arts teacher operates differently, he puts
himself outside the mainstream teaching culture of
the school. The Arts teacher - an outsider already -
has an uphill task to utilise his precious few moments
to establish a different order, a different basis for
action, an opportunity for children to be artists, and
an opportunity for the teacher to practise the art of
teaching. He operates in the teeth of the dominant
teaching culture of the school, even the very good
school. As schools are normally judged good or bad
by their position in the exam league table, one might
even say especially the 'very good' school.

How can these precious hours be best spent? We must
address this question particularly now as we watch
crumble the traditional inhibitor to school disorder -
that is, the promise, or even the hope, of employment.
Our colleagues whose traditional exhortation is "get
on with your work or you will end up on the dole" will
have to sell their subjects on a new ticket soon. I
hope Arts teachers do not employ this exhortation.

At a time when unemployment is close on 3 million, it
may sound mealy-mouthed to say that we must get away
from such notions as "the dignity of labour" and the
"shame of unemployment". I would certainly not take
kindly to hearing the Prime Minister saying this. I
would suggest, though, that there is something
fundamentally optimistic - and refreshing - about a
consideration of education not dominated by the world
of work.

I am aware that talk about the intrinsic dignity of
life without any consideration of the problems of
poverty can easily sound like so much theoretical/
'philosophical'/idealistic cant. A sort of 'let them
eat cake' response. There can be no doubt that
poverty has a great deal to do with inner city
problems and that the most obvious solution to
problems of poverty is employment. However, I am
with trepidation suggesting that we shall have to
find some solution to the problems of both poverty,
and the shame that accompanies joblessness, other than
full employment. At the moment I am doing no more
than acknowledge the problem and admit as a teacher
some responsibility for it. A person's job is
traditionally his public title or label ("What do you
do?"). But there will have to be other routes to a
personal identity of significance - and thereby to a
sense of fulfilment.

To talk of 3 million permanently unemployed may
blacken the heart. However, I am making the rash
assumption that an acceptable degree of wealth-
sharing is possible and that if that were to take
place, a life with much less work ought not to be an
appalling prospect.

Some circumstances elicit pessimism or optimism
according to the nature of the individual rather than
to the nature of the circumstances. Here is one of
my favourite paragraphs on education. You may find
it pessimistic. Some may even find it offensive. To
me it sounds challenging and very relevant to arts
education. R.S. Peters (1973) suggests that education shoul
be concerned with the moment, the sensation of living,
the quality of existence.

> "The quick reply to the question 'What
> is the aim of education?' must resemble
> the quick reply to the question 'What
> is the aim of life?', namely, 'It has
> not got one'. Our basic predicament in
> life is to learn to live with its
> ultimate pointlessness. We are mono-
> tonously reminded that education must
> be for life; so obviously the most
> important dimension of education is
> that in which we learn to come to terms

with the pointlessness of life."

I believe that paragraph does contain a profound truth
and that its implications for the curriculum -
particularly the arts curriculum - are to be faced.
Peters himself goes on to say later in his article:

> "Students should have the chance of
> acquiring a less instrumental, alienated
> attitude to work. Their curriculum
> should foster their imagination,
> sensitivities, critical powers, and
> social consciences, so that they begin
> to come to terms with the situation in
> which they are placed as human beings.
> They should, in other words, be encouraged
> even while at school, to convert mere
> living into a quality of life."

I know this is not new - but it's worth our attention
again - particularly the phrase - "even while at
school".

What on earth can schools do to show children how to
convert mere living into a quality of life? Is it
romantic to suggest that poverty and paradise are not
mutually exclusive? Henry Miller would claim that
wealth is not a precondition of happiness. Perhaps
he and his friends on Big Sur are romantics too.

Anyway, I mustn't get too carried away. Let's start
with what we have. We arts teachers have all the
nation's children for an hour or two a week between
11 and 14, and about a third of them for two years
more. We can turn this to some advantage. I asked
what schools can do to show children how to convert
mere living into a quality of life. I must ask now,
'What can teachers do to give school life itself
quality?' My simple description of the work of the
Arts teacher is just a short-hand form. The Arts
teacher can afford to devote all his time to the
quality of the children's actual experience in the
studio, to materials, to enabling young people to
seek, discover and confirm their selfs, to make sense
of their worlds, to describe their worlds and them-
selves, and to reveal their decisions about colour,
shape, line, space, sound, in fact, to balance meaning

and form.

Arts activities seem to me to be the natural
extension of the play of young children, which in
Winnicott's terms "expands into creative living and
into the whole cultural life of man".[3] This suggests
to me one vital route towards personal fulfilment.
Arts activities are not by any means the only route
to personal fulfilment. Winnicott again suggests:

> "We need to accept the fact that
> psychiatrically healthy persons depend
> for their health and for their personal
> fulfilment on loyalty to a delineated
> area of society, perhaps the local bowls
> club."

Other activities also have the power to renew. A
gardening article in The Sunday Times (1980) opened
this way:

> "It's perverse, really, to write about
> gardening at all. Half the point of
> gardening is that it repairs that part
> of your brain which words and thinking
> are constantly threatening to destroy.
> That's one thing it has in common with
> music: it lies beyond the reach of words,
> and you wouldn't need it if it didn't."

I am not suggesting blankly that gardening is Art,
but I am suggesting that gardening can share something
with the Arts - at best it commands a whole-being
cultural involvement - body, mind, soul - and as
such it can rank with forming and performing ... and
being loyal to the local bowls club. After all, it
is the nature of the involvement that makes an
activity cultural rather than the nature of the
activity.

I do not think I am digressing. I am attempting to
identify the conditions in which a person develops a
sense of identity and a notion of significance. I
believe it to be true that even gardening can have an
arts nature - but gardening's basic function is to
provide food. Its arts nature is a by-product. If
gardening were in the curriculum, it wouldn't be to

"repair parts of the brain". The loyalty a member
feels for his bowls club is no less a feeling in
it being for a bowls club - but the basic function of a
bowls club is to facilitate the playing of a game, not
to be a source of feelings. If bowling were in the
curriculum it wouldn't be to inculcate a sense of
loyalty. On the other hand the core of the arts is
simply to be practised. The distinguishing dignity
of man is to practise art - for its own sake. Man is
sign-making - man "significates" - man is significant.
I believe that the Arts' claim on the school curric-
ulum is simply that they enable man to develop and
state his significance. This understanding gives the
arts a curricular position of enormous and crucial
worth.

Jack Dominion (1978) wrote an article that always
restores my faith whenever I find myself doubting the
value of schooling. Here is an extract:

> "The third and ultimate meaning of
> affirmation is the ability of parent or
> teacher to give a child the feeling that
> he can trust his own inner world. The
> ultimate maturity to which we all
> aspire is to realise our potential, to
> feel significant independently of our
> potential and to be able to evaluate
> the world around us with a basic trust
> and faith in ourselves that we can
> reach an approximation of the truth and
> live by it. The ultimate affirmation lies
> in the core of our identity whereby we
> can use all the external influences
> that have shaped our lives and yet
> retain a sense of our own uniqueness to
> be lovable and effective, on the basis
> of our internal resources. When we are
> stripped of all that has defined us we
> need to have a basic sense that we
> belong to ourselves and to no one else,
> have a unique reality which on balance
> is more good than bad, and on this basis
> offer and receive love with at least a
> minimal certainty that we can love and
> be loved."

I believe there is a special role for the Arts, the
Arts Studios, the Arts Teachers, hinted at in this
paragraph.

Last year we heard one of the speakers describe the
distancing rituals that have grown up around 'good'
music - concert halls, barriers of potted plants
between performers and listeners, neat rows of
numbered seats, best suits, advanced bookings,
imposing foyers, high prices. The Club seems to revel
in being an in-group and everyone knows that the only
point in an in-group is that it is small and impenetrable.
As a cricketing Northerner, I used to be appalled by
what I saw then as the class-based Southern attitude
to County cricket in Cambridgeshire. Only when
finance in the form of hand-outs from the Gillette
Cup enforced a more professional approach did the
Cambridgeshire County Team sully its ranks with the
occasional cricketer from the village leagues. Even
then, relief and delight seemed unbounded if the
intruder fluffed his debut, so that his debut could
also be his swan-song.

The world of Art too seems to me to enjoy being
exclusive. Galleries, Salesrooms, glossy catalogues,
collecting, seem to me to have little to do with the
energy that causes young people to turn their whole
bodies into sign - Signa. I hope we do not forget
that art is for every Man, not just a select few. I
hope the schools will throw up the next generations
of professional painters, designers, illustrators -
but I hope even more that the schools will, in
applauding these victories, not turn aside from
counting the casualties. Must there be casualties?
There are very many 'good' schools where well over
half the children practise no art in their school
week after the age of 14. We must count our dead.
Perhaps you are thinking that they do Music or Drama.
It cannot be guaranteed. What about English? Can
anyone be confident that the English lesson is an Arts
lesson? I picked this out of the Times Educational
Supplement (24.4.81):

> "Mr Anthony Adams, chairman of the
> National Association for the Teaching
> of English warned of increasing pressures
> on English teachers to 'fall back on

> minimum competency programmes of
> isolated language skills emphasising
> the surface features and conventions
> of language at the expense of more
> creative involvement with the
> processes of composition and with
> response to literature.'

> Some local authority English advisers
> were accused of "panic" in the face of
> these pressures and he cited some of
> the guidelines for English being
> produced by some local authorities.
> These emphasised handwriting, spelling,
> sentence construction and punctuation.

> Referring to the Department of Educ-
> ation paper, The School Curriculum, he
> attacked the low priority given in it
> to the arts. It was clear that most
> pupils would have to depend largely on
> English for their aesthetic education."

I believe it is true that many children depend largely
on English for their formal aesthetic education. If
that is the case, and English lessons are increasingly
being devoted to minimum competency programmes, then
"we must count our dead and not pretend they are
alive". I can't stop here with us counting our dead.
I must look into the job of reducing the number of
casualties. The casualties I must focus on are not
those who fall before the battle begins - I am not
writing them off, they represent a cultural/admin-
istrative problem. Nor am I abdicating from
responsibility for administrative problems. They
belong with artists as Henry Morris, the founder of
the Village Colleges, so eloquently expressed.

> "The correct diagnosis of some of the
> characteristic limitations of our English
> system of community education is that
> the main control, both locally and
> centrally, is administrative and not
> cultural. Neither administrators nor
> administration (in which I include
> inspection) can create and inform true
> education; they can insure formal

> efficiency (an important commodity, but
> achieved by ants and bees), but they
> cannot create and sustain authentic
> sanctions. It is not the task of
> administrators, as hewers of wood and
> drawers of water, whatever their private
> aspirations and dreams may be. The
> proper architects of education are
> philosophers, artists, scientists,
> prophets, and scholars, operating in
> freedom."

The casualties I wish to focus on are those who come
to lessons but are gradually eliminated in the quest
for stars - those who set out with us in good faith,
but who are filtered out and finish up writing their
own labels strong and clear "I am no good at art."
"I am a non-artist." What goes wrong?

We all have our own formulae for teaching our subject.
I certainly would not presume to tell anyone here how
to do it. I do, however, despair of talk about aims.
That must be why I warmed to the Peters' article, A
Farewell to Aims. Here is a bit more of it:

> "Processes of education encapsulate aims.
> This applies to teaching methods as well
> as to the more central aspects of
> learning. If you want children to become
> submissive, credulous and dogmatic, you
> will employ authoritarian methods of
> teaching; if you want them to become
> independent, critical minded and
> imaginative, you will use procedures which
> instantiate these qualities of mind. If
> you want them to become instrumentally
> minded, you will immure them in
> institutions geared to prizes and success
> at exams."

The implication is clear. The Arts teacher must
describe what he wants and then employ the methods
of teaching that instantiate those qualities. I hope
the Arts teacher wants everyone to know what it is to
be an artist. It follows then that children are to be
introduced to circumstances in which they are artists -
albeit faltering artists at first. And the first

requirement of an artist is that he accepts some
responsibility for action. All other things must be
equal as preconditions - the trust and devotion of the
good enough teacher, (described in The Creative Arts
by Malcolm Ross), time, materials - and Everyman -
for it is presumptuous to a degree to assume children
bring with them to school no experiential raw
materials for arts action. Peters says, "Something
must be done to sensitize students to the predicament
in which they are placed as human beings, to the
possibilities it presents for joy and despair, ennui
and excitement." An arts teacher might well amend
this and say "Something must be done to cause students
to recognise opportunities for arts action in the joy
and despair, ennui and excitement with which the
predicament of life presents them." It is this
recognition of opportunities that is important.

(An English teacher friend of mine agreed by way of
experiment to suggest to children they should write
as vividly as they could on any subject at all they
felt strongly about. One boy asked at the end of the
lesson if he could stay in to copy out his poem. His
chosen title: "I hate writing!"). Recognising
experiences (feeling responses) as opportunities for
art (sensate problems) is where the action starts.

When children learn to depend upon themselves, in an
atmosphere of trust and devotion, for motive power,
for identification of the sensate problem, and for
the resolve to see the task through, in other words
to see themselves as real artists - though immature -
the teacher is freed from the role of constrainer, or
goad, to exercise his role as enabler. If the teacher
wants the student to be aesthete, then his chosen
procedures will instantiate aesthetic qualities - the
processes themselves will embody meaning and form.
The aesthetic nature of the teacher will find
unconscious fulfilment in the process and context of
teaching.

I worried last Summer about the A.P.U.'s interest in
measuring aesthetic development. What worried me was
whether this fundamental teaching function of
monitoring aesthetic development could possibly
instantiate the notion that children first and fore-
most are to practise art - live art - uninhibited by

the debilitating impact of a lowly position on the
Aesthetic Development ladder. A golfer with a
double figure handicap can play a golfer with a low
handicap without embarrassment, with satisfactory
fulfilment, and yet without deluding himself that he
is as good a player. Is it inevitable that all those
children of ours in schools who are not chosen to help
paint the scenery should label themselves 'no good at
art' and deny themselves their fundamental rights as
human beings? I should hope not.

Perhaps there are people who do not believe that
ordinary people can be, or should be, artists. David
Jones would say Everyman is an artist, or he is not
Man.

Henry Morris was attacked for being committed to the
notion that the ideal order and the actual order can
become one. I make no apology for being an idealist.
Of the Village College model proposed for the new
Secondary Schools to be built after the War someone in
Parliament said, "If there is an excess of idealism
in this scheme, let us be thankful for it." I would
be thankful if all our arts teachers would communicate
to all our children in schools: "Come in, exercise
your inalienable right to be an artist, allow me to
guide you a step or two along the road (let's get
your handicap down). Without deluding yourself that
your steps are still faltering, keep your label on –
I am a Man. I make Sign. I am significant. I am an
artist."

REFERENCES

Carey, John. Vegetable gardening. The Sunday Times.
 24 February 1980.
Dominion, Jack. Authority and maturity. The Tablet.
 13 May 1978.
Jones, David. (1973). Epoch and Artist. Faber.
Peters, R.S. A farewell to aims. London Educational
 Review, Vol. 2, No. 3, Autumn 1973.
Winnicott, D.W. (1971). Playing and Reality.
 Tavistock Publications.

Meaning in Aesthetic Experience, Some Personal Observations

LEONARD JENKINSON

And honoured among foxes and pheasants by the gay
house
Under the new made clouds and happy as the heart was
long
In the sun born over and over,
I ran my heedless ways.
My wishes raced through the house high hay
And nothing I cared at my sky blue trades that time
allows
In all his tuneful turning so few and such morning
songs
Before the children green and golden
Follow him out of grace.

 ('Fern Hill'. Dylan Thomas.)

In what follows I have looked at some of my own
creative work as a painter in the context of some of
my recent reading in aesthetics. I have found this
exercise difficult but rewarding and the resulting
brief essay has been a means of linking and clarifying
certain issues for myself. This is not a learned
paper, but I hope it may be acceptable to the reader
as a personal exploration made public in the hope that
it may be of value for others in revealing the ideas
through the particular experience of one person.

The essay owes a great deal to Michael Podro's book,
'The Manifold in Perception', and particularly to his
chapter on Schopenhauer. Wherever I really understand
the text it is because I recognise my own experience
in it. Here he quotes Schopenhauer:

"The normal man is sunk in the whirl and
tumult of life, to which he belongs through
his will; his intellect is filled with the
things and events of life; but he does not
know these things nor life itself in their
objective significance; as the merchant on
'Change in Amsterdam apprehends perfectly
what his neighbour says, but does not hear
the hum of the whole exchange, like the
sound of the sea which astonishes the
distant observer." (Podro, 1972, p. 104.)

I have been painting for over ten years but there have
been some long periods of inactivity during this time -
Schopenhauer's 'whirl and tumult of life' is always
present and it is inordinately difficult to sustain
the clarity to experience the world in its 'objective
significance'. To experience the world in this way
requires the detachment which characterises aesthetic
experience. We require a special type of attention in
which perception is not curtailed:

"The common mortal does not linger on one
judgement, but in all that is presented to
him hastily seeks merely the concept under
which it is to be brought as the lazy man
seeks a chair." (Podro, 1972.)

In aesthetic attention we do not 'see through' objects
in this way, the world is more opaque. In aesthetic
attention we must transcend concepts and the will.

In discussing Schopenhauer's theories of art Michael
Podro writes:

"... knowledge of things 'in themselves'
might be described as knowledge of things
'for themselves' not as objects seen from
without, but as subjects realized from
within!" (Podro, 1972, p. 96.)

These words express very vividly for me what it is to
experience the world aesthetically and what it is to
paint, for through aesthetic perception I make the
world my own. I invest it with real, personal meaning.
When I am unable to do this it is because the objects
of my perception are drained of personal significance

and point only to the concept or ready meaning which
they indicate. Ultimately my world is robbed of all
but 'second hand' meaning and I become alienated.

This alienation occurs at a fundamental level, it is
ontological, for I know myself and shape myself
through my interaction with the world. There is a
cyclical process at work here. In aesthetic perception
I make the world my own by investing it with personal
meaning, but I then 'read back' that meaning from the
world and in this act I know myself in order that I
can once again invest the world with meaning. If I
cannot know myself then I am indeed alienated and
neither can I know others.

This argument seems incomplete without a consideration
of the idea of intersubjectivity, but such a consider-
ation forms a part of what follows in this paper. If
I move briefly from my personal experience to consider
the consequences of the argument for education then
they appear to me to be enormous. I believe the
alienation and disaffection in many of our schools to
be a natural consequence of a fundamental misunder-
standing of the nature of knowledge and knowing, in
which the primary and personal feeling element is left
out of account.

But what does it mean to make the world one's own and
perceive it 'as a subject realized from within'? I
have a particular interest in space. As a painter I
am deeply involved with the personal meaning of
spaces. I am not concerned with the ready currency of
space in its objective determinations except insofar
as I wish to introduce ambiguity through reference to
these. In a sense I have my own co-ordinates - my own
position. Bachelard quotes Barrault:

> "I find myself defining threshold
> As being the geometrical place
> Of the comings and goings,
> In my father's house." (Bachelard, 1969.)

Jeff Bishop, in an article in the Bulletin of Environ-
mental Education (May, 1977) brings together a number of
sources in illustrating this primary subjective mode
of space perception, and he shows us something of how
it may be constructed. Having introduced us to

Piaget's 'elementary', 'topological' perceptions, said
to be in operation in children from ages 3 to 7 years
he then quotes research which has shown that adults also
construe novel environments through topological
elements. Bishop presents us with a table which
suggests the equivalence of some of Piaget's topo-
logical elements with elements described by other
workers in the fields of architectural psychology and
'semantics'.

Piaget	Norburg-Schultz	Smith	Lynch
Proximity	Place	Context	Node/landmark
Sequence	Path	Routes	Routes
Enclosure	Domain	Grouping	District

These elements may well be the stuff of subjective
space. They could be the medium through which personal
meaning operates, for I am sure that, with Barrault, we
know in the real sense through our particularity, and
the particular proximities, sequences and enclosures
of our early environment are powerfully significant.
In my case, the hill from town up which the bus came
and the lines of lights across the valley, are early
childhood experiences which I regard in this context.
It is interesting that Bachelard speaks elsewhere of
the idea of a genetic phenomenology.

Bishop's article is about architecture, and how it has
'lost its heart'. He maintains that the significance
of subjective elements has been lost. He contrasts
the old organic, internalised centres or focal points
in communities with the alienation of the modern
shopping centre, a conceptual structure all too often
devoid of real meaning. Perhaps of more relevance
for us, however, is his comment on children's
drawings:

> "In a study of maps drawn by children
> aged from 9 to 16, I found that there was
> an extremely abrupt shift in the style
> of map produced from those in top juniors
> (10-11 years) to those in their first
> secondary year (11-12 years). The top
> juniors' maps were colourful, expressive,
> drawn in various modes and altogether
> difficult to classify. After less than

one academic year the secondary
children's maps were, to put it simply,
'geographical' and dull. The cause is,
I suspect, the instant split into subject
teaching in secondary school and the
wishes of subject teachers to impose
their disciplinary modes of thinking as
soon as possible ... This attitude to
what are called primitive or even
childish perceptions has been rigorously
attacked by Herbert Read who argues that
we inhibit and stultify the child through
our attempts to push him too quickly into
what are considered to be adult modes of
artistic expression. Although Read does
not use such terms as 'topological' one
can clearly see that far from considering
these early representative modes as
'childish' in any way he sees them as
essential bases for developing a broad
awareness of art in all its expressions;
in other words they should be with us all
the time. This concern about over-
educating the child is being more commonly
voiced at the moment ... An obvious
conclusion from this is that one might
need to think about 'unlearning'.

I recently submitted some slides of my work to a
gallery and I was asked to provide a brief statement
about my work. I said that the paintings were about
places, spaces, and patches of grass and sky which I
experience as I walk around the city and its borders.
I hope that in the context of this paper this state-
ment may take on a deeper meaning.

My paintings are mostly green and blue because they
are about grass and sky. My method of working is
bound up with my use of the medium - with paint and
its application - exploring the medium in relation to
my feelings about the places with stains, sprays,
impasto techniques, etc. There are sometimes problems
of form which I attribute to the same causes as my
periods of inactivity, that is, they are problems
related to the intensity of my experience (its lack
of intensity) and to interference from non-aesthetic
concerns. An added confusion is often apparent where

there is an awareness of 'art', for example of 'types
of painting'. This is a kind of self-consciousness
although it is clearly impossible not to work in some
sort of tradition. It is a very slow business and I
have been down many blind alleys. I would like to
describe one such significant failure in some detail.

Just before the summer holiday I was having problems
with the painting and I decided I would try to 'find'
paintings out in the environment. I would take very
carefully framed slides of particular shadows and
spaces and combinations of shadows and spaces, that
could be projected on to a canvas and copied exactly.
They would be evidence of my aesthetic perception made
tangible - familiar places or configurations seen in
a new light - little magic slices of my experience,
glowing with meaning. The exercise was doomed to
failure. In retrospect it seems strange that I should
not have anticipated this failure but I have hitherto
kept my artistic endeavours free from my intellectual
knowledge about the artistic process. I had not
conceptualised any of this as relating to my painting.
The thing is all the more amazing because I had already
had a similar experience with photography. Photographs
taken of magical streets and spaces on a walk full of
significance turned out when developed and printed to
be boring and commonplace. They did not reflect my
experience when looking at their subjects.

The new photographs from which I was to paint were,
however, to be very special, I was to look for subjects
that could be used for shaped canvases and for
diptychs (the image was to be repeated, this would
stress its character as an image, something, as it
were, lifted out of context).

I went out several times and gradually found the
images I was after. I was deliberately strict with
myself and very particular about what to photograph,
sometimes I returned home without having taken one
photograph.

When the photographs were developed I was quite
pleased with them and I had some four or five made
into slides. I eventually chose one slide, taken on
a quiet sunny afternoon, of a metal gate enclosing
the space of a small empty car park belonging to a

plant hire firm. The white lines painted on the
surface of the car park were at the same angle (viewed
from my position) as the diagonal lines of the gate,
and the shadows in the picture were very important in
defining the space. The image contained a good deal
of meaning for me, it seemed very still and empty,
and so 'everyday' that I wanted to make art with it.

I projected this image onto a wall in the studio and
with considerable labour made two shaped stretchers,
each some four feet across, which were exactly the
same shape as that section of the image I had chosen
to use. I made up the canvases, and after many days
hard work I had produced the double painting from the
slide. It was a failure. Not only was the painting
technically bad because of the limitations copying
had imposed on my use of the medium, it was also an
artistic failure in that it did not embody meaning.

Paul Stern, writing on the problem of artistic form
says:

> "... It is essential for the aesthetic
> view that all external elements are felt
> directly as an embodiment of something
> internal, as expressions of a certain
> condition of inner life ..." (Stern, 1972.)

and Georg Mehlis (1972) considering 'The Aesthetic
Problem of Distance':

> "In order to find the aesthetically
> important element in the living reality
> the artist must remove himself from it
> 'and' if mere nature is to become
> aesthetically significant then it must
> appear to the understanding eye as an
> image divorced from its material aspects."

The 'expressions of certain conditions of inner life'
could not be embodied in the reproduction of one
image, one component, of the experience which was in
any case not sufficiently 'divorced from its material
aspects'. What was required was the free manipulation
of those basic formal elements through which personal
meaning operates. After the painting was completed I
removed it from its stretchers and used them to make

new works. I placed the photographs around the studio
as a sort of reference (even this was of little use)
and began to work freely with the medium as before.

I am reminded that I once spent several evenings in a
city revisited after a long absence looking for a
particular public house. I never found it - I kept
finding bits of it ... - but the particular pub I
remembered always eluded me. In truth it was just
what my painting was not, it was a phenomenal object,
an aesthetic entity, built up from the combination of
several experiences each divorced in space and time.
What quality, we may ask, caused these separate
experiences to be linked in this aesthetic entity.
If we return to the grouping of perceptions in concept
formation, to so-called 'curtailed' perception, we
recall that they are grouped categorically in respect
of some quality they have in common. Might it not be
that in aesthetic perception we analogise in
detachment in a more fundamental sense? What I believe
we are discussing here is a kind of deep structure
inherent in the phenomenal world.

My intuitive experience as a painter leads me to the
conclusion that in seeing the world 'as a subject
realised from within' we are attending to a sort of
structure, and for a description of this foundational
meaning-carrying structure I would look firstly to the
variously described topological perceptions grounded
in the particular experience of the individual but
common to all in that we all possess a body and are
psycho-physical organisms with a common orientation
towards the world.

When considering the 'primitive' representative
modes referred to earlier in this paper I am reminded
of the statements of Picasso and Klee who with other
great artists wanted to draw like children.

As a painter I will leave the last word with a painter
I greatly admire and respect. John Hoyland writes of
painting:

> "One discovers a painting as one might
> discover a forest with snow falling and
> then suddenly, unexpectedly, come upon
> an open glade with sunlight penetrating

the falling snow, simultaneously.

Paintings are not to be reasoned with,
they are not to be understood, they are
to be recognised. They are an
equivalent to nature, not an illustration
of it; their test is in the depth of the
artist's imagination." (Hoyland, 1980.)

REFERENCES

Bachelard, Gaston. (1969). The Poetics of Space.
 Beacon Press, Boston.
Bulletin of Environmental Education. Town and Country
 Planning Association. Vol. 73, May 1977.
Hoyland, John. (1980). John Hoyland Paintings 1967-
 1979. Arts Council of Great Britain.
Mehlis, Georg. (1972). In S.K. Langer (Ed.), The
 aesthetic problem of distance. Reflections on Art.
 Oxford University Press.
Podro, Michael. (1972). The Manifold in Perception.
 Oxford-Warberg Studies.
Stern, Paul. (1972). In S.K. Langer (Ed.), On the
 problems of artistic form. Reflections on Art.
 Oxford University Press.

Aesthetic Assessment and the Reliability Factor

KAREN M. MOLONEY

I

It is difficult to escape noticing the emphasis
given to the assessment issue in contemporary
publications. Restrictions on public spending have
forced many institutions to prove their worth or face
possible cuts, even closure. Evidence of high
standards of performance by pupils is seen, by many
schools, as a safeguard against these dangers.

More, perhaps, than other parts of the curriculum,
the subject areas traditionally associated with
aesthetics are likely to be threatened by the
political swing in emphasis towards the three R's as
the predominant subjects in the curriculum. Although
the thought of having to justify the place of music,
dance, art, drama, etc., in the curriculum appals
many of us, recent events have indicated that it may
soon be necessary.

One way of providing evidence with which the political
powers are familiar, is to set written examinations
in the subjects and grade them according to pre-
defined criteria of excellence. Another way is to
administer a battery of psychological tests which
yield measures of individual differences in ability,
talent, creativity, aptitude, as well as achievement
and performance. The method of assessment most
prevalent in aesthetic education today is the
evaluation of pupils' art products and performances
by teachers or examiners who are trained to be
sensitive to the significant features of children's
work and are able to integrate these features into a
total impression of estimable quality.

It is worthwhile to examine these three methods in
some depth to see which are the most reliable features
of each, and which, if any, could be considered for a
totally new approach to assessment in the arts.

Written examinations, as mentioned above, come in
various forms. Tests which require the pupil to
select the best of a number of alternative answers,
true-false, multiple-choice, fill-in-blank, etc.,
enable the use of a scoring key or machine so that
assessors agree perfectly on the result.

Structuring the task in this way controls the
performance so that all pupils are judged very much on
the same basis. But this can mean that responses are
constrained, leaving little room for the free express-
ion so highly valued as a factor in aesthetic
development.

A serious charge against multiple-choice tests is that
they tend to be confined to the measurement of simple,
even trivial knowledge of facts. This need not
necessarily be the case. Questions can be designed
which require complex thought and discrimination
between plausible alternatives. The criticism is
levelled against the test content more than the
method.

Written essay-type questions, however, pose a greater
problem for reliability, especially without the
provision of predefined criteria for excellence, as
mentioned above.

The possibility of using a battery of psychometric
tests is not usually considered in aesthetic
education. This is probably because the tradition in
psychometrics has always been scientific. There has
been, among psychometricians, an obsession with
objectivity and reliability, sometimes at the expense
of probing a richer understanding of the field, and
apart from items of information, it is argued, there
are very few useful questions which can be asked in
aesthetics which require a simple right or wrong
answer. The function of a psychometric test is to
measure differences between individuals or between
the reactions of the same individual on different
occasions. The early 'mental tests' measured

individual differences in reaction time, muscular
strength, memory, and were the fore-runners of modern
intelligence tests. But such tests were limited in
their coverage and psychologists realised the need
for tests of special aptitudes. These tests were
originally developed for use in vocational counselling
and the selection and classification of industrial
personnel. Today, mechanical, clerical, musical and
artistic aptitudes are the most widely tested.

During this time, while psychologists were involved
in the development of intelligence and aptitude tests,
traditional school examinations were undergoing a
number of technical improvements. Written examinations
were often complemented by oral interrogation by
visiting examiners; essay questions were replaced by
objective multiple-choice items. These changes were
in response to the accumulating evidence that essay
tests yielded less reliable results than the new type
of 'objective' testing and they were more time -
consuming for examiners and examinees. The 1930's
also witnessed the introduction of automatic scoring
systems which were not applicable with essay items.
As these innovations came into increasing use in
standardised achievement tests, there was a growing
emphasis on the design of items to test the under-
standing and application of knowledge and other broad
educational objectives.

As more psychologists trained in psychometrics
participated in the construction of standardised
achievement tests, the technical aspects of achieve-
ment tests increasingly came to resemble those of
intelligence and aptitude tests. The increasing
efforts to prepare achievement tests that would
measure the attainment of broad educational goals, as
opposed to the recall of factual minutiae also made
the content of achievement tests resemble more
closely that of intelligence tests. Today the
difference between these types of tests is chiefly one
of degree of specificity of content and the extent to
which the test presupposes a designated course of
prior instruction.

The final common method used in the assessment of
aesthetic development, and the one upon which this
paper will concentrate, is carried out by trained

observers, teachers or examiners. Judgements are
made on the basis of what could be described as an
esoteric impression. By this, I mean a judgement made
in response to the total form and content of the work
or performance, the reasons for which are rarely
articulated in words and which is idiosyncratic to
the individual judge.

Although the preferred method amongst most assessors
of aesthetic development, this last method produces
problems of reliability as the next section will dis-
cuss.

II

Esoteric impressions have a number of characteristics
which tend to make them technically unreliable:

1. (a) A judgement made in response to the total form
 and content of a work is often an intuitive
 reaction to some quality of the work which
 may not have been intended by the child. For
 example, meanings are frequently attributed
 where not intended.

 (b) Response to the total work is obviously based
 on more than the summation of the parts, and
 therefore, assessment of all the substructures,
 although important, is insufficient to give a
 total picture of the piece. This is
 acknowledged. On the other hand, overviewing
 the whole work may fail to reveal parts of the
 work which, although inessential to the whole,
 may be worthy of merit in their own right. A
 balance of interest is needed when assessing
 works of art, between the total work and the
 constituent parts.

2. Verbal descriptions of criteria for judging works
 of art are rare in the public examination system.
 Many examiners have their own implicit reasons
 for marking one work as a B+ and another as A-
 but, on the whole, these are rarely articulated.
 Compared to other disciplines, even descriptions
 of works of art are rare, and when these do occur,

it is doubtful that the language of art used to
describe the works is used in the same way by
everyone, (see Moloney, 1980). This
inhibits communication amongst assessors and
casts doubt upon the reliability of individual
judgements.

3. Everyone approaches works of art with a different
 history of experiences, knowledge and attitudes
 and so will bring to bear different reasons for
 valuing some works over others. Certain
 modifications to the single examiner system can be
 made to increase reliability, as will be seen, but
 these again are implemented in too few cases.

How can we ensure that children doing public exam-
inations are given a fair assessment of their art
products and performances? They, and their parents,
need to be assured that they are likely to be awarded
the same grade regardless of who is assessing their
work. The problems associated with the present
impressionistic system can be minimised by the use of
certain measures designed to increase reliability.

The factors determining reliability of assessment are
as follows:

1. The number of people marking the art product or
 performance

2. Their personal experience with the pupil along
 continuums from well-known to unknown, and liked
 to disliked

3. Discussion amongst those marking the examination
 or test

4. The use of some criteria and scales.

Reliability can be increased by the following
measures:

1. Increasing the number of people marking the
 examination or test up to a limit. Too large a
 panel will not easily come to agreement.

2. Discussion and agreement amongst the markers is

not necessarily preferred because of the possib-
ility of dominant personalities having too great
an influence on decisions. Where this problem is
likely to occur an average of independantly
marked scores can be computed.

3. Experience with the candidate, knowledge and
 opinion of his/her background, character and
 previous work need not necessarily produce an
 unreliable bias. Familiarity with the candidate
 can often yield an extremely helpful intuitive
 knowledge of the candidate's real performance,
 especially when considered in addition to
 objective test scores.

4. (a) Obviously, the increased use of criteria for
 performance will enhance reliability but only
 up to a certain point. Having no criteria,
 i.e. basing judgements on factors such as,
 "I like it", or, "I like this pupil" is
 unreliable and inevitably alters over time
 and between judges. At the other extreme a
 definite number of criteria for minimum
 performance may preclude standards which are
 valid and have been achieved but for which
 the candidate will receive no credit since
 they are not included in the examiner's list
 of criteria. Some criteria are necessary to
 establish that, "in my opinion, the candidate
 has achieved the following ...".

 A major influence on any assessment is the
 cultural milieu in which the assessment takes
 place. It should be noted that anyone who
 makes a judgement does so from within a
 particular cultural framework. Questions
 concerning the cultural and sub-cultural
 background of teachers and examiners need to
 be considered when they differ from those of
 the children being assessed. Peer sub-
 cultures between adults are very different
 from those amongst children. Similarly, the
 judgement of adults varies according to
 fashion, time and peer influence.

 (b) Measurement is possible using a number of
 different scales varying in the amount of

differentiation they attempt to describe.

 i) A <u>nominal scale</u> is a set of categories
 such as pass/fail, A, B, C, D into which
 pupils work is assigned according to the
 opinion of the judges. "This is
 certainly a B+ piece of work!"

 ii) Another type of scale, the <u>ordinal scale</u>
 is similar to the above except that
 results are compared to each other in
 order to be placed into the categories
 hierarchically. "This is a B because it
 is better than that to which we gave a
 C." But this tells us nothing about the
 relative distances between pupils and
 their work (unless an equivalent
 percentage scale is used to assign
 grades).

 iii) The <u>interval scale</u> provides this
 information in utilising standard
 intervals between pupils' marks.

 iv) The <u>ratio scale</u> adds to this a zero and
 an upper limit.

The scale used for assessment should be determined
by the circumstance which it attempts to describe.

In summary, a more reliable impressionistic assessment
of children's art works and performances would have
the following characteristics:

1. A panel of judges of size which is practical for
 decision-making.

2. Made up of teachers who have valuable information
 additional to that obvious from the work being
 assessed, as well as <u>more</u> objective judges.

3. The method by which decisions are reached can
 vary, but, in the case of an unrepresentative or
 biased panel, average consensus would be the
 most reliable.

4. The use of an indefinite number of criteria.

III

It is clear that there is a need to increase the
reliability of certain methods in common use in
assessing children's art works and performances. But
this alone does not improve the validity of the
method. By far a more important issue, and one which
we can only touch upon here, is ensuring that the
methods in use are appropriate to the behaviour being
assessed.

Aesthetic development is manifested in many ways, not
simply in the works of art children produce but in
their understanding and appreciation of all the arts.
The various components of aesthetic development are
best assessed with their own most appropriate method.
Certain methods are more suitable for procuring one
type of information than another. For example, to
ask an untrained ear to use a Likert Scale to describe
a child's aesthetic feeling in a performance on the
flute may be wholly inappropriate. As we shall see,
the various components of aesthetic behaviour can be
assessed using modifications of the methods already
described.

Skills of perceptual discrimination present little
problem for assessment. Either a child can or cannot
see, hear, taste or feel differences. Of course, some
children have greater powers of discrimination than
others but this is still assessable in an objective
way using psychometric methods described in Section I.

Tests of simple discriminative skills are reliably
scored by a standard objective measure. A skill such
as playing a pure C# on the oboe can be assessed
using an oscilliscope, if necessary.

More complex skills, however, such as writing poet-
ically or moving gracefully require a more in-depth
appraisal. Where possible, skills such as these
should be exhaustively defined in such a way that
ideally, anyone could score through a check list and
conclude that this pupil achieved, for example, 90%
of the criteria for graceful movement.

But, minute nuances of style could in a case like this
be easily misjudged or overlooked by an inexperienced

eye and, if not included in the check list, the
candidate may not receive credit for including them
in his/her performance.

Another problem is the question of whether or not a
'perfect' performance can be attained. In the eyes
of Olympic gymnastic judges, a skilful and an artistic
performance can add up to a perfect score.

All too often exhaustive definition such as is
suggested above and which could, in theory, lead to a
perfect score being attained does not take place and
more usually, experienced judges make a private
assessment of performance. But it is possible, and is
common practice in the U.S., to write detailed
behavioural descriptions.

A compromise might be to undertake exhaustive
definition of all the behaviours to be assessed and
to put these check lists into the hands of
experienced judges who can credit a candidate with
greater reliability than someone inexperienced, and
who can also credit a candidate with a performance
over and above the one required on paper.

Tests which measure ability to handle media are
usually scored subjectively into given categories or
compared to pre-scored examples in the manual. Two
major problems occur with this type of scoring.
Firstly, the scores of the examples are determined
according to criteria which are often undefined and
which may not be as relevant to the time and fashion
of the present time in which the scores are being
evaluated.

Secondly, the perennial problems of reliability occur
when scorers are asked to make subjective judgement
about works of art without reference to pre-scored
examples.

Assessment of work samples may reflect training to
date as much as true ability, but it is a fair basis
for comparing children who have had similar training.
Merely asking a child to draw a picture or submit a
piece of completed design work, however, does not
make for a standardised comparison. To standardise
the task by requiring everyone to draw from the same

model, on the other hand, leaves little room for
creativeness, unless individual interpretations using
the model as a basis are encouraged.

Skills of discourse can be examined using check lists
of appropriate behaviours.

There are few problems in the scoring of knowledge as
they are usually of the Standard Objective type of
response and can be marked either right or wrong.

Problems can occur, however, in the interpretation of
vocabulary scores. Specialised Vocabulary Tests
correlate very highly with other vocabulary tests and
yet do not appear to distinguish easily between
specialist and other students. Specialised vocabulary
tests could perhaps tell us nothing more about a child
than the size of his/her general vocabulary.

Vocabulary tests utilising a percept/concept inter-
action approach in which the subject is required to
compare visual representations are often marred by
poor quality reproduction which leads to low
reliability. Where possible, colour slides should be
used.

Multiple-choice questions also suffer from the
possibility of ambiguity. Alternative wrong responses
(usually called distractors) have to be sufficiently
different from the correct answer as not to cause
possible ambiguity. On the other hand, distractors
can be made sufficiently close to the correct answer
so that only those who really understand the question
will be able to see that the distractors are incorrect.

Sometimes important information can be lost in
multiple-choice questioning unless reasons for
answering can be ascertained. These should either be
procured at the piloting stage to ensure that the
question is clear, or by using another multiple-choice
question to ask why.

Despite minor limitations, the multiple-choice
question is in my opinion, the preferable method for
assessing knowledge, information and vocabulary.

Many items of knowledge and information are assessed

in essay or open-ended response form. A disadvantage
of this as we have already seen, is that unless
suggestions for exhaustive definition of criteria for
assessment are taken up, scoring can become very
unreliable.

Aesthetic perceptions are difficult to assess.
Straightforward assessment of an aesthetic perception
is rare, usually because problems of defining what
aesthetic perception is need to be overcome before
assessment can take place. More usually, evidence
that aesthetic perception has taken place is
compounded with an attitude or value and assessed.

Feelings can be reported and expressed in a
variety of ways. Thus, restrictions on modes of
expression should be avoided. Aesthetic perceptions
are not always best expressed in words, so the making
of art objects or experiences to express an aesthetic
perception should not be ruled out.

Finally, let us turn to tests of aesthetic judgements,
attitudes, opinions and values.

The assessment of attitudes is both difficult and
controversial. Whether verbally-expressed opinions
can be regarded as indications of 'real' attitudes is
questionable. But even observations of overt
behaviour may not always be an accurate index of
attitude. Self-report inventories of attitudes and
values are the best methods available to us at this
time.

Another major difficulty especially with attitude
inventories, questionnaires, etc., is trying to avoid
suggestion or ambiguity in the question.

The most usual method for assessing values in
psychometric assessment is to ask the Subject to make
a preference or judgement. Three answers are usually
scored by comparison with some 'correct' preference or
judgement dictated by experts in the field.

Unfortunately, rarely, if ever, are reasons given why
some art objects are preferred over others. Agreement
between experts concerning the criteria which make
one work of art better than another may be an

unrealistic impossibility but perhaps an attempt to list these criteria would answer the argument that experts don't know what they're talking about any more than a child.

A similar philosophical argument concerns the standardising of taste. Assessment of children's values may well encounter opposition from those parties which believe that taste in the arts is too personal to be assessed.

IV

In this paper I have tried to give an overview of various methods used in the assessment of children's aesthetic products and performances, to discuss the failure to meet standards of reliability, to suggest where improvements could be made to the reliability and validity of measures appropriate to the various components of aesthetic behaviour.

Inevitably there will be omissions. Methods may exist of which I am unaware, which could alter the light in which methods currently in use could be criticised. It is a trying characteristic of the field which makes the information hard to find and the reasons behind assessment recondite. Nonetheless, this is no reason to remain silent. The concepts with which we conduct our discourse about aesthetics present particular difficulties for analysis, but consistency of usage and comprehension of the most difficult principles for assessment are possible, and should be the aim amongst all those involved in the field. (Moloney, 1981.)

REFERENCES

Moloney, K.M. The Language of Art, A Comparative Analysis. Paper presented at 5th Regional Congress of INSEA, Vienna, August 1980.

Moloney, K.M. Concept Analysis. A new direction for aesthetic education. Journal of Aesthetic Education, Vol. 15, No. 3, 111-114, July 1981.

Author Index

Arnheim, R. 23, 81
Auerbach, F. 121
Bachelard, G. 116, 188
Berlyne, D.E. 60
Bernstein, B. 62
Blacking, J. 94
Blakeslee, T.R. 165
Bloom, B.S. 100
Bogen, Joseph E. 166
Bolton, Gavin 145
Bruner, J. 102
Butler, R. 121
Carey, J. 179
Child, I.L. 10, 49, 50,
 51, 60
Cooke, D. 103
Devlin, P. 94
Dewey, J. 140
Dunlop, F. 140
Dominion, J. 180
D'Onoforio, A. 9, 52
Erikson, E.H. 53
Evans, D. 62
Festinger, L. 61
Feldman, D.H. 48,
 53-56, 63
Fleming, M. 140
Gardner, H. 15, 16,
 22, 48, 48-51,
 56
Gombrich, E.H. 30
Gordon, R. 110

Harrison, J. 95
Hemming, J. 164
Heron, P. 113
Heyfron, V. 29
Hirst, P.H. 51
Hockney, D. 113
Hoyland, J. 113, 193
Hudson, L. 166
Huizinga, J. 96
Johns, J. 115
Jones, D. 81, 170, 171,
 174, 175
Klee, P. 114
Kohlberg, L. 53, 86
Langer, S. 144
Marcuse, H. 36, 83
Matisse, H. 112
Mehlis, G. 192
Merleau-Ponty, M. 43
Moloney, K. 199, 206
Moore, H. 121
Morris, B. 118
Murdoch, I. 147
O'Neill, C. 144
Ornstein, R. 166
Osborne, H. 112
Oxlade, R. 120
Parsons, M.J. 9-14, 27, 51,
 52, 57, 62
Peters, R.S. 177, 178, 183
Podro, M. 186, 187
Raven, J. 164

Read, H. 23, 83, 157
Regelski, T. 100
Reid, L.A. 17, 57, 59,
 65, 113
Reimer, B. 100, 108,
 130
Ross, M. 31, 78, 86,
 96, 147, 162, 184
Sartre, J-P. 36, 39,
 44
Seashore, C. 96
Sheers, M. 126

Small, C. 95
Spencer, S. 112
Stern, P. 192
Suttie, I. 156
Swanwick, K. 98, 99, 102
Sylvester, D. 113, 120
Taylor, D. 98, 101, 102
Warnock, M. 138
Winnicott, D.W. 179
Witkin, R.W. 83, 85, 138,
 159
Wollheim, R. 29, 30, 43,
 44, 83, 84

Subject Index

Abstraction 71-75
Adolescence 157, 159, 164,165
Appreciation 8, 25, 36, 49, 56-59, 62, 70, 71, 76, 85, 98
Assessment 195, 196, 200
Authenticity 37
Being 38, 39
Cognition 5, 14-16, 18, 19, 54, 61, 63, 69, 70, 71, 100, 126
Communication 50, 126, 127
Competence 59
Consciousness 35, 41-44, 80, 142, 144
Concepts 8, 38, 119
Creativity 12, 22, 28, 35, 44, 55, 58, 59, 61, 62, 87, 122, 142, 146, 167, 182
Criticism 56
Embodiment 7
Emotion 155, 156, 158, 159, 161, 162
Engagement 138, 140, 142
Evaluation 28, 29, 119
Examination 195, 199
Expression 14, 29, 33, 35, 70, 73, 83, 103, 104, 105, 127, 131-133, 147, 158, 162, 165, 189, 192

Fantasy 39, 40
Feeling 10, 12, 14, 15, 17-20, 22, 33, 39, 41, 43, 50, 65, 84, 85, 101, 107, 126, 127, 130, 131, 134, 151, 157, 159, 164, 165, 188, 202, 205
Imagination 34, 38, 39, 44, 97, 98, 107, 130, 131, 138, 139, 178, 194
Judgement 10, 13, 15, 21, 30, 84, 86, 87, 120, 198, 199, 202, 205
Making 36, 49, 56, 57, 98
Maturity 7, 11, 21, 22, 23, 31, 131-135, 155, 157, 159, 167
Meaning 6, 7, 13, 24, 39, 82, 107, 128, 129, 143, 186, 192, 193
Medium 149
Morality 12, 51, 52, 86
Objectivity 21, 107, 141, 196, 200, 202
Pattern 37, 38, 44, 126
Perception 31, 38, 79-81, 129-131, 187, 189, 193, 205
Play 96
Procedure 113, 115, 117
Psychometric tests 196, 197, 203, 204
Quality 178

Reliability 195, 196,
 198-203
Scale 201, 202
Sensation 19, 75
Significance 34-41, 72,
 121, 129, 144, 177,
 179, 180, 185, 187,
 192
Structure 16, 30, 53,
 89, 102-105, 118,
 129, 144, 157, 165,
 193

Subjectivity 42, 45, 50,
 147, 188, 189, 203
Symbol 143, 144
Teaching 110, 138, 141,
 145, 149, 163, 172,
 175, 176, 181, 184, 185
Tension 144
Validation 36-41
Value 36, 41, 51, 82, 108,
 122, 206